Cannibal Tours and Glass Boxes

In *Cannibal Tours and Glass Boxes*, Michael Ames examines the role and responsibility of museums and anthropology in the contemporary world. The author challenges popular concepts and criticisms of museums and presents an alternate perspective which reflects his study of critical social theory and his experience from many years of museum work.

Based on the author's previous book, *Museums, the Public and Anthropology*, this edition includes seven new essays which argue that museums and anthropologists must contextualize and critique themselves. In the new chapters, Ames looks at the influence of consumerism and the market economy on museums and in the production of such phenomena as world's fairs and McDonald's hamburger chains, referring to them as 'museums of everyday life.' He also discusses the moral and political ramifications of conflicting attitudes towards Aboriginal art (art or artefact?), censorship (liberating or repressive?), museum exhibits (informative or disinformative?), and postmodernism (a new theory or an old ideology?).

The earlier essays outline the development of museums in the Western world, the problems faced by anthropologists in attempting to deal with the often conflicting demands of professional as opposed to public interests, the tendency to both fabricate and stereotype, and the need to establish a reciprocal rather than exploitative relationship between museums/anthropologists and Aboriginal people.

MICHAEL M. AMES has been director of the Museum of Anthropology since 1974 and is a professor in the Department of Anthropology at the University of British Columbia.

Michael M. Ames

Cannibal Tours and Glass Boxes

The Anthropology of Museums

UBCPress

Vancouver

ISBN 0-7748-0391-6

Canadian Cataloguing in Publication Data

Ames, Michael M. (Michael McClean), 1933–
Cannibal tours and glass boxes

First ed. has title: Museums, the public and anthropology.
Includes bibliographical references and index.
ISBN 0-7748-0391-6

1. Museums – Social aspects. 2. Anthropology – Social
aspects. 3. Anthropological museums and collections.
I. Title. II. Title: Museums, the public and anthropology.

GN35.A44 1992 306'.074 C92-091171-4

Publication of this book was made possible by ongoing
support from The Canada Council, the Province of British Columbia
Cultural Services Branch, and the Department of Communications
of the Government of Canada.

UBC Press
University of British Columbia
6344 Memorial Rd
Vancouver, BC V6T 1Z2
(604) 822-3259
Fax: (604) 822-6083

For Daniel and Kristin

Contents

Preface to the Second Edition

The first edition of this book, comprising Chapters 2–6 and 9–10 in the new edition, was published in 1986 as *Museums, the Public and Anthropology* in the Ranchi University Anthropology Series (Concept Publishing Company) under the general editorship of my friend and colleague, the late Dr. Lalita Prasad Vidyarthi. Sadly, he passed away unexpectedly before the preparation of this revision. It was through his kindness and support that the publication of the first edition was made possible, providing the foundation for this second one. Grateful acknowledgment is also made to Ranchi University and Concept Publishing Company, New Delhi, with whom Dr. Vidyarthi worked closely, for supporting the idea of an expanded edition under a new title.

Much of this book is about the relations between anthropology and the peoples it represents, particularly in museums. How these people should be named therefore requires some explanation. A general term for 'the Other' within the museum context is 'originating populations' (Chapter 13), the people from whose cultures museum collections originated. There are a range of more specific terms for the originating peoples of North America, representing the fact that usage preferences change, and sometimes rapidly. When some of these essays were first written ten or so years ago, the terms 'Native' and 'Indian' were somewhat more acceptable designations than they since have become. 'Native American' still appears to be in vogue in the United States, whereas First Nations, Aboriginal, indigenous peoples, Native (occasionally), and (more recently) First Peoples are becoming the preferred terms in Canada, usually with the first letters capitalized.

What's in a name? 'Why do you call us Indians?' Cree artist Gerald McMaster asked in one of the exhibitions of his works (Ryan 1991).

That term symbolizes to many a history of stereotyping and privations imposed upon First Peoples by Europeans since the days of Columbus. As noted in Chapters 7 and 8, the Aboriginal peoples of North America, like suppressed minorities everywhere, are claiming, and correctly so, the right to name themselves. Since the essays collected here were written over a period of time, however, there was some inconsistency in the use of these terms, reflecting the changes in conventions. Moreover, as the terms 'Indian,' 'Inuit,' and 'Metis' are enshrined in the Canadian Constitution, in scholarly and popular literature, and in public discourse, there is still some purpose to their usage.

The phrase 'Northwest Coast Indian' is still widely used, especially in reference to Aboriginal artists and arts of the North Pacific Coast. The term 'Indian' therefore appears in these essays when the reference is to the Northwest Coast, the classifications of the Canadian Constitution, and to quotations from other sources. The term 'Native' continues to be one of the more common referents used by the Canadian media and it also appears in the titles of some First Nations organizations (e.g., Native Brotherhood, Society of Canadian Artists of Native Ancestry), so it too appears occasionally in this book. Elsewhere currently preferred alternatives have been inserted.

All acknowledgments cited in the preface to the first edition are gratefully repeated here. Much has been gained (though not always agreement!) from discussion with students and colleagues, some of whom are cited by name in the following chapters and in other papers. It is impossible to remember or to cite everyone who influences one's thinking, but I want to particularly mention a few individuals who through discussions and their writings helped me (though to little avail, some of them may now believe) to sort out issues explored in the new chapters: Doreen Jensen, David Jensen, Robert Kelly, Sheila Stevenson, René Rivard, Dolly Watts, Elvi Whittaker in Canada; Aldona Jonaitis, James Nason, and Ruth Tamura in the United States; David Lowenthal in England; and to those Aeotaora/New Zealanders whom I met here and during two visits to New Zealand as a guest of the Art Gallery and Museum Association of New Zealand (1988) and the Cultural Conservation Advisory Council (1990). They include Cheryl Brown, Richard Cassells, Te Ave Davis, Waana Davis, Jonathen Dennis, James Mack, Greg McManus, Marjorie Rau Kupa, Miria Simpson, Keith Thompson, and especially Mina McKenzie.

Special thanks are due to Anne-Marie Fenger of the Museum of Anthropology for more than just her helpful comments on all the new chapters, and thanks again to Sandra Hawkes for her encouragement

to continue with this writing project. I am indebted to Eileen Orwick and Jennifer Webb for assistance in preparing the manuscript, to the University of British Columbia Social Sciences and Humanities Research Committee for its financial assistance, and to the various seminars, conferences, and institutions which provided opportunities to present ideas contained in these chapters.

Special acknowledgment is also made to Haisla artist Lyle Wilson and Museum of Anthropology designer Bill McLennan for the illustration on the dust jacket and to George Vaitkunas for the jacket design; to Laura Houle for compiling the index; and to Emma-Elizabeth Peelstreet, Holly Keller-Brohman, and other UBC Press staff for editorial and other assistance.

Audrey Hawthorn, the Museum of Anthropology's first curator, who, with her husband Harry Hawthorn, the first director, set that museum upon its noble path with their inspirational work and teaching, once observed that working in a museum is always interesting because of the company one gets to keep, both human and artefact. The fourteen chapters collected here record one person's uneven passage through interesting times.

Vancouver
April 1992

Preface to the First Edition: Museums, the Public and Anthropology

Anthropology museums provide windows on other cultures of the world, but when they are examined more closely they can also be seen to mirror the profession of anthropology itself, both its achievements and its foibles. In the series of essays that follow I try to explore in a modest way museums both as windows and as looking-glasses to see what can be discovered about museums and about the anthropological profession. The focus is on the situation in North America, and particularly Canada, since that is what is most familiar to me. Perhaps the examples given here will help to raise more general questions and to encourage others to broaden the comparative base.

Both museums and the profession of anthropology, it is suggested, are in jeopardy and need to be reformed if they are to play useful roles in comtemporary democratic society; indeed, anthropology, at least, likely will have to change if it is even to survive. The major force for change considered is the process of democratization, which has been an integral part of the modernization of societies. What happens to museums and to the profession of anthropology when they are themselves confronted with the democratic idea, that revolutionary populist notion that ordinary people – 'the public' – have a right to free access to knowledge and to its use, is the question asked.

The first chapter [Chapter 2 in the revised edition] sets the problem within the historical context of the growth of public museums in the Western world. Some of the chapters explore specific issues relating to museums and anthropology, while others return to the beginning by asking once again whether museums and anthropology, at least as they are presently constituted in North America, have a useful future – or are their traditional privileges too much in peril. I am concerned throughout with the purposes museums and anthropology do and might serve. An equally important problem is the unsatisfactory state

of theory and method in anthropology, but there is opportunity in these essays to make only a few casual observations.

The essays published in the first edition were the result of some eight years of administration, teaching, and reflection at the University of British Columbia Museum of Anthropology, where I have had the privilege of serving as director since 1975. I have borrowed liberally from the works and ideas of others and am deeply grateful to them. Any merit found herein derives from their contributions, which I am passing on, while the errors, omissions, and distortions are my own inventions. I especially want to acknowledge the following individuals and institutions, because without their counsel or assistance the essays would not have reached this stage.

I thank Dr. L.P. Vidyarthi, a scholar of international repute and Head of the Department of Anthropology at Ranchi University, who kindly invited me to prepare these essays for presentation to his department and to the LXXI Indian Science Congress, which met at Ranchi in January 1984. I was honoured to be a guest both of the congress and of the Ranchi Department of Anthropology during January, and was able to complete the material for publication during that visit. I also learned a good deal about Indian anthropology at the same time and how much it can teach the West about how scholarship can better serve the public interest.

Only Chapter 6 was previously published, though earlier versions of Chapters 4, 5, and 9 were presented to various learned societies in Canada and England; Chapter 5 is published in the Proceedings of the Royal Society of Canada, and Chapter 9 is to be published in the UNESCO journal *Museum*. They are now published together under Dr. Vidyarthi's editorship. I am grateful that through his intervention this study of North American museums and anthropology should be published first in India since it, in a sense, completes a personal circle begun when I first published in North America research earlier conducted in South Asia (Sri Lanka in 1958–9, 1963 and India in 1967–8).

I am also grateful for the wide-ranging discussions with the faculty and students at Ranchi University, which helped to push my own thinking further along. It is clear that a new kind of museum is needed, one that can respond more effectively and more creatively to contemporary problems and opportunities, not only in developing nations like India but also in the so-called developed world of the West. This calls for a new kind of anthropologist as well. The traditional museum, with its elaborate and expensive exhibit constructions resembling little more than purified or genteel versions of Disneyland, is still very much in vogue, however, even though it is becoming evident that such museums serve a limited purpose and a

limited clientele (the higher educated strata). Though ostensibly designed to serve the public, these large museums, it seems to me, are a more accurate reflection of the interests and aspirations of the museum profession. Yet it is difficult to think outside of this standard or mainstream model or to break from it without discarding the word 'museum' itself, and perhaps that is what is required. The problem with museums is that they are called museums, and thus they automatically predetermine their mandate.

The Kwakiutl U'Mista Cultural Society in British Columbia, representing a number of Kwakiutl Indian tribes, calls its institution a 'cultural centre' rather than a museum, though it preserves and exhibits artefacts along with promoting other cultural activities. We reached a similar conclusion in our deliberations at Ranchi in response to the question, 'What kind of museum does a developing country like India need?' India could use museums of all types, of course, if it could afford the luxury; but the one that seemed to attract the most interest was the idea of a 'Cultural Centre of Traditional and Contemporary Performing and Visual Arts,' borrowing from the anthropological notions of sacred complex, cultural performance, action anthropology, and museum ethnology. Anthropologists, with their holistic approach to society and culture, should be ideally suited to initiate and manage such cultural complexes that could assist in the promotion and regeneration of culture, especially for people whose own ways of living are subjected to risk because of rapid change, dislocation, domination, or exploitation. Preserving the past is certainly important, but rather than simply being 'mausoleums' of the past (even if Disneyfied ones), cultural centres could work more effectively, and their anthropologists more energetically, to make the past more relevant to people today, and to enhance the quality of life today. Such a new direction would be an ambitious undertaking, and difficult to achieve where vested interests in the standard model are strong. Perhaps, therefore, we need to look to minorities, indigenous groups, small commmunities, and to developing nations for creative innovations. That, at least, was the conclusion I reached at Ranchi.

The writings of George Appell, Nelson Graburn, Harry B. Hawthorn, Audrey Hawthorn, Tom McFeat, Milton Singer, William Sturtevant, and Wilcomb Washburn had a considerable influence on my outlook on museums, and I am pleased to use this occasion to record my appreciation.

I also benefited from numerous discussions with the officers of the Museums Assistance Programme of the National Museums of Canada, with the anthropologists at the Canadian Museum of Civilization, and with designers David Jensen and Rudy Kovach.

I am grateful to students at the University of British Columbia Museum of Anthropology, whose interest in and critical response to my teaching provoked me to think even harder. And I am especially indebted to my colleagues at the Museum of Anthropology – staff, volunteers, and students – for their patience, encouragement, and inspiration as we together tried to work through many of the ideas and problems discussed here while somehow also managing to operate a busy and 'democratized' museum-as-a-cultural-centre. Thanks are also due to Sandra Hawkes for her editorial assistance, and Lucie Dufresne for preparing the index.

Acknowledgment is made to the Canadian Museums Association, the University of British Columbia Social Science and Humanities Research Grant Committee and the Dean of the Faculty of Arts, and the Social Sciences and Humanities Research Council of Canada for travel and research grants that supported earlier stages of the work represented in these essays, and to the Social Sciences and Humanities Research Council for a leave fellowship (1983–4) that gave me the quiet space in which to prepare the material for presentation to Ranchi University and for publication.

I thank the Canadian Ethnology Society, the Committees on Museum Ethnology and Architecture and Museum Techniques of the International Council of Museums, the Royal Society of Canada, and the International Congress of Anthropological and Ethnological Sciences for opportunities to present earlier versions of several of these essays.

Finally, and most important of all, I express special gratitude to my family for kindly bearing with me and without me these many years.

Ranchi and Vancouver
January 1984

Cannibal Tours and Glass Boxes

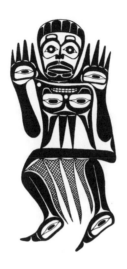

Introduction:
The Critical Theory
and Practice of Museums

The Buffalo Bill Historical Center [Cody, Wyoming], full as it is of dead bones, lets us see more clearly than we normally can what it is that museums are for. It is a kind of charnel house that houses images of living things that have passed away but whose life force still lingers around their remains and so passes itself on to us. We go and look at the objects in the glass cases and at the paintings on the wall, as if by standing there we could absorb into ourselves some of the energy that flowed once through the bodies of the live things represented. A museum ... caters to the urge to absorb the life of another into one's own life ... museums are a form of cannibalism made safe for polite society. (Tompkins 1990:533)

Museums are about cannibals and glass boxes, a fate they cannot seem to escape no matter how hard they try. The problem may not be because they are called museums, which was suggested in the preface to the first edition of this collection of essays, but rather, as Richard Handler (1988:1,036) noted in his review of *Museums, the Public and Anthropology*, because they *are* museums. They 'thus cannot surmount, or even fully recognize, the epistemological and political assumptions that influence museums and define their relationship to others.' Museums are cannibalistic in appropriating other peoples' material for their own study and interpretation, and they confine their representations to glass box display cases. There is a glass box for everyone (Parezo 1986:13, 1988; see also Chapter 13).

That is an important critique of public museums. They were born during the Age of Imperialism, often served and benefited capitalism, and continue to be instruments of the ruling classes and corporate powers, working for them 'in the vineyards of consciousness' (Haacke 1986:67). My own understanding of museums, represented in part by the essays collected here, has been strongly influenced by

this critical perspective. However, there is more to museums than cannibalistic appetites, glass box display cases, and ideology production. What some call appropriation, others see as inspiration; while some view glass boxes as a form of cultural imprisonment, others see them as a way of preserving heritage for future generations; and what some call the channelling of consciousness, others term consciousness-raising.

Museum professionals also recognize and struggle with these issues, regularly debating the epistemological and political assumptions upon which their work is based, as museum conference agendas attest. The tragedy of their struggle is that they may never be able to surmount their problems, because solutions are frequently outside their control, beyond their means, and alien to their interests. It is easy enough to criticize museums for being what they are or for failing to be what one thinks they should be, and to judge from one's own moral perspective the actions and inactions of others. It is more difficult to propose changes that are feasible, and to ground both criticism and reform in an understanding of the situation, the economic foundations, and socio-political formations of the museums to be gauged. The first step is to distinguish between museums as historically situated *social* institutions with their particular structural constraints, governing bodies, official mandates, corporate supports, public responsibilities, economic limitations, and so on, and museum professionals who, as *individual* members of museological professions and trades, march to their own occupational interests, values, and commitments which are not always those of their places of employment. Museum professionals, like other workers, may frequently have nobler ambitions than their circumstances allow. Useful criticism needs to combine assessment with the empirical examination of real situations, recognizing the complexity and intermingling of interests involved, as well as the relations between the individual and the social, and the conditions within which they operate.

The essays in this book, plus a few published elsewhere over the past decade (see bibliography), document my own struggles to achieve a practical understanding of a cultural complex in which I was also actively involved, to relate experience to critique and then to action. I write with the vested interests of a museum administrator for seventeen years and teacher for thirty whose perspective is also strongly tainted by the traditions of critical social theory that descend from the likes of Max Weber and Karl Marx (see, e.g., Bernstein 1978; Fay 1975, 1987; and the introductory and concluding sections of Chapters 11 and 12), and by the 'new museology' critique of René Rivard and others (Rivard 1984; Stevenson 1987). Searching for understanding while alternating between engagement and detachment

will always necessarily remain an incomplete project imperfectly pursued, beset by contradictions, and sometimes demoralizing. It is typically easier to see what should be done which simply requires a judgment, than to get it done, which requires a more extensive analysis of the situation and the marshalling of support. Despair is thus frequently the shadow to ambition in the museum world, like devils following one in the night.

The objective, then, is not simply to criticize museums but also to attempt to locate them (and the critiques) within their social, political, and economic contexts. This is the agenda for a critical anthropology of museums. Seven essays (Chapters 7, 8, 11, 12, 13, 14, and this introduction) have been added to the original seven, and the bibliography and index expanded. (The original chapters were renumbered to accommodate Chapters 1, 7 and 8.) All the new chapters, with the exception of this first one, either were or are to be published separately as essays, sometimes in abbreviated form (Chapters 8 and 11), and occasionally with somewhat different arguments (Chapters 11, 12, and 14). Further details are provided with each essay.

The original chapters remain unchanged except for minor editing, for they record, however imperfectly, the development of a point of view. However, a few criticisms of the first edition merit comment. Apparently Chapter 2 (Chapter 1 in the first edition) misled some into thinking it was an attempt (a poor one at that) at writing a 'history' of museums. To the contrary, it was intended only as a comment on a few significant historical developments to provide a context for the subsequent chapters. The focus of the book, stated at the beginning of that chapter, is on how museums, especially those concerned with the works of humankind, cope with the two historical forces or developments of democratization and professionalization (Ames 1986b). A second complaint was relayed from the staff of the 'Students' Room' at the British Museum's Museum of Mankind, who objected to my statement in Chapter 3 (formerly Chapter 2) that 'they do a marvelous job of politely discouraging inquiries' (about how to meet the curators). I wrote only from several personal experiences and have no comparative data for such an allegation, and therefore apologize for generalizing.[1]

Another limitation of the first edition, repeated here, is the focus on Canadian examples. Important museological developments are occurring elsewhere, of course – in the United States, Europe, New Zealand, Australia, the Third World, and increasingly among 'Fourth World' minorities and indigenous peoples. These are all topics for other essays and other books, among which a few observations on the Canadian experience may find a place.

I must take issue with one of my own concluding statements to

Chapter 5 (formerly Chapter 4), that the University of British Columbia Museum of Anthropology should not attempt to present the 'Native point of view,' since we have been attempting to do something like that all along.[2] What I should have said was that non-Natives, including curators and other scholars, cannot themselves adequately *represent* the views of others, and should no longer try. What they can do, however, is to report on those views and provide better opportunities for people to represent themselves within the established museum context (Chapter 13), through collaboration, joint curatorships, commissioned programs and exhibitions, and other forms of 'empowerment' (Ames 1990; Fisher and Johnson 1988; Jensen and Sargent 1986). This requires a 'reoriented point of view' (Duffek 1991:20), 'one in which First Nations individuals take on an identity as speaking subject' rather than as the traditional object of museum classification and interpretation. Like all good things, that is easier said than done.

There was also a request to give more attention to current issues, the debates of the late 1980s and the 1990s – repatriation of artefacts, the politics of representation, museum exhibition boycotts (two prominent ones occurred in Canada in 1988 and in 1990, both foreshadowing what has become a wide debate over 'political correctness'), the privatizing and devolutionary policies of governments, the commercialization and popularization of museums, and so on. Some of these are touched upon in Chapters 13 and 14, though it is difficult to be current when changes occur so rapidly. Magazines and newspapers are better venues than academic books for examining the topics of the day. (Chapter 14 relies heavily upon those sources.) Even as I prepared the first draft of this introduction during the summer of 1990, a crisis seemed to erupt almost daily somewhere in the world. Perhaps many are exacerbated, or even manufactured, by the ever-hungry media always searching for food. A crisis once and however defined can nevertheless become real in its consequences, with effects trickling down to museums. Iraq's annexation of Kuwait and the subsequent Gulf War meant increased deficits and higher oil prices for everyone else, affecting both commerce and culture; the soaring art market, fueled by millionaire collectors, goes hand-in-hand with increases in art thefts, the looting of historic sites, and the declining purchasing power of museums; the armed stand-off between members of the Mohawk Warrior Society and provincial police and federal troops at Oka, Quebec, ignited protests across Canada for aboriginal rights and self-determination; accusations of racism directed towards the Toronto police force spread to encompass a 1990 African exhibit at the Royal Ontario Museum and by extension all exhibits of the

'Other'; criticism of non-conformist and sexually explicit art was seen as a vanguard of a broader right-wing political agenda; the neo-conservative economic policies of Western governments force museums further into the marketplace, and some into deficits, and so on.

How effectively can museums deal with current issues like these?[3] Most, with the occasional exception of contemporary art galleries, seem to steer clear of the hot topics and big controversies, opting for safer passages through our turbulent times.

Museums, in fact, may not be properly constituted to be topical when advocacy or controversy is involved. To begin with, curatorship is based on the scholarly model of extensive research, careful accumulation and assessment of evidence over time, a focus on objects rather than on issues, and political neutrality. This discourages their immediate public (though perhaps not private) response to sudden events.

There are other reasons for museums' cautious approach towards the world: (1) their mandate to preserve encourages conservatism; (2) a general expectation, in and outside of museums, is that they should be uplifting and emphasize the positive side of history (e.g., the benevolence of science and technology and the creative achievements of cultures and individuals); and (3) the capricious and increasingly politicized funding policies of governments and the private sector, along with a growing dependence on admission fees and other generated revenues, also favour those who play it safe. Here lurks a source of despair for those who fondly hoped that museums might form part of the vanguard for positive social change by providing cultural leadership. Instead, they are more often encouraged to be passive, keeping collective heads down, as it were, belatedly reacting to events rather than initiating them, politely responding to government initiatives more than criticizing them. How many museum professionals in Canada have spoken out (for or against) free trade between Canada and the United States, Canada's Meech Lake constitutional proposals, sovereignty association for the Province of Quebec, the Gulf War, resource exploitation, environmental pollution, government policies on culture and the arts, Oka, Native, women's, minority, civil, or anyone's rights? Who would listen if they/we did? Museum professionals are not trained to deal with current events. Most are not experts on the present, we are typically inexperienced in using the media outside the context of museum exhibitions, and we all like to be thought of as nice people.

Museums are still changing, of course, one reason being that alterations in their political and economic conditions are forcing changes in their mandate. Government policies are driving them, willingly or

not, deeper into the consumer market-place. Becoming more people-oriented – even if as revenue-generating objects of consumption – may be good. It certainly has a populist democratic ring about it and likely will please politicians and benefactors. It may also lead museums, especially those who must support expensive infrastructures (i.e., salary budgets), to increasingly opt for programs and exhibitions that are more entertaining and revenue-productive than reflective and disputatious. Who would want to go through what curator Jeanne Cannizzo and others at the Royal Ontario Museum in Toronto experienced with the controversial 1990 exhibition 'Into the Heart of Africa,' or what their counterparts at the Glenbow Museum in Calgary, Alberta faced with 'The Spirit Sings' (two good exhibitions regardless of the hullabaloo they caused; see Chapter 14)? When deregulation, politicized funding, and consumerism are imposed upon cultural institutions they have the effect, whether intended or not, of muting criticisms and reducing programming to innocuous, and politically correct, entertainment. Unless we resist and revolt. The important current issues for museums to address may very well be the political and economic ideologies under which they are increasingly obliged to operate.

The outlook for museums seems bleak and getting bleaker, according to some observers, at least. If 1990 was any indication, Peter Goddard (1990) noted in his year-end review of the arts in Canada for the *Toronto Star*:

> It's going to be a deadly decade for Canadian cultural institutions. Many museums and galleries may be gone by the end of the century and those that survive will be altered beyond recognition.
>
> It's *that* bad.
>
> The problem may be economic, but the root cause is the market-place mentality that prevails – at least in Ottawa.
>
> Inadequate funding has devastated institutional operating budgets across the country ... The story is the same everywhere: deficits, lay-offs, full-timers cut to part-time status and so on ... The intellectual environment is almost as destructive.

Howard Risatti (1991:9), the Vermont editor of *New Art Examiner*, points to corresponding changes in power and status:

> Culture has become a contested realm, as the recent public battles over censorship and funding over the National Endowment for the Arts as well as the 'Great Books' debate, the question of cultural literacy, and the issue of bilingual education attest ...

As institutions of family and religion play smaller and smaller roles in educating and socializing citizens, our educational system has had an increased burden placed upon it. This has occurred at the same time that financial resources for educational institutions have been cut ...

The increasingly charged debates over education must be understood as nothing less than a questioning of the idea of America as an open and democratic society with equal opportunity and promise for all. The contest over culture – its definition and transmission – has special consequences for education in the arts and humanities, much more so than in other areas such as physics and chemistry. It is arts and humanities education that is now under increasing pressure from various factions, not only over the question of sexual censorship, but also over censorship related to 'Eurocentricity,' 'multiculturalism,' and feminism.

Whether it will be as grim as Goddard and Risatti suggest remains to be seen. (It certainly *feels* that bad sometimes, for external pressures are quickly transformed into internal dissension as people transmit discontent up the line in response to the outside pressures communicated downwards.) Economic pressures are encouraging museums to revise their relationships to their publics, seeking both greater popularity with the populace and the moral approval of vocal minorities. An increased public orientation leads to internal changes, principal among which are efforts to upgrade staff and facilities to keep step with the increased visibility of museum work and the emergence of the newer 'public disciplines' or professions concerned with audience development and satisfaction (marketing, promotion, programming, and interpretation). The work of the newer professions necessarily encroaches upon traditional curatorial territories and traditions, altering the balance of power and status and upping the levels of internal tension and dispute. (See Terrell 1991 for an example of this struggle, which is probably repeated in most major North American museums.) Further discussion of these issues, with special reference to the relations between museums and the Aboriginal peoples in Canada, are found in Chapters 8, 13, and 14. Pretty well everything has been opened up for debate: who owns history, what constitutes knowledge and who may constitute it, whose interests should be served by its representation, and even who should rightfully staff and govern public institutions? The key issues for museums are how they will manage these changes and how they must themselves change to survive the challenges.

Eight essays not included here but written since the first edition of this book supplement the arguments presented. Three were written jointly (Ames and Haagen 1988; Ames, Harrison, and Nicks 1988; Sri-

vastava and Ames 1990) and five separately in response to particular issues (Ames 1986b, 1988a, 1988b, 1989, 1990). They represent two lines of inquiry: a critical anthropology of museums and an anthropology of public culture, the latter because I believe anthropologists and museums should pay more attention to the social and political systems in which they themselves are embedded. We need to study ourselves, our own exotic customs and traditions, like we study others; view ourselves as 'the Natives.' Chapters 11 and 12 on the ideologies of world's fairs and the McDonald's hamburger chain – which might be viewed as museums of popular culture – are included as examples of a major theoretical argument: how popular events and institutions through their daily work can, like museums, turn ideology into common sense and thereby increase its hegemonic power.

The other essays added to this book describe some ways museum professionals are trying to come to terms with major issues confronting them, particularly those involving the originating peoples represented in museum collections. Though the debates may at first appear to be about what kind of museums we want, they really concern what kind of society we wish to live in, how much diversity a society can tolerate and how much uniformity it dares to impose. Afro-Canadian writer Marlene Nourbese Philip (1990:29) cuts right to the core of the problem, asking 'how to open a space for emerging voices which are profoundly contestory of the dominant culture.' It might be argued that museums are ideally suited to provide such spaces, but given the competing demands placed upon them and their restricted economic base, will they be able to?

Most examples in the following essays are chosen from museums of anthropology, art, and human history, particularly in Canada, since they are more familiar to me, but the implications are broader. Though museums of natural history, science, and technology are not discussed here, they are not necessarily immune to criticism. They are also 'ideologically active environments' – to borrow Carol Duncan and Alan Wallach's (1978) felicitous phrase – and are equally burdened by their own epistemological and political assumptions – about the noble and redemptive powers of science and technology, for example. They too may serve as playing fields or battlegrounds (museum professionals like to imagine their institutions, more passively, as 'neutral spaces') on which broader societal issues are contested. The critical dissection of science museums and centres must, however, be left to another time.

A number of recent critical discussions of museums came to my attention while working on the later chapters. Though I was not able to incorporate any of the information into these essays, the general lines

of their arguments appear to be compatible with and even to affirm positions taken here. See especially Clifford's (1991) review of four museums in British Columbia (two Native-operated and two mainstream ones), and other essays in Karp and Lavine (1991), along with Weil's (1990) collection, Price's (1989) critique of how established institutions primitivize the Other, and Harris's (1990) important collection of essays, two of which (1978 and 1981b) I have returned to repeatedly.

I want now to sketch a wider context for the essays that follow and comment upon some of the social and political issues that form part of this context. First we must recognize that museums, as we know them, are recent phenomena, and that they are undergoing further changes which will likely produce a new kind of museum by the twenty-first century resembling only vaguely what we know today. The idea of publicly funded museums emerged during the eighteenth century, but not until the last century did governing bodies generally agree that it might be appropriate to make these institutions accessible to more than the gentry, well-to-do classes, and scholars. By the turn of this century the idea was increasingly promoted that museums could serve as useful instruments of education for the moral uplift of the ordinary classes. It therefore came to be accepted that public museums should become accessible to *everyone*. Only during the last twenty or so years, however, have museums been expected to *work actively* to attract visitors from all classes, and begin to focus more on entertainment. Of course, public museums have always been concerned with research, education, and entertainment, and Boas (1907:924) may have been correct in estimating that, even by the early part of this century, some 90 per cent of visitors came more to be entertained than to be educated or to do research. But only recently have museums come to embrace entertainment as an explicit priority, and as a context for presenting other functions such as education and scholarship, and to devote both major resources and expertise to its manufacture. This has led museums to adopt more of the characteristics of a consumer society, Wallis (1986:28) argues, such as corporate sponsorship, mass spectacle, and entertainment packaging.

Increasing consumerism is changing museums. As they become integral parts of consumer society they are also buying into the ideology of consumerism – an ideology that is steadily colonizing education and information services (that notorious hegemonic process again). The populist slogan that 'the customer is always right' now applies to museums and other cultural 'industries' as readily as to hamburger chains and shopping malls (Chapters 11, 12, and 14). The

trend is to define museums as 'attractions' or 'attraction industries' expected to compete in an 'open market' for customers. They are, as a result, more inclined to promote lifestyles in harmony with the goals of a capitalist economy than to criticize it (Wallis 1986:29).

The consumer adage that institutions should listen to their customers is also having quite another impact on museums, one usually discussed within the framework of the 'postmodernist critique,' which is to encourage them to accept the relatively novel idea that museums also should pay more attention to the Aboriginal peoples whose heritage they contain and display. For anthropology museums this especially means listening to 'the Native,' an idea long taught but seldom practised beyond accepting people as informants *on* their own cultures rather than as representatives *of* their cultures. Faced now with increasing calls for the repatriation of artefacts and reburial of skeletal remains, museums are recognizing that First Peoples have a legitimate stake in museum operations and in how their histories are represented. These issues are volatile and evolving, and the literature is scattered, voluminous, and prolific. Chapters 7, 8, 13, and 14 serve only as introductions, and there have been many changes since those essays were written. Some of the debates can be tracked through the newsletters of museum and anthropology associations, in art magazines, and in the pages of the Council for Museum Anthropology's Newsletter *Museum Anthropology* (u.s.) and *Anthropology Today* (Britain).

The consumer revolution has brought two publics to the museum which it is expected to serve more effectively, though in different ways (Ames 1988a; Chapter 13): those from whom principal financial support is derived (the 'constituents,' 'taxpayers,' or mainstream society, especially the middle and upper classes and the corporate powers, from whom most museum audiences are also drawn); and the originating populations, frequently lower in class, whose histories and cultures are represented in museum collections. The two may overlap, the latter forming a subset of the former. It is also likely that they will have separate interests in the museum, the constituents more focused on being informed about and entertained by glimpses of other cultures and earlier times (the more exotic the better), and the originating peoples more concerned about how their own cultures and histories are being used as exotic entertainment by and for others.

The challenge for museums is for them to market themselves successfully to their constituents, increasingly as sources of entertaining education (someone coined the term 'infotainment'), so that they can survive financially while they devise more progressive ways of serv-

ing the equally legitimate and increasingly insistent (though more costly than financially rewarding) needs and interests of originating peoples. This need to be both publicly responsive (to diverse publics) and economically self-sufficient can push museums in opposite directions, entertaining some with the cultural emblems of others; calling for increased professionalism which also raises operating costs; seeking innovative programming while wanting to play it safe; using collections while attempting to preserve them; and seeking corporate and individual support while asserting curatorial autonomy. There are tightropes to walk in every direction, and beneath the ropes eggshells everywhere.

As part of their continuing struggle towards self-determination many First Peoples in Canada and elsewhere are seeking to establish their own institutions – museums, cultural education centres, language and job training programs, and so on (Haagen 1989). This may lead some mainstream museums to think they can then be released from responsibilities towards these peoples, but that is not so. They still hold collections and positions of cultural authority in the eyes of the public and the media, and consequently have continuing obligations to their various publics. Although the development of parallel institutions among underrepresented communities may strengthen the museum movement in the long run, and certainly allows for some self-determination, significant change probably will occur only when minorities seek and receive increased representation within mainstream organizations. The possibility of ethnically separate and *equal* institutions is not too likely overall. Both separate and integrated institutions are needed if the cultural apartheid or 'ghettoization' of minority interests is to be avoided. In modern states such as Canada majorities and minorities can live separate lives to some degree, but must also interrelate. It is these interrelationships, in addition to the separate determinations, that mainstream and minority museums will need to pursue more actively. Aboriginal peoples most likely will have to participate in cultural policymaking at the state level if they wish to recover and preserve the right to their own within it, for the agendas and economies for these matters are usually set here.

Mainstream museums played an important role over the past 150 to 200 years, collecting and preserving the heritage of populations at risk. We are now entering an era where formerly dominated and underrepresented populations – at least those who survived – are asserting their rights to self-determination and to control of their own histories. Museums will be expected to respond creatively. Will they be able to? Will the museum professions show sufficient flexibility to enable them to respond effectively to the competing demands for

popularity, integrity, responsiveness, and financial responsibility? Mitigating against such flexibility is the tendency among professionals to place the job interests of their professions above those of the institution (in this case the museum) that employs them, thus limiting the freedom of the institution to act in *its* own interests.

Anthropology as well as museums must continually reconstitute their relationships to the 'Other' as a legitimate object of study and discussion. Even though the morality of using others as a source of knowledge is now widely contested – with good reason considering the unequal power relations typically involved and the distorted representations that frequently have resulted (Chapters 13 and 14) – that task is still worthwhile, probably even necessary. The two extremes are to be avoided: the imperialist assumption that the scholar, curator, or museum has a natural or automatic right to intrude upon the histories and cultures of others in 'the interests of science and knowledge'; and the nihilistic, postmodernist claim that all knowledge is relative, all voices are equal, therefore 'We' can only 'invent,' rather than more or less accurately come to know, the 'Other,' and only 'They' can speak knowingly about themselves. Reality is found, however imperfectly and incompletely, somewhere between the extremes. Truth, the German philosopher Friedrich Nietzche once said (1975:17, quoted in Richardson 1990:19), is a 'mobile army of metaphors' which exists in a dialogic relation to falsehood: 'The falseness of a judgement is to us not an objection to a judgement; it is here perhaps that our language sounds strangest. The question is to what extent it is life-advancing, life-preserving, species-preserving, perhaps even species-breeding . . . '(ibid.).

The rationale for anthropology, its purpose, John Rowe (1965:2) reminds us, is to study others in order to understand ourselves. If we are sufficiently careful, we might also come to understand a little more about those others as well, a useful achievement in a world daily becoming more crowded, more unsettled, and not a little crankier. The history of others can benefit ourselves, Tzvetan Todorov (1982, also cited in Richardson 1990:19) noted in his study of the Spanish conquest of Mexico, 'because it allows us to reflect on ourselves, to discover resemblances: once more the knowledge of self passes through that of the other.' If knowledge of the self passes through others, then equal attention needs to be given to what returns: there lies a direction for reconstituting scholarly and curatorial relationships along more democratic, responsive, reciprocal, and critical lines.

The Development of Museums in the Western World: Tensions between Democratization and Professionalization

It has been said that once upon a time the Welsh poet Dylan Thomas walked into the museum in his home town and looked at the stuffed animals crowded into their dusty cases with faded labels.[1] 'This museum,' he observed, 'ought to be in a museum!' (Morris 1983:1).

My purpose in this series of essays is to go beyond Dylan Thomas and to scrutinize all museums, both the new as well as the antiquated, those venerable institutions designed, as one sage put it (Welch 1983:61), for 'useful and curious learning.' I want to look at museums as artefacts of society, as exhibits in their own right, to see what can be learned about them and, through them, about ourselves. My focus is on museums of anthropology in Europe and North America, since I am more familiar with them. Their ostensible purpose is to provide windows on the other cultures of the world, but upon examination we will discover that they mirror as well the profession of anthropology itself and its socio-cultural context. I look at the anthropology museum in the Western world as both window and looking-glass to see what can be learned about museums and anthropology and their uncertain futures. The essays are presented as exercises in the social anthropology of museums and anthropology.

The first task is to consider how modern Western museums of anthropology came to be what they are, how they formed part of the general evolution of museums in the Western world. I limit myself to only a few incidents in the recent history of museums and refer to only a few examples. My purpose is not to provide a detailed history but to outline a general process and to speculate about the implications of that process. Since the history of anthropology museums is part of a larger social movement, it will be necessary at times to refer to museums of history, art, and science as well. They share the same evolutionary path, though my primary interest is in the consequences for anthropology and how it is practised.

My historical overview will be incomplete in several other ways as well, for I will not consider such museum-like institutions as fairs, sideshows, circuses, zoos, and church and temple reliquaries; nor can I consider the history of museums outside Europe and North America. Both my time and my knowledge are too limited to attempt such important tasks.

There are nevertheless still some useful things that can be said about my circumscribed topic, the development in the West of museums that deal with the history and works of humankind. Their evolution parallels in important ways the growth of scholarship since the Renaissance and the concomitant growth of the revolutionary idea that people have both a need and a right to learn freely and to have free access to knowledge. These developments are all part of an overall trend towards increased democratization. What happens to museums and those who work in them as they become progressively, even if at times begrudgingly, democratized is what I want to consider in this chapter.

A few hundred years ago in European countries scholarship and museum collections were restricted to a few people, typically only members of the ruling classes or gentry. Public access to writings and works of art was strictly limited to distant viewing in formal institutions such as cathedrals or on formal royal occasions. Scholarly work on museum collections was insignificant, for private access was granted only through the favour of the owner, and there was neither the necessity nor the means of communicating knowledge beyond the privileged few. Many collections of natural and cultural materials began as private trophies, curiosities, and booty of the wealthy; other collections were religiously inspired and were used by the churches more for veneration than for study.

The Renaissance brought expansion and intensification of scholarly activity along with the growth of the middle classes, while the growing European exploration of the rest of the world contributed to the accumulation of treasures and souvenirs gathered from all over. As the collections grew in size and complexity, so did the need to house and care for them, and, therefore, also the need for people who specialized in the care and management of collections.

The invention of the printing press, the spread of education in vernacular languages, the increasing importance of the middle classes, and the development of political democracy all contributed to a wider distribution of knowledge. The movement to cities brought about by the industrial revolution encouraged various forms of popular expression and also the recognition of the need for social reforms and more accessible education. In this context of change and growth

large private collections shifted into public or government owner-
ship, and museums began to open to the public.

The earliest public museums established in western Europe, dur-
ing the eighteenth and nineteenth centuries, owed much to the
already existing collections that were in private hands. On the conti-
nent, 'the cabinets of curiosities' of royalty were especially important;
in England, private collections of scientists and travellers, who were
guided to some degree in their collecting by a plan of research or by a
certain set of ideas, played the larger role (Frese 1960:6).

Some of the European royal cabinets were of considerable age.
They were founded to house exotic tributes, such as rare and pre-
cious gifts received from foreign ambassadors and other goods roy-
alty seized as their natural right. These various objects illustrated the
world-wide powers and interests of the reigning monarch or prince
and his dynasty. Many of the ethnographic objects in the great Musée
de l'Homme in Paris, for example, came from French royal collec-
tions. The cabinet of curiosities of the Danish kings led to the Na-
tional Museum at Copenhagen. The collections of the electors of
Brandenburg and kings of Prussia formed the nucleus of the Berlin
Ethnographic Museum, and so on (Frese 1960:7).

When museums took over royal collections they also took on a
number of the royal functions, such as the protection they offered
learning, the safety and continuity provided the collections them-
selves, and the 'symbolic function of being a national treasury or
shrine' (Frese 1960:8). There was another function or role museums
added, 'one of the essential aspects of the change in the first half of
the nineteenth century from cabinets of curiosities to museums,'
which was the introduction of systems of scientific classification and
interpretation of artefacts (ibid.). With the emergence of public muse-
ums we find also the emergence of a museum profession.

With some exceptions, especially regarding the scholarly collec-
tions in England and Europe, many of the early cabinets of curiosities
were, until the middle of the nineteenth century, haphazardly or-
ganized and managed, a jumble of the quaint and the curious. The
gradual incorporation of collections into museums with their own fa-
cilities and full-time staff to care for them led to a different way of
handling and interpreting the collections. What were objects of curi-
osity or glory became scientific specimens, and scholars devoted
themselves to their study and classification. Collections were organ-
ized and grouped according to what at the time were thought to be
universal themes, such as race or evolutionary stage. The keepers of
these nineteenth-century public museums considered their scientific
work of such pressing importance that it was, in fact, still some time

before the public was granted much access. But access was eventually granted, and once granted it could only increase; over the next hundred years, as public attendance grew, scholarly work seemed to decline. Specimen classification also appeared to change, from serving the interests of the scientist to serving the needs of popular education. In those changes lie the source of many problems.

An example is useful at this point. Consider the origins of one of the great museums in the world, the British Museum in London.[2] Three major collections owned by English notables provided the foundation for the British Museum.

In 1753 a physician and botanist, Sir Hans Sloane, bequeathed his extensive collection of botanical, geological, and zoological specimens to the British nation, on condition that 20,000 pounds be paid to his family, 'desiring very much that these things, tending many ways to the manifestation of the glory of God, the confutation of atheism and its consequences, the use and improvement of the arts and sciences, and benefit of mankind, may remain together and not be separated.' This bequest apparently served to speed up legislation for a national repository to house this and other collections which the Crown was acquiring, especially the library of Sir Robert Cotton.

The Cotton library was not bequeathed to the Crown but seized by it, on suspicion that certain seditious manuscripts had been deliberately placed there by its owner. Whether or not this was true, the government apparently thought that most of the books were worth keeping anyway. Also, around this time the Countess of Oxford decided to sell to the government for 30,000 pounds the library and antiquities of Robert Harley, the first Earl of Oxford.

These along with other events led to the establishment of the British Museum. It opened to the public in 1759, and in 1781 the Royal Society turned over its entire collection to the trustees of the British Museum. Establishing a national museum to house major collections is one thing; making those collections accessible to the public is quite another, however, and took much longer to bring about.

At first it was felt that only the desirable public should be admitted to the museum. As Henry remarks (1911, quoted in Key 1973:36) in his history of the British Museum, 'it demanded something like a mathematical calculation to determine when the building was and was not open.' For example, it was open every day

'except Saturday and Sunday in each week; likewise except Christmas Day and one week after ... also except the week after Easter and the week after Whit Sunday and except Good Friday and all days which are now, or shall hereafter be specially appointed Thanksgivings or fasts by public authority.' Then followed a further reminder that 'Between the

months of September and April inclusive, from Monday to Friday the museum be opened from nine o'clock till three and likewise at the same hours on Tuesday, Wednesday and Thursday in May, June, July and August but on Monday and Friday only from one o'clock to eight in the afternoon.'

After figuring out the timetable, the visitor was advised that no more than ten people could be admitted at any one time, and that they would be escorted around in groups for a thirty-minute tour. To sign on, Archie Key (1973:36–7) reports in his history of museums,

> personal application was made to the porter at his lodge who inscribed in the register the name, condition (drunk, sober, clean, dirty, seemingly of means or otherwise) after which the librarian or his understudy decided whether the applicant was 'proper' for admission, 'and until . . . the solution being in the affirmative . . . either of those officials issued an invitation, the prospective visitor had no more chance of getting inside the museum than Satan has of eluding the vigilance of St. Peter.'

The British Museum was not the only institution to contend with visitors. The first public museum in England was Oxford's Ashmolean, which opened its doors in 1683 (MacGregor 1983a:97). When the German scholar Zacharias Conrad von Uffenbach visited the Ashmolean in 1710, he had serious reservations both about the quality of people granted admission and the way the custodians cared for their collections. As he later recorded in his diary (Welch 1983:62):

> The specimens in the museum might also be much better arranged and preserved, although they are better kept than those in Gresham College, London, which are far too bad considering their splendid description. But it is surprising that things can be preserved even as well as they are, since the people impetuously handle everything in the usual English fashion and, as I mentioned before, even the women are allowed up here for sixpence; they run here and there, grabbing at everything and taking no rebuff from the *Sub-custos* [deputy keeper].

In 1773 an evidently exasperated owner of a private museum inserted the following notice in a London newspaper (Bogaart 1978:43):

> This is to inform the public that being tired out with the insolence of the common people who I have hitherto indulged with a sight of my museum, I am now come to the resolution of refusing admittance to the lower class except they come provided with a ticket from some gentleman or lady of my acquaintance.

In the 1700s it would require several visits to obtain an admission ticket to the British Museum, and a third visit to actually gain entry (Key 1973:37). Regulations were gradually relaxed over the years, but only slowly. Even in 1882, 123 years after the museum first opened to the public, it still took determination and perseverance. As one man noted (ibid.), after waiting two weeks for his tickets,

> It was the room, the glass cases, the shelves which I saw; not the museum itself, so rapidly were we hurried through the departments ... In about thirty minutes we finished our silent journey through this princely mansion, which would have well taken thirty days. I went out much about as wise as I went in, but with the severe reflection that, for fear of losing my chance, I had that morning abruptly torn myself from three gentlemen with whom I was engaged in an interesting conversation, had lost my breakfast, got wet to the skin, spent half a crown in coach, paid two shillings for a ticket, and had been hackneyed through the rooms with violence.

National museums gradually introduced more liberal policies towards admissions as they became progressively more involved in the social and political developments of the eighteenth and nineteenth centuries. Educational and welfare reforms called for more services to the working classes, and that included opening the doors of museums and other educational institutions. This democratization of museums had important repercussions for the philosophy of the museum enterprise and for the public role of museums, something which Duncan Cameron (1971) has pointed to in his widely quoted paper, 'The Museum, a Temple or the Forum.'

Collections held in private ownership, Cameron said (1971:15), made private or personal statements about the owners:

> The collections may have said, 'Look how curious I am and how meticulous and how thorough. Here is my scientific collection, which reaffirms my belief in the order of the universe and the laws of nature.' The collection may have said, 'See how rich I am,' or 'Look at this. Look at how I surround myself with beautiful things. See what good taste I have, how civilized and cultivated I am.' It may have said, 'Oh! I am a man of the world who has travelled much. Look at all the places I have been. Look at all the mysterious things I have brought back from my adventures. Yes! I am an adventurer.'

When others viewed a private collection they were not expected to identify with it, to see it as *their* collection; nor were they expected to

accept the collector's view of the world or of himself. It was understood that the collection represented a personal statement, a personal possession.

The transfer of private collections to public hands and the introduction of the idea that the public should have access to these collections brought about a significant shift in how people interpreted the meaning of those collections. They were no longer considered a private matter. In declaring these collections to be publicly owned, Cameron states (1971:16): 'it was no longer being said that this was someone else's collection that you, the visitor, could look at. Rather, it was being said that this was *your* collection and therefore it should be meaningful to *you*, the visitor.'

The granting of public access therefore also entailed the granting of a degree of public control over the museum enterprise, the purpose of the institution and the collections it contained. This control was founded on the expectation that publicly owned collections would be made meaningful to that public. Thus, gradually, the public – or more correctly, the educated classes – came to believe that they had the right to expect that the collections would present and interpret the world in some way consistent with the values they held to be good, with the collective representations they held to be appropriate, and with the view of social reality they held to be true.

These values, collective representations, and models of social reality reflected the interests of the educated classes, of course – those people who, since the beginning and to this day, control and patronize the great museums of the world. Museums are products of the establishment and represent the assumptions and definitions of that establishment, just as do most other major institutional complexes in large-scale societies. That is hardly surprising, nor is it unusual that most members of the educated classes assume that their view represents the proper view for society as a whole. The museum becomes a temple for the society that sustains it (Cameron 1971:17):

> Those segments of society with the power to do so ... created museums that were the temples within which they enshrined those things they held to be significant and valuable. The public generally accepted the idea that if it was in the museum, it was not only real but represented a standard of excellence. If the museum said that this and that was so, then that was a statement of truth.

The museum is where you would go to compare your own private perceptions of reality with what was the accepted and approved, and therefore 'objective,' view of reality, enshrined within the museum.

Before the advent of publicly owned museums, to summarize, large collections were the personal property of the wealthy, royalty, and a few scholars, and these collections were used, by and large, to further personal interest and personal definitions of value and social reality. Visitors, on those rare and special occasions they were permitted to view these private collections, were not expecting that what they saw would be meaningful to them in a direct and personal sense. Collections were interesting 'curiosities.'

The nationalization of major collections leading to the establishment of national or publicly owned museums meant the nationalization of imagemaking as well. Museums now 'owned' by the public also became responsible for reflecting and promoting the public's definition of truth and value. For this reason, Cameron says (1971:17), the museum became closer in function to the church than to the school:

> The museum provides opportunity for reaffirmation of the faith; it is a place for private and intimate experience, although it is shared with many others; it is, in concept, the temple of the muses where today's personal experience of life can be viewed in the context of 'The Works of God Through All the Ages; the Arts of Man Through All the Years.'[3]

The great museum of today is equivalent to the cathedral of the Middle Ages, the palace of the eighteenth century, and the Eiffel Tower in the nineteenth century: it expresses in a modern idiom – both in its architecture and its content – the essential values and world view of a community, and through this expression it authenticates (Meyer 1979:130).

The museum as a publicly owned civic temple is the culmination of several centuries of development. Personal collections and private museums existed for centuries, and they continue to exist. Religiously oriented relic chambers, ornamented cathedrals and temples, and monuments also have long histories. But publicly owned and publicly accessible museums identifying with the state or the nation in a secular rather than religious sense, expressing and authenticating established views, are a new phenomenon, probably no more than a hundred to two hundred years old.

A large public museum may express and authenticate the established or official values and images of a society in several ways, *directly*, by promoting and affirming the dominant values, and *indirectly*, by subordinating or rejecting alternate values. A work of art that never gets hung in major art galleries is art that is likely to be forgotten. Images and records that are relegated to the closed store-

rooms of a museum are relegated to obscurity.

Sociologist Dean MacCannell, in his provocative book on the tourist (1976), highlights this double role of affirmation and subordination played by modern museums. The idea of the modern museum, he says (1976:84), is to contribute to the unification of society by exercising control over both tradition and nature, subordinating both to modernity. Museums put nature and culture in their proper places, under glass in display cases, and, therefore, under control. MacCannell says that in this sense museums are both 'anti-historical' and 'unnatural.'

They are not anti-historical and unnatural in the sense of being opposed to history and nature, but in that they *control* and *subordinate* both to contemporary definitions of social reality. Museums preserve history and nature by taming them both, subjecting them to the technical control of the designers and fabricators and the conceptual control of the curators. As museums preserve, MacCannell continues, 'they automatically separate modernity from its past and from nature and elevate it above them.' Nature, the past, and traditional societies are made a part of the present, not as things of equal value with the present, but as 'tourist attractions.'

Museums place history, nature, and traditional societies under glass, in artifically constructed dioramas and tableaux, thus sanitizing, insulating, plasticizing, and preserving them as attractions and simple lesson aids; by virtue of their location, they are implicitly compared with and subordinated to contemporary established values and definitions of social reality. When we 'museumify' other cultures and our own past, we exercise a conceptual control over them; and when this 'museumification' involves high technology – elaborate dioramas, life-sized reproductions of actual settings, and complex audio-visual aids – we are demonstrating and exhibiting the superiority of our technology (Halpin 1978). A museum in Canada has installed in its anthropology gallery one of the finest fishing scenes I have seen anywhere. It is complete and accurate down to the smallest detail, with carefully fabricated replicas of fish and plant life shown underwater, and with fish hooks and nets hanging down from above to demonstrate how Native people used to fish. One curator reports that the most frequently asked question by the public does not concern the Indians or the fish, but how the designers were able to construct such a realistic scene. Though the Indians were apparently clever fishers, they obviously did not compare with the wonders of modern museum technology.

The museum as it has developed into the twentieth century, especially in North America, has become something like a public temple,

an institution that plays an important role in expressing and authenticating established values and images of society (Cameron) and in affirming the subordination of other values and images (MacCannell). The large civic or national museum of history or art is treated by the public as a standard and an authority on history and culture and as a custodian of the socially approved definitions of social reality, principally those definitions representing the interests of the educated classes.

During the past twenty years or so, however, the democratization that began several centuries before has continued to work towards an ever broadening definition of those who are to be included. The definition of the 'public' that is to be served by museums expands accordingly, to include such categories as school children, the working classes, minorities, and the handicapped. But there is another twist to the story. Today, democratization of museums not only means extending access to a wider range of people, but also entails the obligation to *work to make the people come*. Museums are now expected to actively and energetically seek a broader audience, and to please them as well. Increasing attendance figures and high public profile have become the two most common factors used to rate the success of museums.

This further extension of the democratic principle, which obliges museums to make themselves increasingly attractive to the public, greatly affects their organization and operation. Just as in the nineteenth century the granting of limited public access to national museums entailed granting a degree of public control over the museum enterprise, so today the granting of popular access also entails a further extension of public control. Museums are now expected to present an image of social reality and to promote a set of values that will appeal to the masses while also remaining within what the establishment would consider to be appropriate limits. The inner workings of museums are changed accordingly. Rather than museums existing for the purpose of preserving and studying collections, museums and collections, expecially in North America, at least, now exist more and more for the purpose of serving the public. This changing emphasis, a logical extension of a process begun many decades earlier, has profound implications for the social organization of museums and for the conditions of work within them. What this means for anthropologists who work in and around museums, and what it means for the future of both anthropology and museums, are matters I consider next.

Dilemmas of the Practical Anthropologist: Public Service versus Professional Interests

It is an honourable tradition in anthropology to talk about general issues on the basis of particular field studies, and that is what I attempt here.[1] I am interested in the dilemmas that confront anthropologists in contemporary society, especially those produced by the continuing growth of social and political democracy. One democratic belief that is especially interesting is the idea that the public has a right to share in and benefit from knowledge produced by scholars (Manning 1983b:5). How are anthropologists responding to this expectation?

Following the anthropological tradition, I explore this general issue through the idiosyncrasies of a single case. I do not cover all anthropology, which is too broad a topic for me to handle. Instead, I limit myself to the socio-cultural branch, which I refer to, following the museum custom, as 'ethnology.' Within that category I focus on those ethnologists associated with museums in North America, and particularly in Canada. Like Malinowski and his Trobrianders, Firth and his Tikopeans, Rivers and his Toda, and Seligman and his Veddah, though I am afraid with considerably less skill, I offer my study of an exotic tribe of North American museum ethnologists as a comment upon a general issue that should concern us all. I even suggest that my tribe, for many years now a neglected and unstudied part of anthropology – a 'weaker section,' as it were – may be, in fact, a bell-wether for the future of the discipline.

I begin my field report with a brief comment on the cultural history of North American museums. Around the middle of the last century two institutions were established in the United States that represented successful and dramatically contrasting ideas of what a museum should be. Each idea would have a different set of consequences for people working in museums.

One of those nineteenth-century institutions was the National

Museum of the United States, subsequently known as the Smithsonian National Museum of Natural History, which came into being in the American capital of Washington during the 1850s as a result of a bequest from the Englishman James Smithson. Another important institution to emerge around that time was the American Museum in New York City, which the famous American entrepreneur Phineas T. Barnum purchased in 1841. Barnum's museum burnt to the ground in July 1865, whereas the Smithsonian went on to become one of the world's great museums; yet both made important contributions to the public understanding of museums, and their contrast in styles reflects one of the major dilemmas North American museums, and those working within them, face today.

The Smithsonian was established, in accordance with Smithson's original bequest, 'for the increase and diffusion of knowledge among men' (Kopper 1982:37), and it represents today the classical model of a distinguished museum, with its seven disciplinary departments representing the biological, anthropological, and earth sciences, and its scientific collections of over 60 million specimens ranging from the famous Hope Diamond that came from the Indian subcontinent, four million plant specimens, 26 million insects, 34,146 nests and eggs, several tons of meteorite fragments, over 20,000 human skulls, numerous ethnological items, 14 million postage stamps, and even, it has been said, the ashes of a deceased staff member and his first wife and the pickled brains of former curators (Bonner 1981; Kopper 1982:26, 53–4; Smithsonian Institution 1977). The museum has maintained since its early days active programs of collecting, research, scientific publication, and public education.

Barnum, by contrast, bought the American Museum in New York City as a business venture. His intent was profit, not education or moral uplift, and he 'pursued any feature or oddity that might attract customers. Advertisement and display rather than scholarship and comprehensiveness were his strong suits' (Harris 1981:56).

Barnum's collections, though smaller than the Smithsonian's, certainly competed for variety. He acquired numerous 'curiosities and performers' including three serpents fed noonday meals before the public, two whales that swam in a tank of salt water, a white elephant, hippos, bears, wolves, a herd of American buffalo, waxwork figures, midgets, dwarfs, giants, bearded ladies, fat boys, rope dancers, jugglers, performing American Indians, a tattooed man, gypsy girls, albinos, and a group of 'industrious fleas' (Alexander 1979:49–50; Harris 1981:40; Wallace 1959).

While the Smithsonian concerned itself with scholarship, Barnum emphasized razzle-dazzle. He decorated the exterior of his museum

with brightly coloured banners advertising the wonders of the world to be seen within, installed spotlights on the roof, a musical band on the exterior balcony, and lectures, performances, and plays inside (Harris 1981:54). He also advertised widely and cleverly manipulated the local press to his advantage. The Smithsonian, not surprisingly, was more conservative in its actions and operated on public funds appropriated by the United States Congress. Barnum operated his museum at a profit earned from admission fees.

Barnum's American Museum in New York City, though short-lived, became the most popular institution of its kind in the country, and though it and others like it were condemned for their vulgarization – 'a mere place of popular amusement,' scoffed one learned critic in 1851 (Harris 1981:33) – they catered to a public whose interests were being expanded by the growth of the democratic spirit in America. Following the American Revolution (1775–83), there were increasing public proclamations that all authority – social, moral, aesthetic, and religious – should ultimately rest 'in the hearts and minds of the ordinary citizen, the much-celebrated common man' (Harris 1981:3). Barnum was fully conscious of this new democratic sensibility, 'and he appealed directly to its vanities and deceits' (ibid.:4). In contrast to the dignified image of the British Museum, with its tediously catalogued treasures of art and science and its erudite programs of research and instruction, which was at that time promoted as the index of civilization, the Barnum-type of museum was little more than, in the caustic words of our 1851 critic (Harris 1981:3, 310), 'a place for some stuffed birds and animals, for the exhibition of monsters, and for vulgar dramatic performances.'

North American museums have struggled ever since with this challenge: Can they be serious and popular at the same time? Can they retain their scholarly credentials while catering to untutored public interests? Can an institution be both Smithsonian and Barnum? The dilemma, cast in these terms, seems extreme; but in keeping with the tradition of anthropological case studies, an exaggerated example may highlight the problems that result when the privileges of scholarship are confronted by the growth of the democratic spirit.

Barnum's museum burnt to the ground twenty-four years after he acquired it, but the idea of a museum that can be successful by serving public interests continues. And the attempt by museums to fulfil this idea creates incredible stresses and strains for those who work within them, including, of course, ethnologists who strive to be both professionals and public servants. To understand the nature of these pressures it will be useful to explore more fully the two models I have introduced, of the distinguished scholarly museum on the one

hand, and of the blatantly popular museum on the other. Taking the scholarly institution first, we can say that its purposes are at least two, 'first, to provide a source for scientific research and second, to stimulate the public interest, by exhibitions and other means, in the results of these researches' (Washburn 1961:192, quoting from the handbook of Sweden's Nordiska Museum). According to Smithsonian scholar Wilcomb Washburn (ibid.), the traditional American definition of 'museum' says that a museum is intended to educate, promote research, and preserve cultural heritage; but that, he says, is not enough: 'It is not enough ... to give three cheers for research, education, and preservation, as the great functional trinity of the museum. In a great museum, as in a great university, research into the unknown must be the passion which dominates all and on which the functions of conservation and education depend.'

'I do not hesitate to say,' Franz Boas wrote in his 1907 paper on museum administration, 'that the essential justification for the maintenance of large museums lies wholly in their importance as necessary means for the advancement of Science' (Boas 1907:929). The large museum, he continued, 'is the only means of bringing together and of preserving intact large series of material which for all time to come must form the basis of scientific inductions.' The museum, in the proverbial nutshell, is 'to serve the progress of science.'

Paul Joseph Sachs, who for many years taught museum work at Harvard University's Fogg Museum, and trained generations of American museum workers, also emphasized the role of scholarship in the training of a curator. A proper curator, he said (Meyer 1979:41), 'must first and foremost be a broad, well-trained scholar, a linguist, and then in due course, a specialist, a scholar with wide bibliographic knowledge, a scholar with broad human sympathies including a belief in popular education, a curator and administrator.'

There is, on the other side, a view of museums that emphasizes their public functions. Barnum, to return to our extreme example, did not develop his museums (he operated two in New York City, a third in Philadelphia, and an aquarium in Boston) to increase knowledge or public enlightenment, but simply to make a profit by attracting the public (Harris 1981:56). Governments today recognize that publicly operated museums cannot be expected to make a profit, but they *are* expected to give priority to serving public interests. Consider as one example the policy statement on museums issued in 1977 by the government of Quebec, a provincial administration in Canada (Boucher 1977:54): 'Museums should be perceived as vehicles for cultural promotion,' the Quebec minister of culture stated, 'while, at the same time, providing attractions, encounters, exchanges, and extension

services.' There is no mention of research here, nor in the list of priori-
ties for museum development that the minister presented:

1 to assure the conservation of our cultural heritage
2 to promote the relevance of collections through the development of
 the educational aspects of their presentation
3 to assure their availability to the greatest possible number of
 Quebeckers
4 to transform museums and exhibition centres into culturally alive
 institutions.

The act of Parliament which established the National Museum of
Man in Canada also highlights the public role of the National Mu-
seum. Its purpose, the act states (Taylor 1982:5), is 'to demon-
strate ... the works of man, with special but not exclusive reference
to Canada, so as to promote interest therein throughout Canada and
to disseminate knowledge thereof.' In 1972, the government of Can-
ada announced a museums policy for all of Canada, the objectives of
which were 'to increase physical and intellectual access to our natu-
ral, cultural and technological heritage as represented in collections
across Canada, and to ensure that these collections are preserved for
the benefit of present and future generations.'
 These government agencies are not calling for a Barnum museum
of curiosities, with its bearded ladies, dwarfs, performing whales,
and industrious fleas–though, I dare say, some museums would ben-
efit from more lively programming – but they are stating that muse-
ums have a primary obligation to be accessible to the public and to
inform them in an entertaining manner. The public as the true owners
should be true beneficiaries of public museums (Cameron 1982:179).
In response, museums have made energetic efforts to increase their
service to wider publics. It is as if they were running popularity con-
tests, Duncan Cameron, one of Canada's leading museum adminis-
trators, observed (ibid.:180):

> We desperately wanted to be popular. We wanted to be loved. And we
> were reacting to the voices of our masters – boards of governors, govern-
> ments and their funding agencies – who wanted to see dramatic growth
> in attendance curves and some of whom saw us in competition with
> zoos, Disneyland, the local country fair and Evel Knievel.[2]

Disneyland is today's version of the Barnum problem: how can a mu-
seum be as popular as Disneyland without actually becoming a Dis-
neyland, an image – like Barnum's American Museum – guaranteed

to make all upstanding museum people cringe? A good museum, it is now often said, with more longing than hope, should be 'more than a Disneyland experience,' which means it should avoid 'flashy multimedia presentations' and other gimmicks, yet still provide lively educational messages that will appeal to mass audiences (Bruman 1982; Levine and Sears 1982). The goal, Jean André, one of Canada's top museum exhibit designers, recently observed, is (Freedman 1980) 'a nice balance between exciting visuals and swallowing the pill. We're not supposed to be Disneyland.'

Few museums have worked more energetically to achieve a happy balance between mass public appeal and scholarly respectability than has the Smithsonian itself. Although a few Smithsonian staff members may, as Philip Kopper put in his magnificent story of the Smithsonian (1982:197), 'look up from their microscopes and down their noses at what they call "public entertainment",' the vast majority willingly accept the museum's public responsibility (ibid.:191, 194)

> to diffuse knowledge broadly among people without regard to scientific background, intellectual origin or academic status. Many of the scientists do it daily as they freely offer advice to everyone from schoolchildren seeking grist for science reports to farmers fighting a new pest to bemused heirs hoping to name the pressed herbs in late Great Aunt Julia's treasured herbarium. Other scientists devote the greater part of their professional time for some years to the planning, design, and installation of an exhibit which may well last longer than they will. As one department chairman puts it, 'Any scientist who isn't interested in public education shouldn't be here.'

The public galleries of the Smithsonian are thus designed to appeal to the public, 'to accommodate – indeed to impress and edify and boggle – everyone who enters' (Kopper 1982:191).

As museums become more oriented to public service through programs of education and entertainment, however, opportunities for scholarly research appear to recede. This is at least the case for those institutions that cannot afford to maintain separate and insulated research divisions. A number of large public museums in Canada, for example, have ruled that research, other than for exhibitions, must be done on a curator's own time. The curator trains in the university system where individual research is presented as the primary good, and then works where the collective need to serve the public is given primacy. The dilemma for the curator is twofold: first, to seek status within one's own profession, ethnology in the case at hand, one must research and publish in scholarly journals, while to retain status

within the museum one must also engage in public service; and second, to conduct scholarly research one must follow a pursuit that is typically individual and competitive, whereas to do museum work one participates in endeavours that are interdisciplinary and collaborative. The museum ethnologist is caught between what often appear to be rapidly diverging standards. This is the 'curator's dilemma,' a conflict of interest between duties towards the collections and personal research, to say nothing of exhibits and meeting the visiting public (Fenton 1960:335), a situation some (Squires 1969) more dramatically refer to as curatorial schizophrenia.

The curatorial function should have a high degree of professionalism associated with it, says Donald F. Squires (1969:19), who was once deputy director of the Smithsonian National Museum of Natural History, but curatorial work often 'bogs down in service activities.' Museums are increasingly populated by specialists trained in the image of the university professor, Squires continues (ibid.:20), who seek employment in museums because they believe, incorrectly, they will be more sheltered there. But once in the museum, says Squires (ibid.),

> the curator frequently finds that he is asked to pass judgment upon and participate in a bewildering variety of activities – lecturing to children's groups and adult members, preparing materials for grade and high school classes, writing popular articles and books, book prefaces and reviews, preparing, evaluating and pricing materials for museum shop sales, serving as moderator for a public that is acquiring materials and seeking to know their values and authenticity, providing long-range judgments of future needs of the scientist in his own and related disciplines and specialties in larger museums, supervising the maintenance of a large and often burdensome collection of objects, tending to the needs of his visiting associates, keeping up the new literature, and undertaking original research in his own specialty.

This 'multiplicity of activities ... forces the curatorial staff to adopt a corresponding "multiple" view toward their careers,' Squires concludes, 'and this I believe is the nub of the problem causing schizophrenia of these museums' (ibid.).

There is a particularly good example of this curatorial plight that I would like to present here. Dr. Marie-Françoise Guédon is a Canadian ethnologist who served for six years at Canada's National Museum of Man, before resigning to accept a professorship in a Canadian university. She published an article (1983) commenting upon her years in the museum, entitled 'A Case of Mistaken Identity (the

Education of a Naive Museum Ethnologist).' I quote from her article.

There are basic contradictions built into the role of museum curator, Guédon states: 'the impossibility of being at once a full-time researcher, a full-time administrator, a full-time curator, and a full-time exhibit specialist . . . ' (1983:253).

When she applied for the position of ethnologist at the National Museum, she said she was attracted by the offer of fieldwork as part of her duties (ibid.:254): '60 per cent of my time to be spent on research, the presence of huge collections and the opportunity to be in contact with the public, with administrators and with colleagues.' It was only after taking the position that Dr. Guédon learned to her regret that the job 'was more than full-time.' She writes:

> Let me say right away that I had not counted on the administrative nature of the institution. I had to learn to cope with the multiple pressures of administrative duties, administrative personnel, and administrative restrictions. I had to learn, too, to be on the defensive all the time, since in terms of duties, division matters came before the research programme for which one was hired and which formed the reference for one's advancement and working level. (ibid.)

Dr. Guédon continues: 'Let us face it, research does not have a good reputation in museums, no matter how praised by directors. It is of no use to administrators. So, unless one refuses to answer memos asking for reports, calculations, information, budgets, other items of no consequence, there is little time left for research' (ibid.).

Dr. Guédon said that when she finally realized, after six years at the National Museum, that fieldwork had become a privilege rather than a duty, she was ready to leave the museum (1983:255): 'By choice – and by calling – I am an ethnographer; I was turning into an administrator . . . a common complaint, none the less true since it had become a cliché. I was not strong enough to shut my door and work in, rather than for, the museum.'

The pressure of exhibit work was one of the deciding factors for Dr Guédon (ibid.):

> Exhibits are the 'raison d'être' of museums, particularly anthropology museums. Anthropologists working for museums may know this, but it took the naive employee which I was several years to understand how exhibits were shaping my life and my career. I include here not only the work for temporary or permanent display open to the public, but also the work on related items; catalogues and popular publications, didactic collections of artefacts, and information sheets for schools and visitors, and so on.

Exhibits could be exciting work, she adds, but they are not because they are collective endeavours performed within a hierarchical organization that operates according to established standards and schedules. The intellectual freedom the scholarly entrepreneur has been taught to expect as a natural right does not prepare such a person for the kind of teamwork and public responsibility required in museums today.

Guédon contrasts the production of an exhibit with what is expected in academic circles (1983:256–7), and I repeat her comparison here in detail.

a. In a museum, one is instructed to present certain information for a given display or project which one very rarely chooses. (The academic usually generates his own subject.)

b. The text is reviewed – which often means corrected, shortened, lengthened, or rewritten, by many different authors, including administrators, designers, and other exhibit specialists. (Imagine the uproar if the head of an anthropology department checked the faculty's papers before conferences.)

c. Any change in a text requires, of course, if not a change in design or artefacts or lettering, at least the signature of all supervisors ...

d. Instead of writing for other specialists, one writes 'for the public.' According to most guidelines, the public's intellectual level oscillates between ten and twelve years of age. So: 'Use simple words,' (do not introduce such terms as matrilineal, even with a definition). 'Use short sentences.' (Do not play with abstract concepts.) Everything one wants to convey has to be presented in statements; no question marks, no nuances ... these are apt to confuse the visitor. (No wonder museum catalogues are hardly the stuff of academic promotion ...).

e. [The National Museum] caters to a wide audience and a large one, in effect to crowds, so one must streamline one's production so that it can be swallowed 'on the go.' A film should not last more than six minutes; a text should be short enough to be read practically while walking. The public does not want to be taught; so one has to be catchy, emphasize the spectacular ...

f. Above all, we do not want trouble. Any error means trouble. Check and recheck your text ... to make sure nobody may be offended – or – Heaven forbid – disagree with anything shown or said there ...

g. And finally:
 – No personal statement, please
 – Be optimistic
 – But be serious – this is the people's TAX money, remember.

I quoted Dr. Guédon at length because she identifies with precision and eloquence three issues I want to consider: the ways in which administrative and public duties interfere with personal research, why individual interests are subordinated to collective and hierarchical responsibilities, and how the educational intent of anthropology exhibits is inhibited by the requirement to reduce all text to a lowest common denominator (no error, no offence, no personal opinion, and no big words).

The third point, how simplification may dilute the educational mission of the museum, I discuss elsewhere (Chapter 10: 'Are Museums or Anthropology Really Necessary Any More?'). The point I make there is that the error lies not in the requirement to simplify, but in the expectation that anthropology exhibits are educational in the sense that they can effectively convey cognitive information. I suggest that, to the contrary, museum exhibits are relatively ineffective instruments for conveying knowledge, at least as they are typically constituted in museums today. No wonder Dr. Guédon experienced frustration in her exhibit work; there was no way she could succeed. I would like to reserve further discussion of this point for another time, however.

Here I want to consider the other two problems Dr. Guédon highlighted: the conflict between research and other museum duties, and between individual and collective interests. These conflicts have been increasing features of museum work ever since museums accepted the mandate to increase their services to the public. When in 1914 Edward Sapir was thinking of moving from the National Museum in Canada to a museum in the United States, Franz Boas advised him as follows (quoted in Darnell 1976:117 and Halpin 1983:262):

> The fundamental difficulty that you would find everywhere is that all purely scientific work, particularly the work in which you are interested, would have to be done as a side issue, and that the essential interest of the museum is not exploration, but the exhibit, and ordinarily the popular exhibit ... I understand from your previous remarks that the administrative work that you have to do in Canada worries you and is not particularly sympathetic to you; but please do not believe that in any position that you may take, you will be relieved of this kind of work in one form or another, least of all in a museum position.

How can museums and those working within them resolve these conflicts, the 'curator's dilemma'? One way, and the approach favoured by many large civic and district museums, is to abandon all pretence at research except that which is directly related to exhibit

and collection needs. In some of these museums, in fact, the curatorial contract explicitly excludes personal research from the list of official duties. Curators in such institutions become 'librarians' to their collections and information officers to the public, expected to know a little about everything the museum holds, but not too much about any one thing.

A second solution, and the one most commonly attempted by major museums, is to increase the opportunities, facilities, and rewards for research (Sturtevant 1969:636). This is usually attempted in the form of a binary organizational structure, with one section, higher in prestige, for the 'scientists,' who are expected to conduct important research, and a second section for 'museologists,' 'administrators,' and 'educators,' who are expected to manage the collections and public programs. Only the very large museums with multi-million dollar annual operating budgets can afford this kind of differentiated structure. The differentiation is frequently expressed in architecture as well as in social organization. The Canadian Museum of Civilization (before it moved into its new building in 1989), for example, had its public galleries in downtown Ottawa, while its store rooms and 'scientific' staff were hidden away in the suburbs. (The new facility consolidates much of what was physically separated.) The Royal Museum of British Columbia has a large squat building devoted to exhibits, which is open to the public seven days a week. The reserve collections and the curators, however, are in a carefully guarded tower nearby, and access to it can only be obtained by appointment. The British Museum's Museum of Mankind in London has its public galleries in the centre of the city, only a few minutes walk from Picadilly, and its reserve collections miles away in an old warehouse. Where the curators are, I have no idea. Though one is sometimes able to get them on the telephone, one does not often have the chance to meet them in person. Assistants working in the 'Students' Room' adjacent to the public galleries at the Museum of Mankind are apparently responsible for screening visitors, and they do a marvelous job of politely discouraging inquiries.

The benefits of a binary organizational division between private scholarship and public service are obvious: the scientists would be given time to pursue their personal research interests while more practical people are charged with the day-to-day responsibilities of running the museum, and since they are typically lower in rank and academic training, they are not expected to have scholarly aspirations nor, thus, scholarly frustration. It is as if every museum should be a Smithsonian with a few Barnums on staff to entertain the public, thus allowing scientists to do the real work behind the scenes. This ar-

rangement does not always work, however. Scientists are frequently drawn into the daily museum enterprise because of its collaborative nature, as Dr. Guédon's lament documents, and many of the curatorial assistants cannot ignore their own intellectual aspirations or the higher status and rates of pay that research roles provide.

Dr. Guédon hoped that by moving to a university department she could escape burdensome administrative and public duties, and perhaps she can. Museum scientists who close their office doors, as she put it, may also be able to avoid many irksome tasks. But what kind of solution is this? One of the problems the profession of ethnology faces today – and at least in Canada it is said to be a major crisis (Tremblay 1983) – lies precisely in this scholarly withdrawal from responsibilities to the broader community of students, colleagues, and the public. Have ethnologists, as part of their collective scorn for the crass showcraft of Barnum and his industrious fleas, or Disney and his mice and ducks, derogated as well the whole idea of private scholars performing public service? In rejecting Barnum and Disney we may have rejected too much.

It is understandable that academics trained in the university tradition of competitive individual scholarship would find little merit or personal reward in teamwork organized to serve broader interests. But here again lies a source of difficulty for ethnology. Traditional notions of scholarly autonomy are being called into question as our societies become more democratic. It no longer seems to be sufficient to say that scholarly work is justified provided it serves the interest of 'theory' or 'the progress of sciences'; it now must *also* serve broader public interests.

The eminent Canadian ethnologist Marc-Adélard Tremblay said recently (1983:332) that anthropology is undergoing a crisis that is threatening the very foundations of the discipline. Its traditional objectives, methodologies, and findings are all being called into question. We must analyze our weaknesses, he said, and consider alternative courses of action so that we might, in the end, 'come up with ideas and suggestions instrumental in redefining our objectives, in discovering new paths for gaining knowledge and in sharpening our guidelines for the practising of anthropology' (1983:341).

Attempts to resolve professional role conflicts brought about by the progress of democracy by, for example, separating research scholars from applied workers, or by seeking the seclusion of an ivory tower, only succeed in postponing the resolution. It may be more productive to confront directly the conflicts and tensions, and to admit the possibility that we may have to change the way in which we conduct our work.

Museums have been subjected to the pressures of democratization more than have universities because they have been more closely integrated into the daily life of their communities and therefore more fully appropriated by those communities. Perhaps, therefore, we should look to museums for hints as to how our profession may evolve over the next several decades. Anthropology museums, which purport to be the storehouses of the past, may also be windows onto the future.

I conclude by citing the conclusion to a paper written by my colleague at the University of British Columbia Museum of Anthropology, Dr. Marjorie Halpin, who serves both as a curator of ethnology in the museum and as an associate professor of anthropology in the university's Department of Anthropology. The title of her paper, which she delivered to a conference convened in 1981 to assess the state of Canadian ethnology, is 'Anthropology as Artefact.' This title, she says (Halpin 1983:273),

> is meant to suggest that the situation of the ethnologist in museums is not unique, but that the bureaucratic museum context permits us to see more clearly than the university context the choices facing all scholars as we approach the 21st century. When we become clear as to what our choices are, it becomes ever clearer that we have no choice. We can either (1) recognize the conflicts, contradictions, and pretences that reside in the condition of museum ethnology, and ride those contradictions, as creative opportunities, or (2) recognize the condition and despair. At the Museum of Anthropology, we have resolved to ride the contradictions in search of a new mandate as ethnologists. We invite our academic colleagues to examine the museum for a glimpse into a possible future.

The solution, it would appear, lies neither in becoming production geniuses like Barnum nor in retreating behind the closed doors of secluded offices, but in charting a path somewhere between, where the dignity of serious scholarship combines with the nobility of public service.

What Could a Social Anthropologist Do in a Museum of Anthropology? The Anthropology of Museums and Anthropology

A few years ago Professor Robin Ridington, a colleague of mine in the University of British Columbia Department of Anthropology, wrote a paper entitled, 'What is a Clown Doing in the Museum of Anthropology?'[1] He was considering the role of Garbanzo, the anthropology-trained professional clown who regularly performs at the university's Museum of Anthropology, where I also work, and at anthropological conferences throughout North America (Gibbons 1983).[2]

Ridington concluded that it was appropriate to locate a clown in a museum because he is an effective teacher, bringing the collections alive through mime and storytelling. 'The clown's introduction to the artefacts and images in the Museum of Anthropology,' Ridington wrote (1979:90), 'is true to the spirit of native teaching in that it creates a situation in which, without words, knowledge of the transformative vision is strengthened.' The clown-teacher shows children how to see as well as what to see. He takes children, and adults, through a looking-glass land into the world of images and ideas.

What is interesting about Professor Ridington's argument, and also Garbanzo's performance, is how readily other anthropologists are willing to agree that it is a great idea. Anthropologists do not seem to have any problem understanding what a clown might be doing in an anthropology museum.

However, when one asks the question, 'what might a social anthropologist[3] be doing in a museum of anthropology?' anthropologists appear less certain of the answer. Clowns belong in museums all right, but do social anthropologists? Judging by the attitudes expressed by many of our colleagues, social anthropologists belong in museums if they take to clowning, as anthropologist Gibbons has done in the form of Garbanzo, or perhaps if they are seeking to retire from the rigours of academic life; but it is difficult to think of any

other sensible reason for them to be there. In fact, during this century there has been a steady shift by anthropologists from museums towards universities and colleges, and as the location where most anthropologists work has changed, so also has the nature of their work.

During the early history of anthropology it was closely tied to museums, which provided the principal institutional bases and financial support for research. Sturtevant (1969:662) refers to this beginning phase, running from about 1840 to 1890, at least in North America, as the 'Museum Period.' By the 1880s universities in the United States and England began to offer training in anthropology, taught first mostly by anthropologists who also held museum positions. Sturtevant names this the 'Museum-University Period,' running up to the 1920s. (He notes that similar developments occurred in Europe and elsewhere, though perhaps beginning earlier at least in Europe, so his chronology should be adjusted accordingly when applied outside North America.)

The 'University Period' of anthropology began in North America in the 1920s, and within ten to twenty years the majority of anthropologists had moved full time into teaching institutions, and universities and foundations had taken over support of most fieldwork (Sturtevant 1969:624). Where anthropologists were once closely associated in museums with zoologists, botanists, and other natural scientists interested in the study of concrete materials, as they moved into academic environments they began to associate more closely with social and behavioural scientists who were more concerned with symbolic or ideational components of culture. University-based anthropology became more social science-oriented in methodology and more 'mentalist' in its interests, increasingly interested in studying the mental or ideational products of primitive humans – or, at least, the products as reconstructed by anthropologists – rather than studying what 'primitive' people did and made. Early manifestations of this approach, which Harris (1979) characterizes as 'cultural idealism,' went under the rubrics of structural functionalism, culture and personality, cognitive anthropology, and structuralism. Terms heard today include psychological anthropology, symbolic anthropology, semiotics, and hermeneutics.

Anthropological interest in the study of material culture and in museums steadily declined as anthropologists themselves moved away from the museum environment. In their 1954 review of the role of the museums in anthropology, Collier and Tschopik asked whether the study of material culture had by then become a 'dead duck,' and they concluded that essentially it had. This 'alienation' of anthropology from museums is continuing, Maurice Freedman

(1979:54) observed in his 1979 *Main Trends in Social and Cultural Anthropology*. If anything, the poor old material culture duck is more dead than ever.

Museum anthropologists frequently express embarrassment and dismay over the lack of attention they receive from their colleagues. 'Anthropology is in the situation,' Sturtevant remarked (1969:625), 'of having the responsibility for huge and irreplaceable collections which represent a large investment over many years of time, thought, and money, but seemingly have very little importance for current anthropological research, especially ethnological research.' Sturtevant estimates there are some four and one-half million ethnological artefacts stored in museums around the world (1969:640), most only a few hundred years old, and perhaps as much as 90 per cent never studied (1969:632).

There are various reasons why museum collections attract little scholarly attention. First, many items are not worth studying anyway, either because they are intrinsically uninteresting or because they lack sufficient data concerning provenance, function, or meaning. Second, many museums, ironically, offer meagre facilities to researchers and some seem inclined to discourage visiting scholars. Museum storerooms, especially those associated with large museums, are difficult to gain access to, and museum staff are usually too busy to provide much assistance. Third is the absence of important theoretical issues in material culture studies. Research on museum collections actually never did play an important role in the development of ethnological theories (Sturtevant 1969:621–3, 632), though it did in archaeology and it was more relevant to ethnology earlier than now, and though museums provided employment for many ethnologists. And there has been little theoretical development associated with material culture research itself. General questions are seldom being asked or answered, and ideas derived from collections research are rarely being related to broader intellectual or professional issues in anthropology, with the exceptions of art and archaeology. Museum ethnologists need to do more theoretical work, to develop both theories of the object and theories of the museum.

To summarize my first point: the prevailing attitude today in anthropology towards museum anthropology is that it is drifting about in the swampy backwaters of the discipline, suitable only for clowns and dead ducks. This attitude is generated in part by the academic setting to which most anthropologists have shifted in order to do their work. Today, in fact, most anthropologists know very little about museums. As Nancy Oestreich Lurie, curator of anthropology at the Milwaukee Public Museum, noted in a 1981 paper (1981:181):

'Whole generations of anthropologists have now completed profes-
sional careers without ever having had to set foot in a museum ... '
At the 1979 Canadian Ethnology Society meetings, to give another ex-
ample, museums were included in a list of *new* areas of prospective
employment for young anthropologists.

My next point concerns how the conditions of work in museums
today differ from those found in universities, and the influence these
differences have on the kind of anthropological work that gets done
and could be done. Museums have not remained static since anthro-
pologists began fleeing from them forty to fifty years ago. In contrast
to universities, which have maintained a degree of autonomy and
insulation from the communities that support them, museums have,
for better or for worse, become more closely integrated into and
involved with the communities in which they are located and, thus,
in a sense, more 'democratized' than universities. Museum person-
nel, therefore, have had to become more responsive to a wider public,
especially to those they study and from whom they collect, from
whom they draw their visitors, and from whom they obtain funding
for museum operations. Academic anthropologists, by contrast, are
still, by and large, responsible only to their professional peers and to
foundations that provide personal research grants. They do not have
to answer, except in a more generalized way, to the public, to the
board of trustees, or even to the people they study.

Ethnology, by the nature of its style of research – the solitary inves-
tigator spending a year or more 'in the field' as a participant-observer
– has few reality-testing mechanisms. Anthropologists rarely check
the work of their colleagues through systematic replication, being
content instead with comparing a personal interpretation of one's
'own' village or tribe or clutch of informants with the interpretations
advanced by other anthropologists on the bases of their personal field
experiences. Much depends upon how cleverly one can argue the
case for or against some idea.

Museum anthropologists share these personalized reality-testing
mechanisms that are internal to our discipline; but their work is sub-
jected to external testing as well because of the higher visibility and
interdisciplinary nature of the work they do. The products of their en-
deavours will be reviewed by other professionals in the museum
community, by the governing bodies, by the public, and, perhaps
most important of all, by members of the populations they study and
exhibit. Academic anthropologists usually do not have to deal with
the people they study except on their own terms, such as when they
go into the field and treat people as informants or when they recruit
them as students. In both instances the academic anthropologist de-

termines the occasion for interaction and places the 'native' in a subordinate role. However, these same natives are likely to march into a museum any day of the week and expect – quite rightly – to be treated with the same respect that other visitors receive. Also, because museums are highly visible public institutions associated with the establishment, they and their representatives are particularly vulnerable to public criticism. Scholars working within universities are more insulated from any negative consequences of such criticism.

There are other ways in which the conditions of work for museum anthropologists differ from those for university counterparts. Most museum work is practical or applied rather than 'pure' and is collaborative rather than solitary. Curators must work closely with technicians, designers, conservators, educators, business administrators, and volunteers in a process of co-operative production. Academics also engage in group work, for example, co-teaching, co-editing, and joint research, but occasionally rather than routinely, and they collaborate less frequently with such a broad range of specialists or across the boundaries of the pure and the applied.

We need to consider one important structural difference within the museum community – that between curatorial roles in museums of history and anthropology, on the one hand, and the counterpart roles in galleries and museums of art, on the other. The differences are particularly clear in approaches to exhibitions and other public programming, and they help to explain the lower esteem in which anthropology and history curating is sometimes held.[4]

Curators of history and anthropology are concerned with the reconstruction of what they judge to be the original contexts of their specimens – to display them in a fabricated originality, as it were. This requires considerable cleverness and technical skill, but not much original scholarship. Research is directed mostly towards identifying the provenance and function of particular objects and then translating this information into palatable educational packages for the public (Guédon 1983). Curating an anthropology or history exhibit is like writing an elementary textbook with a liberal use of visual aids. The exhibit is based on scholarly work usually already published, and it certainly consumes a major part of the curator's time; but it is not itself, in the typical case, considered to be original scholarly research.

By contrast, curators in galleries and museums of art, and the art community to which they are connected, regard an art exhibit as an 'original scholarly statement' in its own right. This is because the selection and presentation of works of art are expected to be an informed personal interpretation by a knowledgeable person, an 'ex-

pert.' Art exhibits are regarded as (National Museums of Canada 1982:2) 'a means of contributing to a dialogue within the artistic community regarding artists, their work, their significance, their acceptance over time, and their influence upon each other. These latter considerations are largely irrelevant to the objectives of museums and their exhibition policies ... which [are] directed almost solely at [the] public.'

To summarize my second point: the social organization of museum work makes museum anthropologists more visible, and therefore more vulnerable, than their university counterparts. Much of their work is interdisciplinary and collaborative, and concerned more with interpretation than with original discovery. This situation produces excitement or despair according to the individual. Some working in museums try to close their office doors and concentrate on their own work to the exclusion of other responsibilities, a regular practice in Academe but rarely possible in museums except perhaps the large and wealthy ones. Other museum anthropologists submerge themselves in the practical day-to-day work of collections management and public education, engaging in research only for artefact identification and textbook exhibitions, in effect, renouncing their scholarly aspirations.

Neither alternative seems very attractive, either to hide from the world or to submerge oneself in busy work; nor am I myself qualified – the criticism of some of my colleagues notwithstanding – to serve as a museum clown. So I return to my first question: What can a social anthropologist do in a museum of anthropology? Given the conditions of work and the opportunities and constraints they entail, what can one do that is worth doing? This leads me to the third point I want to make: because of the peculiar structural position of museums in modern society, they provide a fertile ground for pure and applied research on a variety of topics and for the development of anthropological theory relevant to our present concerns.

I will give an example of what I mean. Several years ago I visited one of the Museum of Anthropology students who was managing a small museum in a town about eight hundred miles north of Vancouver, British Columbia. She showed me around the museum and talked about the town and her position in it. As the curator-director of the museum, she had to deal with a number of people, to seek support for her institution, and to promote better understanding of the heritage of both the First Nations and European settlers. Part way through our conversation she stopped and said to me, apologetically, 'but I never get time to do any research here!' Trained as an anthropologist in the university mould, she viewed research as the study of

Natives and their ancestral traditions. She did not realize the amount of informal research on local politics she had carried out in order to do her job. During our conversation she had sketched for me, in rich detail, a sociological portrait, of who governs and who matters in this town. That was great material, but she did not think of it as research or as something she might one day want to write about.

At the University of British Columbia we now train our students to be more reflexive, to inspect and write about their own work situations and to do the ethnography of their own museums. We could call this 'practising anthropology in our own backyards' (Ames 1979).

I mentioned earlier how most museum research focuses on objects in the attempt to retrieve information about them, to subject them to stylistic analyses, or to prepare them for public exhibition. There are other ways of looking at objects, however, that will open up many more possibilities for social anthropological research. One way is to extend the idea of the object to include the museum itself as an artefact of our own society; and another way is to examine the social history of the objects, especially in their reconstructed contexts.

The study of the organization of museums and their role in the community is a way of viewing museums as artefacts. Small museums, for example, provide opportunities to explore such topics as the interpersonal dynamics within small groups, the role differentiation between professional and amateur anthropologists and historians (Cannizzo 1979; Vallance 1981), and the genesis of a community's collective representations (Cannizzo 1982; Halpin 1983; Singer 1977).

I myself have investigated ways in which anthropologists and museums contribute to the redefinition of the peoples they study, helping to manufacture their own objects of research (Ames 1981b). (I have more to say about this in Chapter 6, 'How Anthropologists Help to Fabricate the Cultures they Study'.)

Another way to view museums as objects is to view their activities and programs as cultural performances, an approach derived from the work of Milton Singer (1972). That is to say, an exhibition in which a museum presents the artefacts of another culture may itself be examined as an artefact of our own. We look for the unintended messages conveyed along with the official ones. The best example of this approach I know about is provided by one of our own curators at the University of British Columbia Museum of Anthropology, Dr. Marjorie Halpin (1978). She reviewed a new anthropological gallery at a nearby museum, and in the course of her review outlined her approach. An exhibit, she says, should be seen as a cultural performance or statement made not only about Native cultures but also about ourselves. Looked at in this way, 'We can perhaps see how much more we are saying than intended.'

I quote from her article, published in *Gazette,* the journal of the Canadian Museums Association, in 1978 (p. 41):

> This is rather a delicate approach, for we swim so securely in the waters of our own culture that it is hard to see. Even sophisticated anthropologists seem at times to operate in terms of an implicit assumption that the rest of the world's peoples swim unknowingly in culture, whereas we deal directly and rationally with reality. What we need is a mechanism for estranging ourselves from ourselves in order to see ourselves, to pierce the veil of comfort and necessity within which cultural activities perforce seem right and proper. We need to become the anthropologists of ourselves. But perhaps that is too grandiose. We can, however, learn to see something of how we reflect ourselves in the exhibits we invent about others, just as we can find ourselves reflected in cereal boxes, automobiles, leisure suits, billboards, television, and textbooks.

The exhibition Dr. Halpin reviewed deals with the history and culture of the Indians of British Columbia, the westernmost province of Canada. It combines a superb collection of Northwest Coast artefacts all packaged in a superbly constructed exhibition involving advanced exhibition design and technology. The exhibition demonstrates the past artistic achievements of local Indians combined with a more subtle message about the present technological sophistication of the museum's designers, technicians, and curators. As Halpin observed (1978:47), 'to walk through these galleries, contrasting the Indian cultural performance with our own, is to learn as much about ourselves as them. Even more, it is to *see* the clash of two cultures and *experience* the technological and political ascendancy of one at the expense of the other' (emphasis in the original).

Museums also provide convenient locations for practising ethnographic techniques that can be used in program evaluation and impact assessment studies. The ethnographic method is increasingly being utilized in evaluation work (Alexander 1981; Britan 1978a, 1978b: Wolf 1980), so it makes sense to give our students some practical training along these lines (Ames 1979). What better place for a practicum is there than a museum with exhibits and other public and educational programs, the description and assessment of which would benefit both the museum and the student?

For those anthropologists who prefer to focus on material objects, rather than on social objects such as museums, there are still ways to broaden the research agenda. The traditional purpose for studying objects, as I mentioned above, is to identify or reconstruct their original, or at least earlier, settings, with a focus upon the properties, provenance, use, and meaning of those objects. The possibilities for

useful theoretical results are limited, however, because there is sel-
dom sufficient information about the original or earlier contexts of
museum collections to pursue questions very far. This may change
somewhat as we are able to make more extensive use of sophisticated
analytical techniques, but the fact remains that traditional material
culture research so far has not answered many theoretically impor-
tant questions.

There is another area of research, still centring in the object, for
which data can be gathered, however, concerning what might be
called the 'recontextualization of the object' (Halpin 1983). By that I
mean the social history of the object: the study of what happens to ob-
jects, and to the people they attract, once they leave the hands of the
original users, and most particularly, once they become appropriated
by scholars, collectors, and museums in the wealthier nations. Ob-
jects live beyond their origins, and acquire new meanings, new uses,
and new owners along the way. As Stephen Inglis, one of our stu-
dents who has done material culture research both in India and Can-
ada, noted in a recent paper on Canadian folk art (1982 and 1990), a
patina develops on the surface of the study of objects as well as on the
surface of the objects themselves, and the study of this conceptual
patina will reveal to us currents in intellectual history. In his 1978
review of anthropology, Maurice Freedman said that the museum
was a 'palace of the concrete and . . . a machine for decontextualiza-
tion.' He was only partly right. Museums – and also scholars, collec-
tors, and others – certainly remove objects from their earlier contexts
(not always with full respect for local laws and customs, one might
add); but through this removal they place those objects into new con-
texts, the contexts of our own history and culture. This *recontextualiz-
ation* or redefinition should interest anthropology, for it not only
informs us about ourselves but also about recurring features of cul-
ture contact, culture domination, and culture change.

The study of the arts of acculturation and the transformation of
tribal arts from archaic specimens to tourist souvenirs to fine art
(Graburn 1976) is a good example of what I mean by the study of the
reconstruction of the object or of its social history. These studies
would increase our understanding of the processes of social change
and how they affect populations at risk, and they might also assist
those populations in coping with change (Appell 1977:15; 1980). To
give another example, Karen Duffek, another student, examined the
production and marketing of Northwest Coast Indian handicrafts in
British Columbia and identified effects the market had on style, qual-
ity, and quantity of objects produced by indigenous craftspeople. Her
work illustrates how multi-faceted museum research can become

when it is conducted in a reflexive manner with an eye towards practical as well as theoretical applications. In the course of her research, Duffek mounted a small exhibit of contemporary Indian crafts in the University Museum of Anthropology and interviewed museum visitors to find out the criteria they used to judge such works. In addition to completing her thesis (1983c), she produced a consumer guide for the general public (1983a), presented and published scholarly papers (1983b, 1983d), and helped contribute to the revision of the Museum of Anthropology's policies on the acquisition, exhibition, and sale of contemporary Indian art.

I began this chapter by considering whether social anthropologists have useful roles to play in museums, besides those of textbook writers or clown-teachers. After commenting on the distancing relations between academic anthropology and museums and their different structural settings, I reviewed some of the research in which social anthropologists in and around museums are presently engaged. My examples were mostly limited to the Museum of Anthropology, though other examples could be cited. As Butler and Horn noted in a recent issue of the United States journal *Museum News* (1983:43): 'Recent efforts include research in education, the analysis of visitor behaviour and philanthropic behaviour in a community, museum management practices, marketing, communications systems and the sociology of museums.'

I summarize by presenting two general conclusions regarding museums and their relevance for social anthropology.

First, museums are representations of the societies in which they are situated (MacCannell 1976). They are repositories of culture, machines for recontextualization, and platforms for the creation and promotion of cultural heritage. As such, they provide numerous opportunities for social anthropologists to examine cultural patterns and cultural properties as they are actually being conceived, practised, manufactured, transformed, disseminated, used, and misused. By studying museums in their social and historical settings we can study the making of culture in its concrete reality.

Second, museums are also scholarly institutions with unique benefits and defects (McFeat 1962). They are repositories of data; they encourage long-term research; they facilitate joint and shared work; they disseminate knowledge to wider publics; and they are obliged to relate directly with publics beyond specialized disciplines. This public dimension of museum life constitutes a great stress for some members of these institutions and a powerful stimulus for others; either way, the situation provides opportunities for individuals to hone their traditional anthropological skills, to acquire new ones, and to

use their anthropological knowledge in their daily work as well as in their occasional research. The challenging environment of modern museums provides opportunities for creative innovations in the theories and methods of anthropology.

How Anthropologists Stereotype Other People

I want to consider the ways in which anthropology, particularly through its museums, structures the ways we think about other cultures.[1] As one of the social sciences, anthropology attempts to produce 'objective knowledge' about the world, particularly the world of other cultures. Presumably these objective productions are represented in the exhibitions presented by anthropology museums. When we examine the history of museum exhibitry, however, we discover changes in philosophy and style. What museums once thought was the objective truth subsequently becomes no longer fashionable. Museum exhibitions thus appear to reflect, or to exhibit, the changing images of other cultures that anthropologists have produced during their work. Even though anthropologists may be engaged in scientific research, they nevertheless also actively help to construct the phenomena they study.

I describe four ways ethnographic collections have been displayed in museums, from the early curiosity cabinets to the most modern exhibitions in major American museums, to illustrate how each approach, both subtly and explicitly, characterizes in a particular manner the arts and crafts of Third World peoples and ethnic minorities, the traditional subjects of anthropology museums. Each exhibit philosophy is derived from a different set of assumptions about what constitutes the proper study of the works of humankind, and each has played an important role in determining how museums present anthropological information through museum exhibitions. These four perspectives may be represented by different museums, by stages in the evolution of a particular museum, or by the separate components of a single large museum. The great Smithsonian Institution in the United States, for example, developed many exhibition

styles over the years and at least one for each of its divisional muse-
ums. As Lawless and Cohen describe the situation in their article on
the 'Smithsonian style' (1977:59):

> Each [Smithsonian] museum approached its collection in its own way –
> in the museums of art with a taste for beauty and simplicity, in the his-
> tory museums with a passion for the excesses and variety that is the
> story of the American genius, in the science exhibits with explicit dem-
> onstrations of the structural facets of our technological civilization.

CABINETS OF CURIOSITIES

The first perspective I want to discuss is usually associated with the
foundation of museums and therefore actually precedes the develop-
ment of professional anthropological perspectives.

Several hundred years ago and more the material properties of
tribal peoples were classed with strange flora and fauna, as objects of
wonder and delight, to be collected as trophies, souvenirs, or amus-
ing curiosities during one's travels to far and distant lands.

Cabinets featuring collections of both natural and artificial exotica
became a common feature of royal and noble households throughout
Europe during the sixteenth and seventeenth centuries, forming 'cab-
inets of curiosities,' 'cabinets of rarities,' or 'houses of curios,' as they
came to be called (MacGregor 1983a).

These cabinets were unsystematic and idiosyncratic in composi-
tion, and were filled to overflowing. It was common for travellers to
bring back whatever they could find that was strange or wonderful as
illustrations of their adventures in newly contacted or recently colo-
nized lands abroad. What was important was to select objects that
would stimulate admiration and wonder and reflect upon the daring
exploits, special knowledge, or privileged status of the collector.
These cabinets of curiosities provided the foundations for major mu-
seum collections in Europe, and the curiosity they provoked contrib-
uted to the development of a scientific interest in the study of cultural
and natural materials.

The major museums of the world have long since replaced the idea
of curiosity cabinets, however, through their introduction of system-
atic collecting, analytical classifications, and educational displays.
There has been considerable progress and increasing sophistication
during the past hundred years in the management and exhibition of
museum collections, as museum workers themselves become more
professionalized and develop new ways of presenting the object.

EARLY ANTHROPOLOGY MUSEUMS AND THE NATURAL HISTORY APPROACH

'Cabinets of curiosities' were gradually transformed into organized museums as museum staff professionalized themselves and their conditions of work (Baxi 1973:60; Frese 1960:8). By the latter part of the nineteenth century, while anthropology was emerging as a distinctive discipline in the universities, anthropological museums began to take shape as well. Both the profession of anthropology and anthropological museums were outgrowths of the nineteenth-century expansion of Western imperialism and rationalism (Frese 1960:194). A typical objective of early anthropological displays was, therefore, to present artefacts from 'primitive societies' as if they were specimens akin to those of natural history. Following the tradition of the cabinets of curiosities, primitive peoples were considered to be parts of nature like the flora and fauna, and therefore their arts and crafts were to be classified and presented according to similarity of form, evolutionary stage of development, or geographical origin. The comparative theme was the essential ingredient. (For examples, see Thomas Wilson's 1891 report of anthropology exhibits at the 1889 Paris exposition and Burton Benedict's 1983 *The Anthropology of World's Fairs,* especially 45–52.) This early anthropological perspective can still be found in many museums of natural and human history around the world. The great Pitt Rivers Museum at the University of Oxford is perhaps the bext example (Blackwood 1970).

MODERN ANTHROPOLOGY AND CONTEXTUALISM

The modern anthropological approach to museums developed out of this background associated with natural history, and, at least in North America, it owes much to a German immigrant and founder of professional anthropology in the New World, Franz Boas. Boas's first serious involvement with museum work occurred when he supervised the arrangement of ethnological collections for the Chicago Exposition in 1893, collections which subsequently formed the nucleus of the Chicago Field Museum. He next went to the American Museum of Natural History in New York City, where he installed displays in the galleries. Through these installations Boas popularized a different form of anthropological display, exhibiting artefacts in fabricated settings that simulated the original cultural contexts from which they came, rather than as natural history specimens representing some typology or evolutionary sequence. Artefacts should be

grouped together to illustrate a way of life, he said, and that way of life – the context – would give the artefacts their meaning (Mead and Bunzel 1960:305; Stocking 1971:155–6).

The idea of artificially contextualizing through the craft of an exhibit designer the data or specimens from other cultures is justified by the assumption that this is necessary if we are to see objects from the 'native point of view,' that is, how they were used in their original context. According to Boas and his followers, it is the mission (though a self-appointed one) of anthropology to present the native point of view, and creating contextualized exhibits is the normal way anthropology museums attempt to fulfil that mission. On a more general level, contextual exhibits are designed to answer two questions (Adams 1981:292, 296): How can collections add to the understanding of other societies and how can collections be used to illuminate anthropological concepts and insights? Some anthropologists mistakenly believe that these two questions are identical.

FORMALIST PERSPECTIVE: ETHNOGRAPHIC SPECIMENS AS FINE ART

A fourth way of looking at objects is also attributed to Boas's inspiration, though ironically it seriously challenges the contextualist view he promoted and takes us back to the principle of curiosity. This fourth point of view, which we may call the aesthetic or formalist perspective, looks at the material culture of primitive societies for examples of fine art; form becomes more important than content.

When the Metropolitan Museum of Art in New York City opened its Michael Rockefeller Wing of Primitive Art several years ago, it proudly proclaimed that primitive art had finally been recognized and had taken 'an equal footing' with the great art of the world. 'Today,' wrote Douglas Newton (1981:10), chair of the Met's Department of Primitive Art, in the catalogue issued in conjunction with the opening of this gallery, 'attention is paid to the work of art from another tradition for its own sake, its own identity, even when it comes from so remote a source as one of the world's primitive cultures.' (New York City always likes to believe it is first, but similar statements were made years earlier by other museums, including, for example, The Canadian Museum of Civilization in Hull, Quebec, the Royal Museum of British Columbia, the Museum of Anthropology at the University of British Columbia, and so on. A number of museums in Europe could be cited as well.)

It was Boas, Newton stated in the catalogue (ibid.:9), who evoked the word 'beauty,' so rarely used before in the analysis of tribal mate-

rials, and it was he who insisted on the existence of aesthetic knowledge among all peoples, and therefore, presumably, our right to view the creations of primitive people as aesthetic objects and to subject those works to formal analysis.

Some formalists reject the contextualist approach on the grounds that it is no less an arbitrary arrangement than the old curiosity cabinet, because the simulated context of the exhibition represents the mental reconstruction of the anthropologist further elaborated by the technical artistry of the exhibit designer. Such exhibitions, the formalists suggest, may tell us as much about our own exhibit technology and fashionable theories as they do about the cultures contextualized therein.

The contextualists, however, reject the formalist perspective as being completely inappropriate for a museum of anthropology. Taking specimens 'out of context' – that is, displaying them as art objects – is considered immoral by many anthropologists. An eminent British anthropologist, for example, recently dismissed all museums with the damning phrase that they were merely 'machines for de-contextualization' (Freedman 1978:54; see also Chapter 7).

Though the formalists and contextualists hold opposing doctrines, they are usually willing to tolerate differences providing the formalists remain in art museums and the contextualists remain in their museums of anthropology and natural history. Only when boundaries are crossed do people get agitated or confused. If a museum of anthropology displays the material workings of a tribal society as fine art, then a boundary is violated, categories become mixed, and people are likely to become disoriented and upset.

In summary, I described four different ways museums look at, think about, and present strange objects, and thus attempt as well to structure the way we look at and think about those objects. Museums may present objects as curiosities, as natural history specimens, as contextual elements, or as fine art. Though there are important differences among these approaches, and some are today more popular than others, they nevertheless share certain common features.

First, all four approaches are comparative. They attempt to place particular objects into wider contexts of intellectual discourse and analysis. However much distortion this comparison involves, it is also a necessary aid to generalization. Second, all four are imperfect. Though each may be fashionable in certain theoretical circles, each represents only a selection of a larger totality. Each is, therefore, chronically incomplete, and even in combination they do not represent the whole. Third, all are outsiders' views looking in at the past of another people (Merton 1972). Even contextualists who claim they

represent the native point of view are still outsiders who are attempting through their reconstructions to stimulate someone else's experience. 'The display of people is a display of power,' Burton Benedict (1983:52) concluded after surveying the ways people were exhibited at world's fairs: 'It is a symbolic performance demonstrating power relationships, but these relationships are not necessarily real. They may be idealized from the point of view of the exhibitors. They may be highly deceptive and represent a kind of symbolic wishful thinking.' They represent the thinking of outsiders, and this brings us to the fifth perspective: the insider's point of view – 'the point of view of the Native.'

THE INSIDER'S POINT OF VIEW

In October 1982 the University of British Columbia Museum of Anthropology invited the Haida from the Queen Charlotte Islands, north of Vancouver, to come down and raise a new totem pole carved by one of their own. It was an exciting event, involving several thousand people, both Indian and white, working together to raise the pole in a simulated traditional manner. The museum staff were very pleased about this event because it seemed to be such a great success for everyone. We were proud that we were able to bring the groups together in a common cause. I felt very good about it myself. Shortly afterwards, however, I was talking to an Indian artist who was not involved in the pole-raising but knew about it. He brought me down to earth very quickly: 'You haven't done a damn thing for Indians. We don't feel at home in your museums – any of them – because they don't tell us *our* story. When you talk about origins you refer to archaeology and the Bering Straits, and "origin myths," "legends," and "prehistory." We don't know anything about the Bering Straits or about myths and legends. We *know* who we are and where we come from. Our elders tell us that. They speak in truths, not in myths.'

His people, he continued, always had their history, which anthropologists would occasionally try to record and to describe as 'mythology,' 'legends,' or 'folklore.' Their own history, their insider view, increasingly has had to contend with the outsider white man's views propagated by missionaries, Indian agents, teachers, and anthropologists. He admitted that some Indians eventually succumbed to the outsider's views and incorporated them as their own. But others are trying to preserve, to recover, and even to rediscover their own perspectives. These are more personal views of history than any portrayed by museums. Knowledge is derived from the memories of the elders rather than from the so-called objective facts of the social scientists.

First Nation communities in North America have become increas-
ingly disenchanted with anthropology, in fact, and some have gone
so far as to ban anthropological research. For example, in one recent
case, the Band Council of the Massett Haida, in response to their dis-
satisfaction with a study of their community published by an anthro-
pologist, passed the following resolution, dated 7 June 1983:

> THAT WHEREAS: The Haida people of Old Massett resent the intrusion of
> anthropologists, archaeologists, and other persons who spend their time
> studying specimens of humanity;
> AND WHEREAS: The Haida people are concerned that any information
> that is gathered is of no benefit to the Haida people and only benefits the
> social scientists in their quest for recognition;
> AND WHEREAS: The Haida people have a right to live out their lives in
> dignity and quiet enjoyment;
> AND WHEREAS: Certain individuals have made a practise of infringing
> upon the rights and privileges of members of the Massett Band and
> abused privileged information that they've gathered from the elders of
> the Band;
> THEREFORE BE IT RESOLVED: That the Massett Band Council ban one [X
> Anthropologist] from the Massett Reserve #1 and that any information
> concerning the Haida people of Old Massett be returned to the Massett
> Band Council forthwith, and that no further contact be made with any of
> the members of the Massett Band.

Not only North American First Peoples reject the legitimacy of tradi-
tional anthropological research. Note the following statements made
by Papua New Guinea students, recorded for a United States public
television film called *Anthropology on Trial* (Holecek 1983:1).

> **Nahua Roodney:** I think, in the '80s, we must stop anthropologists com-
> ing into the country. Secondly, we have our own academics, we have
> our own Papua New Guineans who now can become anthropologists
> themselves . . .
> **Student:** Sometimes they tell us, 'You go to the library and you look up
> this book, and you read this.' And sometimes we ask the lecturers, 'Can
> we do it from our own background knowledge?' And they say, 'Oh no,
> you have to read the books in the library.' And that's why we get very
> upset. Why should I read a book that is written by somebody from out-
> side, when I can tell it from my own knowledge, my own society?

History from the 'Indian point of view' is the fifth perspective, the
added ingredient that is needed in order to think about Indian objects
in museums. It is not a matter of either or, an insider versus an

outsider monopoly on truth. Nor is it correct to believe that the recon-
structed contextualist view of the modern anthropologist is an ade-
quate portrayal of the insider view. Insiders reject that possibility out
of hand. It is, rather, a question of how the insider and outsider per-
spectives might interact and build upon one another in the process of
truth-seeking and understanding (Merton 1972:36).

What is this insider perspective, the so-called 'Indian point of
view'? First, we must immediately recognize that there is no *one* in-
sider perspective, no one orthodoxy. Views are continuing to evolve,
to formulate and to reformulate, as times change and as generations
of elders come and go. There are views of the past that may be only
dimly remembered; moreover, most objects in museums belong to
that dimly remembered past rather than to present generations. This
is not unique to the Northwest Coast of North America; what we
have here is simply an example which we may consider in order to
think about objects in museums and to think about how museums try
to structure the way we do that thinking. Second, we must admit that
we cannot easily characterize the insider perspectives, because to do
so would be to transform them into our comparative and interna-
tional languages, thereby reconstructing them like our fabricated
exhibitions. Perhaps it is sufficient at this point to learn to listen
to them.

This is some of what we hear around the University of British Co-
lumbia Museum of Anthropology:

1 As already seen in the pole-raising, celebrated by some Indians and
 mocked by others, some appreciate the opportunity to display their
 heritage, while others consider heritage to be private and do not
 wish to put themselves on display.
2 Native peoples are ambivalent about the relevance of museums. A
 representative of a tribal council planning a major cultural centre
 on Vancouver Island, for example, said to me recently that he does
 not like to use the word 'museum' to describe what they want. The
 museum is a white man's institution, he explained, and we don't
 want that sort of thing in our culture. He said they do not want to
 be constrained by the limitations of the category 'museum.' Then
 his tribal council hired one of Canada's top museum exhibition de-
 signers to help design the facility, virtually guaranteeing that they
 will end up with a traditional museum display after all.
3 Several years ago the Museum of Anthropology opened a special
 exhibition of traditional Salish sculpture and engraving, the first
 time such works had ever been exhibited in their land of origin and
 the first time younger generations of Salish people had ever seen

such things. We had to borrow pieces from other museums because little now remains in the Salish area. (The Salish traditionally inhabited what is now known as Greater Vancouver and the southern part of the adjacent Vancouver Island.) Salish people bussed in from all around to see the exhibition. Most enjoyed it, I suppose, but some of the elders who came said they were saddened to see all the spirits locked up in glass cases. Perhaps the objects should have been left in the foreign museums from which they came rather than brought back to stimulate sad memories.

4 Some Northwest Coast Indians, and others as well, say it was wrong to salvage the old totem poles that now stand in museums. They should have been left to decay in their deserted villages. Other Native peoples – some of whom are not themselves descendants of totem pole cultures – say that when they stand in a place like the Great Hall of the Museum of Anthropology, where the old poles are grandly displayed, they can feel the presence of the spirits and are filled with joy, pride, and power.

5 Some say that the poles (originally purchased from Indian families or band councils) should be returned to the villages of origin, or to Indian museums. Others continue to ask museums to buy or to store the traditional objects they still own.

6 Museum staff habitually treat their collections with respect and care, handling the objects gently and displaying them with reverence. We should not assume, however, that the original users of those objects shared our attitude of sacredness. One day a Kwakiutl gentleman came up to me in the museum and pointed to several large wolf feast dishes that we were carefully displaying, protected by 'Please Do Not Touch' signs, and he said to me with a smile, 'Do you see those feast dishes? When we were children they used to be stored under our house, and when the river flooded we would paddle around in them as if they were canoes.'

There are many voices, many stories. They do not add up to one consistent view, nor should they, because they represent different people with different interests and experiences. We nevertheless need to listen. Native points of view may remind us that outsiders do not have the final word. It is the continuing interaction between these various perspectives that is important.

I do not believe that the University of British Columbia Museum of Anthropology, for example, should attempt to present the 'native point of view,' which it could never do properly anyway, whether by reconstructed contextualist exhibits or by other means. It is more important for a museum to concentrate on what it can do best, which is

to present its own point of view as a professional institution, recognizing the limitations that implies, and to work in partnership with the museums and cultural organizations of the 'Native' or indigenous peoples. A museum is only one volume in an encyclopedia of culture that is always being written. No one museum can say it all, nor should it pretend that it can.

LOOKING AT OBJECTS

I have described in this chapter some of the more prominent conceptual schemes museum people use to think about objects and to give meaning to the specimens they display: objects are presented as artificial curiosities, as specimens of nature, as elements or building blocks in reconstructed contexts, as works of fine art, and as fragments of an insider's history.

The perspective one chooses is derived from broader assumptions one holds regarding the significance of the works of humankind and the nature of knowledge. Though a perspective may be presented as the 'truth,' its appropriateness is determined by a particular theoretical framework. It is not necessary to renounce one's own point of view or to accept the principle of relativism, however, in order to grant the possibility that the other views also make useful contributions to knowledge. It is not a question of there being an infinite number of views with which to contend, but a limited number that may, to a degree, complement one another – providing we are willing to recognize the limitations as well as the strengths of each view.

How Anthropologists Help to Fabricate the Cultures They Study

The classical portrait of an anthropologist is one of a solitary scholar travelling off to far and distant lands in search of little-known societies to record them for the sake of science and humanity.[1] It has been a noble quest that has produced some remarkable results, from which we all have benefited. There is another side to this quest, however, that I would like to consider here, and that is the extent to which anthropologists help to create through their own work the societies they purport to be discovering.

I will consider only one example; the study of the arts and crafts of the Indians of the Northwest Coast of North America by museum anthropologists. I suggest, however, that the creative reconstruction we see operating in this one example – whereby anthropologists through their curatorial and research activities are actively contributing to the development of the phenomena which they are so busily collecting and studying – is a feature common to most ethnographic reporting.

My example concerns how museum anthropologists have assisted in the creation, promotion, and distribution of 'acculturated artefacts' (Graburn 1968) on the Northwest Coast, thus contributing to what is now being referred to as the 'renaissance' of Indian art in that area. By 'acculturated artefacts' I mean those produced within the context of acculturation (see especially the work of Nelson Graburn).

The problem with which I begin is a simple one. Some twenty years ago observers were recording the disappearance of Northwest Coast Indian art. Today people talk about its 'renaissance' (Vastokas 1975; Young 1980). How did this renaissance come about, and what did museum anthropologists have to do with it?

British Columbia artist Jack Shadbolt wrote to a Vancouver newspaper in 1954, stating that the magnificent heritage of Northwest Coast Indian art was dying to the ground, and that its prospect was

very bleak (Shadbolt 1954). In her *Art through the Ages,* published in 1959, Helen Gardner noted that from as early as 1910, in fact, good quality Northwest Coast Indian crafts were deteriorating 'beyond recall' (Gardner 1959:623).

By the mid-1970s, however, the production and distribution of contemporary Northwest Coast Indian arts and crafts had become a multi-million dollar industry. Newspapers are now referring to the 'great art bonanza' of Northwest Coast Indian art (Scott 1978). Contemporary pieces have become collector's items, eagerly sought by both museums and private collectors. The carvers themselves are receiving wider and wider recognition and are increasingly being referred to, or refer to themselves, as 'artists' rather than as 'carvers.'

A number of factors may account for this renaissance of Northwest Coast Indian art during the past twenty years (Vastokas 1975). First, industrialized societies have a growing interest in primitive art, the search for authentic experiences, and the desire for souvenirs of touristic journeys (MacCannell 1978). Second, Indian political and cultural movements have contributed to a growing awareness among Indians of their own heritage and its value. Third, the marketplace has provided increasingly attractive rewards for both the quality and quantity of Indian souvenirs and collectibles produced. Fourth has been the role of museum anthropologists who not only have aided the revival but also have actively participated in its genesis and in governing its direction. Museums and their anthropologists entered the marketplace in full flight, buying, evaluating, and promoting contemporary Indian arts and crafts to a remarkable degree. This fourth factor is explored here.

INFLUENCE OF MUSEUM ANTHROPOLOGISTS

Museum anthropologists influenced Indian art and craft industries on the Northwest Coast in at least three ways: through their reconstructions of the meaning of Northwest Coast art; by promoting and legitimatizing art and artists, as patrons to clients; and by inverting the relationship between anthropologists and Indians, so that the patrons become clients. Each influence is discussed in turn.

Reconstructing the Meaning of Northwest Coast Indian Arts and Crafts

Anthropologists produced a distinctive and widely influential interpretation of the material culture collected from the Northwest Coast. This interpretation included both a *codification* of the elements or principles of Northwest Coast Indian design, and a *redefinition* of its

meaning or aesthetic quality, from a 'primitive' or curio art to a 'fine' or 'high' art comparable to the arts of Western civilization.

The codification of design elements has encouraged a standardization or rationalization of design and technique. The consequences are comparable to customary law being transformed into written law: a general stereotyping of form and content follow. (Another factor that has had a counter-effect is the tendency among some more advanced Indian carvers to accept in part the role model of the 'modern artist,' who is expected to be individualistic and experimental.) Two anthropologists in particular played leading roles in this codification: Franz Boas and Bill Holm.

Franz Boas was not the first to do anthropological investigations on the Northwest Coast, nor was he the first to show serious interest in Northwest Coast Indian design; but he did produce one of the single most influential codifications of that tradition, first published in the 1897 *Bulletin of the American Museum of Natural History* and subsequently in Chapter 6 of his *Primitive Art* (1927). He provided a masterful discussion of the elements and principles of Northwest Coast Indian art, such as the oval eye form (now called ovoid), the double curve design, split U's, split representation, and dislocation of parts, along with a set of illustrations that still rank among the best in the literature.

As Helen Codere remarked in her introduction to Boas's *Kwakiutl Ethnography* (1966:xx-xxi), 'even rather superficial knowledge of the elements of this art and its symbolic and operational conventions, as Boas has analysed and described them, makes it simple to specify what is wrong with anything that is not, but only purports to be, Northwest Coast art.' Codere then went on to make a prophetic statement: 'There seems to be no reason why thorough mastery of the details of Boas's analysis, with a requisite technical skill in painting or carving, should not make it possible to produce authentic new Northwest Coast art.' She pointed out how this would provide a generative test of the adequacy of Boas's analysis, and this is precisely what has happened.

Bill Holm, of the University of Washington and Thomas Burke Museum, is recognized as the leading analyst of Northwest Coast design. He took codification even further than Boas, at least for two-dimensional or flat design, and produced what has become the standard text studied by anthropologists and Indian carvers (Holm 1965). Holm taught himself how to produce Northwest Coast art, then he taught others, including Indian carvers. He briefly assisted in the development of the 'Ksan style of Northwest Coast art at Hazelton, British Columbia, for example, which is an amalgam of traditional and

anthropologically reconstructed rule-based principles. In fact, in 1966, the year Codere's prophetic statement was published, Holm took his slides and notes to Hazelton and lectured on the elements of Northwest Coast flat design. The codifications produced by Boas and Holm provide the primary criteria according to which the Northwest Coast artist is judged. Indian carvers themselves both learn and teach from the Boas and Holm books.

The second way anthropologists contributed to the reconstruction of the meaning of Northwest Coast Indian art was to promote a change in classification, from the exotic status of 'primitive art,' where it was compared to other tribal and curio traditions, to the more dignified status of 'fine art,' where it is now compared with the great traditions held in highest esteem by Western civilization. Lévi-Strauss was perhaps the first anthropologist to propose this redefinition, writing in 1943 that 'certainly the time is not far distant when the collections of the Northwest Coast will move from anthropological museums to take their place in art museums among the arts of Egypt, Persia, and the Middle Ages. For this art is not unequal to those great ones' (1943:175).

On the West Coast since the 1950s a number of people, through their teachings, writings, and exhibits, also promoted this theme of Northwest Coast Indian crafts as fine art. Wilson Duff, curator of anthropology at the Royal Museum of British Columbia (RMBC) and then a professor of anthropology at the University of British Columbia, played an especially important role. One of the more significant exhibits during this period was the 1967 'Arts of the Raven' at the Vancouver Art Gallery, curated by Doris Shadbolt, with the assistance of Duff, Holm, and Haida artist Bill Reid.

In the catalogue prepared for that show, Shadbolt (1967) referred to the 'shift in focus from ethnology to art' that the exhibit represented. Eight years later, looking back upon that exhibit, Duff wrote that 'Arts of the Raven' was the 'threshold over which Northwest Coast art has come into full recognition as "fine art" as well as "primitive art"' (1975:13)

In the catalogue Duff prepared for his spectacular exhibition of prehistoric stone sculpture, 'Images: Stone: BC' (1975:24–5), he remarked upon the high intellectual and aesthetic quality of Northwest Coast art. With the Images exhibition, he stated, we are at last beginning to grant to the Northwest Coast 'artist philosophers' of long ago 'credence as people of intellect and mature wisdom.' In his words: 'To the existing proof of the prior claim and Indian presence in Canada may be added, however poorly understood, this evidence of thirty centuries of hard thinking.'

There is by now a well-established litany repeated by anthropologists and others on appropriate occasions. In his foreword to the 1977 Graphics Collection of the Northwest Coast Indian Artists' Guild, for example, George MacDonald of the National Museum of Man (now the Canadian Museum of Civilization) stated that Northwest Coast art 'is only now being internationally acclaimed by experts as of similar importance to the artistic heritage of mankind as are the arts of ancient Egypt and China.' William Taylor, director of the National Museum of Man (Canadian Museum of Civilization), contributing a foreword to the 1978 Graphics Collection of the Northwest Coast Indian Artists' Guild, observed that Northwest Coast Indian art is 'one of mankind's great artistic achievements ranking with the outstanding traditions of China and Japan, tribal Africa, pre-Columbia Middle America and the European Renaissance.' He then repeated Lévi-Strauss's proclamation that Northwest Coast Indian art can be placed 'on a par with that of Greece and Egypt' (Taylor 1978).

This attempt to redefine and upgrade the meaning of Northwest Coast Indian art, and especially its present representations, has not by any means received universal acceptance. Not everyone has agreed to remove it from the category of primitive or curio art. To give just one example, the Northwest Coast Indian Artists' Guild asked the Vancouver Art Gallery if the guild's first graphics collection, issued in 1977, could open at the gallery. The Indian artists, of course, wanted to proclaim to all the message that their silkscreens were 'fine art' deserving exhibition in a major art gallery. The Vancouver Art Gallery agreed to have the opening, but hung the prints in an antechamber to its gift shop, through which people had to go in order to see them. The only gallery staff at the opening were the gift shop manager and her sales clerks who were there to sell the prints.

Promotion and Legitimization of Indian Art and Artists through Patronage

Museums in British Columbia, especially the three big ones (Royal Museum of British Columbia, University of British Columbia Museum of Anthropology, and Vancouver Museum) have been since the 1950s major patrons of contemporary Indian artists. These museums provided or arranged a number of major commissions which helped to establish the legitimacy of contemporary carvers. Probably the single most important event was in 1949 when Audrey and Harry Hawthorn of the UBC Museum of Anthropology commissioned Kwakiutl carvers Ellen Neel and Mungo Martin to restore some of the poles at the university. This commission established Martin as a full-time carver and informant in residence, first for two years at UBC and

subsequently for ten years at the RMBC with Wilson Duff. It demonstrated publicly that an honourable living could be made by producing high-quality carvings for whites and their museums. (It is interesting to note at this point, and I discuss it again later, that Duff's successor at the museum, Peter Macnair, has since endeavoured to demonstrate that carvers can now also make an honourable living by carving once again for Indians.)

After Martin came Bill Reid and Douglas Cranmer, both commissioned to design and construct Haida houses and poles for the UBC Museum of Anthropology from 1957 to 1963. Henry Hunt and his sons (relatives of Martin) worked at the Royal Museum of British Columbia. The Haida house project was a major one for both Reid and Cranmer. It not only had a considerable influence on their own careers, but also attracted wide attention and influenced others. Through the 1960s and 1970s commissions multiplied as did the number of carvers who emerged to take advantage of them. Newly carved totem poles now dot the BC landscape and have become a standard gift item for other nations. During the last ten years carvers have begun to carve and erect poles in their own villages as well. Even Indians are beginning to collect Indian souvenir art.

In the twenty-four years from 1956 to 1980 the major museums and galleries in British Columbia, occasionally with the assistance of their gift shops, have produced over thirty temporary exhibitions of Northwest Coast Indian art and have opened two major permanent exhibitions (RMBC and UBC), all of which promoted the aesthetic merit of Northwest Coast Indian art and most of which included contemporary examples (Table 1). The first important show of this kind was Audrey Hawthorn and J.A. Morris's 1956 'People of the Potlatch' at the Vancouver Art Gallery. Other exhibits that had a major impact were the 1967 'Arts of the Raven'; the 1969 'Northwest Coast' exhibit at Montreal's Man and His World by the Museum of Anthropology; the 1971 'Legacy'; the 1974 'Bill Reid Retrospective'; and the series of solo and print exhibits instituted at the UBC Museum of Anthropology in 1977 (Table 1). The first shows featured early pieces along with a small sample from contemporary artists, but gradually the balance has shifted to a preponderance of contemporary works of living artists. The RMBC, for example, commissioned most of the pieces for its two 'Legacy' exhibits.

One of the most powerful statements about the aesthetic merits of traditional Northwest Coast Indian art was made by the new UBC Museum of Anthropology when it opened in May 1976. It would not be unreasonable to say that the Great Hall of massive carvings and the Masterpiece Gallery stunned the public. This was the first time

anywhere that such a wide variety of first-class Northwest Coast Indian carvings, ranging in age from 13 to 200 years, were ever collected and elegantly displayed in one place as 'masterpieces of fine art.' Art experts did not hesitate to proclaim the earlier sculptures as high art on a plane with the great artistic traditions of the world.

TABLE 1

Some exhibitions of Northwest Coast Indian material culture displayed as art by major museums and galleries in BC, 1956–80

Date	Exhibit	Location	Curator, Organization
1956	People of the Potlatch	VAG	J.A. Morris, A. Hawthorn
1958	100 Years of BC Art	VAG	R.M. Hume
1967	Arts of the Raven	VAG	D. Shadbolt
1968–70	Age of Edenshaw	VCM	W. Duff
1969	Mungo Martin Retrospective	?	A. Hawthorn
1969	Henry Speck	New Design	A. Hawthorn
1969–70	The Northwest Coast	Man & His World	A. Hawthorn
1971	Robert Davidson	VM	Gift Shop
1971	The Legacy	RMBC	P. Macnair
1973–4	Selections from the Lipsett Collection	VM	L. Maranda
1974	Bill Reid: A Retrospective	VAG	D. Shadbolt
1975	Images: Stone: BC	AGGV	W. Duff
1975	Northwest Coast Renaissance	VM	Gift Shop
1976	Legacy: Opening of new UBC Museum of Anthropology	UBCMA	P. Macnair et al.
1976	The Cook Argillite Collection	VM	Gift Shop
1976–7	BC Indian Artists at Work	VM	L. Maranda
1976	Selections from the Lipsett Collection	VM	L. Maranda
1977	Opening of the Anthropology Gallery	RMBC	P. Macnair et al.
1977	The 'Ksan B Show	VM	Gift Shop
1977	Roy Vickers: Beginnings	UBCMA	H. Ratner
1977	The Lightbawn Collection	VM	Gift Shop
1977	Norman Tait, Nishga Carver	UBCMA	H. Ratner
1977	Silver Workshop: NWC Carvers at Work ('Treasures of London')	VM	R. Watt

(continued on next page)

Table 1 (continued)

Date	Exhibit	Location	Curator, Organization
1977	NWC Indian Artists' Guild 1977 Graphics	VAG	Gift Shop
1978	Joe David	UBCMA	H. Ratner
1978	NWC Indian Artists' Guild 1978 Graphics	UBCMA	H. Ratner
1979	NWC Indian Artists 1979 Graphics	UBCMA	H. Ratner
1979	Cycles: The Graphic Art of R. Davidson	UBCMA	M. Halpin H. Stewart
1979	The Evolution of Bill Reid's Beaver Print	UBCMA	Student Exhibit
1980	West Coast & Kwakiutl Graphics	UBCMA	Student Exhibits
1980	Salish Weavers	UBCMA	Student Exhibit
1980	Bent Boxes	UBCMA	Student Exhibits
1980	Legacy II (Edinburgh Festival)	RMBC	P. Macnair et al.

Abbreviations:
AGGV Art Gallery of Greater Victoria VM Vancouver Museum
RMBC Royal Museum of British Columbia UBCMA UBC Museum of Anthropology
VAG Vancouver Art Gallery

To complement its exhibits of traditional carvings, the Museum of Anthropology immediately instituted a program of presenting contemporary Indian artists and their works after the fashion of shows of white art produced by art galleries (Macfarlane and Inglis 1977; Macfarlane 1978; Halpin 1979).

In 1976 the Royal Museum of British Columbia opened its Anthropology Gallery, and that same year the Museum of Man (Canadian Museum of Civilization) in Ottawa opened its Children of the Raven Gallery, both of which again played on the theme of fine art. Also in recent years the Vancouver Centennial Museum, especially through its gift shop, has promoted contemporary Indian artists, holding shows for Robert Davidson, Tony Hunt and his colleagues, and the 'Ksan. Indian art shows are now a regular occurrence among commercial galleries in Vancouver and Victoria, which suggests that contemporary Indian art is becoming well established in local circles.

What the public museums are in effect doing through their exhibits and acquisitions is to museumify contemporary Indian artists and their works, and this legitimatizes both artists and artefacts in the eyes of whites and Indians alike. Whites see artefacts displayed in museum contexts as collectibles and investments. Indians discover a

new value for their own material heritage, seeing what were once stage props now treated as valued objects, sanctified through being coveted by curators, lovingly cared for by professional conservators, and elaborately displayed by artistic designers. Even the carver gets displayed and labelled as a modern artist. At the UBC Museum of Anthropology, for example, Indian carvers are hired to lecture to students and to the public, and arrangements are made for them to be interviewed by the art critics.

Redefinition of the Anthropologist and the Role of Museums

The third way museum anthropologists have influenced the Indian art scene has grown out of their redefinition of the museum enterprise itself. Some museum anthropologists are inverting the relationship between anthropology and the Indian.

In contrast to the traditional role of museums, which was to collect from Indians to show to whites, this new role involves collecting from whites to show to Indians. For example, The Royal Museum of BC and the Canadian Museum of Civilization for awhile competed in high-priced international art markets to purchase and repatriate to Canada prized pieces of earlier manufacture (Bruce 1976). Another example is provided by the Ethnology Division of the RMBC. This division has drawn upon Indian resources to prepare exhibits for the museum's galleries in the traditional museum manner. In addition, however, the division has become more and more involved in drawing upon its own resources to cater to the cultural needs of local Indian communities. Museum anthropologists have become the clients and the Indians the patrons, though the anthropologists (or, more correctly, their institutions) continue to pay the bill.

Here are two examples initiated by the Ethnology Division of the RMBC:

1 Ever since Kwakiutl master carver Mungo Martin joined the museum in 1952, Indian carvers have been employed to carve in residence, both to copy museum pieces and to experiment on their own. Ten to twenty years ago, museums in BC were concerned about assisting the growth of white markets for these carvings. In more recent years, however, Peter Macnair, chief curator of ethnology, has also attempted to stimulate an Indian market. He paid his carvers to produce pieces for Indian potlatches and has both loaned items from the museum's collection and donated newly carved pieces to sponsors of potlatches. When he first invited several young carvers to produce masks for a potlatch a few years ago,

they were sceptical, remarking that it was a rather strange thing to do (personal communication from P. Macnair, 1977). Today, the masks carvers make for potlatches rank among their own most prized possessions (Macfarlane 1978).

2 The Ethnology Division is also putting on tape and film a detailed record of contemporary Kwakiutl potlatching. According to the arrangements worked out by Macnair, the museum acquires custody of the information but ownership remains with the Indians. The museum grants access to scholars only with the permission of the owners, and the owners at no cost to themselves are given photos and copies of the tapes which they use to plan future potlatches or to entertain themselves. (There is also a sign in the Anthropology Gallery prohibiting the use of tape recorders because the songs and music played in the exhibit are 'copy righted by Indian families.')

Thus data collected are recycled to the source from which they came, codified electronically and sanctified institutionally perhaps, but recycled nevertheless and without most of them being routed through the traditional scholarly or public audiences of the museum. The Ethnology Division is a leader in providing important cultural services to Northwest Coast Indian communities which traditionally were exploited to serve the cultural and economic interests of others.

Indians, traditionally treated by museums only as objects and clients, are now patrons. The next step has also occurred. Indian communities establish their own museums, seek their own National Museum grants, install their own curators, hire their own anthropologists on contract, and call for the repatriation of their own collections (Inglis 1979). (One notes here the irony of contemporary anthropology: the more widely Indians accept the anthropological definition of their former greatness, the less willing they are to accept the anthropologists themselves. Anthropologists are taking on the second-class role among Indians that Indians have always held among whites. But that is another story.)

CONCLUSION

Graburn (1968) says that the production of ethnic art in rapidly changing situations functions as an identity-maintaining mechanism for the subject population. What is happening on the Northwest Coast is the active participation of museums and their anthropologists in defining that ethnic identity and the ways it is to be promoted. Anthropologists sit in judgment about what constitutes a proper artefact, a proper price, a proper potlatch, and, by implication, a proper Indian.

Meanwhile, Indian communities, in co-operation with established museums, are beginning to develop their own museum ideologies and to establish their own museumification programs. Both anthropologists and Indians extol the moral and museological virtues of repatriation of museum collections and of staged authenticity in displays and programs. It would seem that for some people, at least, the line between museum anthropologist and Indian has blurred; each is acculturating to the standard of the other. Some anthropologists even carve and dance at potlatches. Museum anthropologists are thus helping to manufacture the objects they study. But this is hardly a new phenomenon. Anthropologists have always been in the business of reconstructing by means of their own theoretical categories the social constructions of those they study. It is not surprising that material culture should receive the same treatment. Nor would it be surprising if we discovered that anthropologists working in other areas are also engaged in the same creative process of helping to create what they set out to study.

The Definition of Native Art: The Case of Willie Seaweed

How should we think about Native or Aboriginal art? Is it really art, should it be exhibited as art, and who are Natives anyway?[1]

The Western world is still struggling to come to grips with Aboriginal peoples and their arts. There is no longer even a generally acceptable term for them. Around the beginning of this century, they were once commonly called 'savages' and 'barbarians,' later referred to as 'primitives' (anthropologists, at least, are now nervously shying away from that term). Now they are more likely to be known as 'tribals,' 'natives,' 'Indians,' or, more possessively, 'our native peoples.' None of these terms are happy choices, being if not insulting at least either misleading or condescending.

This uncertainty about how to refer to other peoples – only slowly and reluctantly do we learn to call others by the names they call themselves – reflects a deeper uncertainty about how we should think about what these people do and the creative works or arts they produce. At one extreme is the nominalist position that if Aboriginal peoples do not have a word for 'art' in their language they can hardly have any art in their culture. So observers should not even talk about their creative works as art. If they do not name it we cannot see it! The other extreme is occupied by those who venerate anything 'primitive.' If it is made by an authentic native (whoever that might be), it must be good: primitive art is art because it is quaint, exotic, mysterious, and preferably, though not necessarily, simple and aesthetically pleasing.

Between these extremes lies the connoisseur's appreciation. It is ridiculous to assume, Haida artist Bill Reid (1982:34) asserts, that if there is no word for 'art' in Aboriginal languages, 'the people of the past had no appreciation of the "formal" elements of their creations, that they had no aesthetic criteria by which to distinguish good work

from bad, that they were not moved by excellence and beauty. Without a formal and critical public, the artists could never, in these societies as in any other, have produced the great works they did.'

Franz Boas, the founder of professional anthropology in North America and a pioneer student of Northwest Coast Indian cultures, was one of the first anthropologists to evoke the words 'beauty' and 'art' in connection with the creative works of other peoples (Newton 1981:9). Aesthetic pleasure is felt by all humans, Boas (1955:9) said; even the simplest tribes 'have produced work that gives them aesthetic pleasure, and those whom a bountiful nature or a greater wealth of inventions has granted freedom from care, devote much of their energy to creating works of beauty.'

Though some anthropologists may be willing to recognize art as a universal category of culture, they disagree over how Aboriginal and non-Western arts should be presented or exhibited to the rest of the world. According to what is probably the dominant view among anthropologists, and perhaps among art critics as well, the meaning of art is determined by its context; therefore to view art otherwise is to distort it. Worse, said critic Fleming (1982) in her review of 'The Legacy: Continuing Traditions of Canadian Northwest Coast Indian Art,' an exhibition produced by the Royal Museum of British Columbia and opened at the University of British Columbia Museum of Anthropology in November 1981, a non-contextual exhibit is a form of appropriation and therefore exploits the peoples whose work is being displayed. To display Aboriginal art out of its context becomes immoral. Because The Legacy curators were only interested in formal analysis, argues Fleming (ibid.:18–19), they failed 'to reflect on the history and socio-cultural circumstances of Native art objects and the peoples who made them ... Formal analysis has, in this instance, divested the objects of their religious, political, and mythological meanings; a type of exploitation has therefore taken place, with Natives being the last to benefit.' The catalogue issued by The Legacy curators provided some of the descriptive information Fleming wanted (see Macnair, Hoover, and Neary 1980).

The other view holds that works of art can stand by themselves and communicate on their own terms as creative achievements without denigrating the history of which they are a part (Reid 1982:34). There is, nevertheless, a continuing reluctance to consider Northwest Coast Indian art in this autonomous or transcendental fashion. Jo-Anne Birnie Danzker (1984:38), then Vancouver Art Gallery curator, wrote in her review of Bill Holm's two 1983 exhibitions of Northwest Coast Indian art in Seattle: 'We do ... seem to have lacked the means to extract West Coast Indian art from its anthropological context, to reveal

its dramatic, conceptual, philosophical power, and to make it available to non-Indian artists and viewers as a compelling and vital part of their own cultural heritage.' Confining an artistic tradition to its original setting, and requiring this context to always be part of our understanding inhibits a work of art from developing that transcendence which is a hallmark of all great achievements and makes it difficult to judge a work according to general standards of aesthetics (assuming, reasonably, that there are aesthetic standards sufficiently general to apply to historically separate instances).

Museums frequently give public recognition and honour to Native arts, however, letting those works 'stand by themselves' in elegantly designed exhibitions and specially constructed galleries. The Metropolitan's chair of the Department of Primitive Art, Douglas Newton, wrote in his introduction to the catalogue issued at the opening of the Michael C. Rockefeller Wing of Primitive Art in 1981, that attention is now being paid to a work of art from another tradition for its own sake, its own identity, 'even when it comes from so remote a source as one of the world's primitive cultures. Early art is becoming familiar to the public directly, rather than filtered through Western artists, and has taken an equal footing in the major museums with other great art' (Newton 1981:10).

Can art be political or utilitarian? Like the common positivist assertion that social science research should be value-free, it is also frequently asserted by the arts community that true or aesthetic art must be free from political or religious interest; if it is utilitarian it may be dismissed as 'only decorative,' just as practical or contract social research is dismissed by academics as 'only applied.' Art can excel, it is said, only if it is independent. It may be all very well for Native arts to be viewed within their ceremonial settings – how else, indeed, are we to understand the exotic? The characteristic of great art, however, is that it transcends its time and its place in history, and thus becomes, in the eyes of its advocates, a universal art. 'Primitive sculpture is not art in our sense of the word because the plastic or decorative product is not separated from other manifestations of life. Art was one form of social expression amongst others, born of man's knowledge of his community, and of his religious experience. Since the Gothic age it has no longer held this function in Europe' (Wentinck 1978:5).

Western artists today, whether they are considered great or not, begin by reaching for this autonomy from their social and political contexts. They do not want their work to serve the establishment (though they voice fewer objections to government support or to their work serving as criticism of established values).

Not only are there standards asserted by art historians to be universally applicable, then, but also universal forms of art; typically – if we take as typical what major Canadian art galleries display – that usually means art after the western European tradition, or 'white art,' as it is sometimes called. Native or tribal arts are still seen to be somehow inextricably and harmoniously bound up with ceremonial systems, all part of an exotic tribal complex, that is actually impossible, conceptually illogical, and ethically improper to disentangle. It is further assumed that when particular Native social conditions cease to exist, the art associated must die as well since it is not imagined to have any legitimate autonomy of its own. More than one museum and gallery official has suggested that the only good Northwest Coast Indian art is dead Indian art: that which was produced in the misty past when, so the myth of the Romantic Native goes, they lived in a stable, integrated, and happy tribal society. The coming of the Europeans brought about the decline and fall of the untouched primitive, and everything produced thereafter lacks a true essence, a cultural meaning (the traditional social system is no more, after all). Recent works are written off as deviations from scholastically defined traditional standards and not considered suitable for important art galleries. Contemporary Native artists who try new media or new forms are criticized for abandoning their traditions or for catering to the money market. If Native art is to retain its purity, its acceptability in wider society, it seemingly must remain parochial, unchanging, and exotic, that is, 'primitive.' Evolution of form and style, like freedom from cultural embeddedness, is a privilege reserved for white art.

A counter-argument for the functional autonomy of symbol systems holds that any art style is capable of working out (or being worked out) of its original social milieu and constructing a history of its own, and perhaps even subsequently returning to its roots to redefine and resuscitate the society from which it sprang. Although all art traditions originate in socio-cultural situations, and are culturally embedded, all have the potential to spring loose. We encourage transcendence in Western or 'white' art but seem less willing to grant it to other art traditions. Yet to seek the meaning of a work of art solely in terms of its social origins is to make a fetish out of context and a museum piece out of the artist.

When, to what extent, and by what means could an art form extend beyond its primary social boundaries? How much assimilation into a dominant society can an indigenous community undergo before it ceases to be a community in its own terms? Can a non-Native or one with mixed Native-white parentage produce authentic Native art? Is being Native enough, or must one be born into the right tribe? When,

if at all, does a *Native* artist become an *artist* who is Native? Must the artist change pedigree or art form? When does he or she merit an exhibit in a major museum or gallery? Museum and gallery officials become worked up over these issues when trying to decide what to collect, to exhibit, or to sell in their shops. Perhaps insecure in what they are doing, they usually keep their arguments to themselves. Artists, and more frequently their agents, also express concern about the lack of standard definitions and the narrowmindedness of those museums and art galleries that do not acquire what the agents have to sell. (A discussion of these and related issues pertaining to Northwest Coast Indian art can be found in Duffek 1983a, 1983b, 1983c, 1983d.)

Bill Holm, longtime curator of Northwest Coast Indian Art at the Burke Memorial Museum and professor of art history at the University of Washington, Seattle, does not directly address these issues of definition and conceptualization in his writings and exhibitions. He more wisely concentrates on presenting meticulously researched ethnographic and historical accounts of Northwest Coast Indian sculpture and painting. I want to review here his exhibition and catalogue on the art and times of – let us not mince words – a master artist called Willie Seaweed. Seaweed (c. 1873–1967) was from the village of Ba'a's, Blunden Harbour, Queen Charlotte Strait, an artist and leader of his people whose works 'were prized and preserved by the Kwakwaka'wakw traditionalists for whom they were made, as well as by museums and collectors' (Holm 1983:8). As in all good empirical research, much in the Seaweed exhibit and catalogue, and in the way Holm presents his material, bears upon issues much broader than the particular study itself. In this case it is the question of how we might see and think more imaginatively about the creative workings of other peoples.

Willie Seaweed – his Kwak'wala familiar name is translated as 'Smoky-Top,' suggesting a volcano – was chief of the 'Nak'waxda'xw, one of the groups of Kwakwaka'wakw (speakers of the language Kwak'wala) who are commonly, but incorrectly referred to as Kwakiutl (a term properly belonging to only some of the Kwakwaka'wakw groups). A note on Kwak'wala orthography, based on the system adopted by the language program of the U'Mista Cultural Society of Alert Bay, British Columbia, is appended to the catalogue's introduction. (That orthography is only approximately followed in my review.) The catalogue begins with an unequivocal answer to the question, 'Who are they?' First, they are to be defined properly in relation to themselves, not as they relate to the Western world – people Columbus mistook for residents of India and who were subsequently colonized, disorganized, and deculturated. Grant them at least the

dignity of their own names, Holm implies, which is a privilege customarily denied most dominated peoples.

Did Seaweed produce 'true' art in the white tradition that claims universality, or only in a more parochial tribal form firmly embedded in ceremony? Holm, who through many years of ethnographic and museum research knows Seaweed's work better than anyone, talks about his control of line, proportion, scale, and balance; his intellectual approach and 'passion for perfection'; his outstanding craft; his adoption of new techniques when they facilitated his work; the 'power' of his creations; the evolution of his style; and his reputation among the Kwakwaka'wakw, museums, and collectors as a great carver within a recognized genre. Holm also describes the cultural and littoral setting of Seaweed's work. Almost everything he made, except for some miniature totem poles for sale to whites, was for use in the Kwak'wala social gatherings, political manoeuvrings, ceremonial displays, and economic exchanges anthropologists call the potlatch. It is evident from Holm's analysis that Seaweed's work, as all good art must be, is both deeply embedded in a complex cultural ecological system and transcends it. Good work can be viewed both ways, singularly as artefact-in-context or as art-standing-by-itself, and binocularly as a creative work possessing both local history and comparative significance.

Can good art also be political? Seaweed's work certainly was. Not only were his pieces prized instruments of the Winter Dances, an integral part of élite Kwak'wala society, they also made 'political' statements in a broader sense. Throughout Seaweed's productive career Kwak'wala ceremonies were denigrated and suppressed by white authorities. Regalia were at one point seized by the Crown, and owners threatened with imprisonment if they did not renounce potlatching. Seaweed, along with others, continued to produce and to participate in ceremonies, frequently in remote, secret places like so many resistance fighters. Some of his finest works, the magnificent monster bird Hamatsa masks, were made during the 1930s and 1940s, years 'following the most active oppression of the potlatch and the Winter Ceremony when it was widely believed that both institutions were dead' (Holm 1983:109).

When does a Native cease to be a Native and become assimilated into the dominant society? Holm says Seaweed was born in a cedar plank house on the shores of an inlet that knew only canoe travel, and by the time he died guided spacecraft were landing on the moon. He lived through a century of rapid, disruptive change during which the very foundations of his society were being questioned; his people dislocated, divided, and proselytized; their traditional economic pur-

suits eliminated; and their ceremonies suppressed. Seaweed never-theless lived a full, productive life through it all, and was honoured by his people and by outsiders. He never stopped being a 'Nak'wax-da'xw even while he borrowed ('assimilated') Western technology, material culture, and custom. His legacy extends beyond the objects he produced, most of which have now been retired to museums and private collections. Holm's study makes clear that Seaweed's life and works continue to inspire and to challenge new generations of Kwak'wala artists and performers who appear as thoroughly assimi-lated into white society as they are committed to Kwak'wala heritage. 'The most expert carvers,' Holm says, referring to Seaweed and others, 'were, and are, in demand, and they in turn make every effort to live up to their reputations for imagination, skill, and knowledge' (ibid.:86). Seaweed and others, Holm says (ibid:34),

> kept concepts alive in spite of that change and the active opposition of every outside authority which forced its way over them. He lived to see his art honored by those same authorities. The traditions which he, Mungo Martin, and others of their generation held and perpetuated have been taken up by younger hands. The new generation of Kwak-waka'wakw artists are inspired by the work of those predecessors. They are carrying the tradition, just as Willie Seaweed did in his own time.

A Kwakwaka'wakw is thus one who, regardless of the accidents of parentage or degree of acculturation, consciously shares in the privi-leges and responsibilities of a particular heritage rooted in a particu-lar coastal setting, as both *continue to evolve*. It is a cultural, ecological self-definition that cuts across anthropological, political, and legal definitions the Kwakwaka'wakw have acquired, and have had be-stowed upon them, more recently. When we think about other peo-ples, then, we must first recognize that complexity and ambiguity are likely to be natural parts of the situation and that we will come to un-derstand the significance of self-definitions only as we learn to listen.

The story of Willie Seaweed demonstrates that works of art can take on universal significance precisely because of their primordial strength and that they can continue to be meaningful even while ev-erything around changes or when they are examined away from their locality. *Smoky-Top: The Art And Times of Willie Seaweed* is a valuable contribution not only to our limited yet growing understanding of Northwest Coast Indian art and culture, but also to our appreciation of cultural and artistic differences everywhere.

The Emerging Native View of History and Culture

Contrary to widespread expectations, the indigenous peoples of North America are not disappearing.[1] Their numbers have steadily increased since the early part of this century, and their cultural distinctiveness persists (Lurie 1966). This survival of indigenous peoples is not unique to North America; it is a world-wide phenomenon.

Something is happening among indigenous peoples around the world; it is a growing consciousness among those who have survived of their common predicaments, common interests, and common strategies. A Fourth World of indigenous peoples (Graburn 1981) are working towards similar objectives. Thomas R. Berger, one of Canada's foremost advocates of Native rights, recently observed (1985:176): 'Native peoples the world over fear that, without a measure of self-government and their own land-based economy, they must be overwhelmed, facing a future that would have no place for the values they have always cherished.' Cultural autonomy is as important to indigenous peoples as economic independence. 'Native peoples everywhere,' Berger continues, 'insist that their own culture is still the vital force in their lives; the one fixed point in a changing world is their identity as Natives.'

Although the degree of self-assertion varies with country and circumstance, a common thread runs throughout: the rise of Native intelligentsia and pan-tribal socio-political solidarities as indigenous peoples advance through the educational systems of the dominant societies. Legal, political, and cultural initiatives are taking precedence over violent rebellions and messianic retreats as more practical alternatives for those who are vastly outnumbered and steadily absorbed by the nation-states that have encompassed them. Tribal leaders in India, reports Surajit Sinha (1981:121), conclude that improving their condition lies in aggressively asserting their distinctive tribal

identities and solidarity through political and cultural means. Ac-
cording to Muratorio (1984:3), ethnicity among South American trib-
als is being reformulated as 'an opposition ideology' directed against
'present and past systems of domination.' Noel Dyck (1985), intro-
ducing a collection of papers, *Indigenous Peoples and the Nation State*,
cites parallels in Canada, Australia, and Norway: their stubborn per-
sistence despite assimilation policies; their attachment to ancestral
lands as cultural and economic resources; their continuing allegiance
to tribal forms of social and political organizations; their deep sense
of grievance and injustice; and their persistent struggles in political,
legal, and public arenas for autonomy within the larger nation-states.
Indigenous peoples are refusing to assimilate; they will not give up
their ideas of who they are (Berger 1985:184): 'Their fierce desire to re-
tain their own culture can only intensify as industry, technology, and
communications forge a more deeply pervasive mass culture, exclud-
ing diversity of every kind' (ibid.:176).

The relations between the indigenous peoples of North America
and anthropology museums – particularly those prevailing on the
Northwest Coast of Canada – reflect the persistence and resurgence
of Fourth World peoples as they work 'with fierce desire' towards re-
possessing their histories and cultures. They form but one limited
case study within that broader context and are the subject of this
chapter.

Anthropology has a long tradition of drawing upon and benefiting
from the heritage of indigenous peoples. Many anthropologists, espe-
cially those trained in North America, honed their theories and meth-
ods while studying Natives and the Inuit. Museums acquired thou-
sands of scientific specimens; indeed, some have become world
famous for their large Native collections and impressive exhibitions
(see, for example, Cole 1985). The Western tradition of self-criticism
has also been aided by contact with aboriginal societies (1) because
members of those societies furthered that criticism by actively oppos-
ing and resisting Western policies; and (2) because their societies
presented alternate images of what a good society could be like
(Berkhofer 1979).

Indigenous peoples benefited from serving as a major resource
base for anthropologists and museums, who provided a valuable his-
torical record that these peoples regularly consult. Anthropologists
and museums also provide valuable assistance in promoting more
positive and relatively well-informed views of these peoples and
their customs, in contrast to the more negative and ill-informed ste-
reotypes typically portrayed through the media (Ridington 1986).

However, the relations between museums and indigenous peoples

are changing. Increasingly concerned about preserving and recovering their dwindling natural resources, indigenous peoples are also recognizing the importance of their traditional lands and cultural traditions as *resources for their future as a people*. While calling for the return of their lands, they are reclaiming their own histories from anthropologists and others so that they may exert more control over how their cultures are presented to themselves and to others. Naturally any community wants to control how its image is made and presented, but minorities and dominated populations within larger states frequently have to struggle to win this right. They must even struggle to persuade others to call them by the names they call themselves rather than by those such as 'Indian' bestowed upon them by explorers, missionaries, map-makers, and anthropologists.

The 'Native point of view' is increasingly being heard, and the attitudes and policies of anthropologists and museums are changing as a result. Change may appear to be slow, but the trend is there. Though some may not yet have heard the call to revise how they represent other peoples, they likely will.

This chapter reviews some current changes in the relations between indigenous peoples and museums in Canada. It includes efforts by Native intellectuals to free themselves from what some describe as 'their ethnological fate' of always being presented and treated as anthropological specimens. Also considered is the emergence on the museum scene of the 'Native point of view.' Though reference is made to other parts of North America, the focus is upon the Northwest Coast where, as Lois Day aptly observed and is illustrated in Chapter Six (Day 1985:17): 'Whites and Indians ... are conniving with each other in a process of creating meaning, defining what domain belongs "naturally" to each race, and how each can provide what the other lacks.' (The 'repatriation' of artefacts from non-Native to Native-operated museums, though certainly relevant, falls outside this chapter. See Inglis 1979, Nason 1981.)

For several hundred years or more, whites widely assumed that the indigenous peoples of North America would either vanish or assimilate. Their distinctive ways of life, beliefs, and values, their 'cultures,' were expected to eventually disappear. Given those assumptions, anthropologists reasonably considered themselves as the appropriate custodians of and spokespeople for the Native image. But the indigenous peoples have neither disappeared nor have they altogether assimilated. Instead, many are stubbornly persisting 'as definable little communities and as an unassimilated minority' (Lurie 1971:418). They are becoming more culturally conscious, politically active, and numerous.

These changes have been taking place all over North America for many years, though to different degrees and in different ways according to local circumstances. The late John Price (1984:19), an anthropologist who taught Indian Studies at York University, near Toronto, suggested that developments in the United States tend to be twenty years ahead of those in Canada. This may very well be the case (see the discussion of 'Indian modernism' below).

Crucial turning points – in Canada at least – included the following: since the 1960s, integration of indigenous peoples into white schools; since the 1970s, federal funding for their political associations and cultural programs, growing indigenous participation in post-secondary educational institutions, and the introduction of Native studies courses and programs; and in the 1980s, an emerging alliance between aboriginal land claimants and environmental activists who, together, are attempting to preserve traditional lands against intrusion by governments and resource industries. Indigenous peoples point out that the land is part of their cultural identity; the trees, rocks, and rivers are historical sites containing memories and records of their past. Land is thus their primary source of spiritual inspiration, the economic means of maintaining a tribal lifestyle, and their only guarantee of a culturally distinctive future. Government and industry, however, view land more as an exploitable commodity to which they must have access for the common good (see Dyck 1985:7–8). (This alliance between environmentalists and indigenous peoples may not last. Environmentalists want to preserve wilderness areas and tend to view Natives as 'close to nature,' whereas the Natives want closer control over the distribution of benefits to be derived from the natural resources in their areas.)

How are anthropologists and museums responding to the increasing efforts by indigenous peoples to control their own cultural identities? They are no longer willing to be treated as resource banks into which graduate students and their supervisors may dip at will, nor as interesting textbook examples of tribal society. They protest against the treatment of their heritage as a commodity. They and others increasingly challenge the notion that scholars carry everywhere with them the privilege of academic freedom that endows them with the right to study anyone anywhere 'for the sake of science' (Nason 1981). Like people everywhere, they are more insistently and publicly asserting their right to privacy.

What is to be done about these indigenous peoples who are developing the awkward habit of speaking out and talking back? What are these peoples to do about the rest of us? Maintaining traditional academic and curatorial associations with the Natives – treating them as

specimens, informants, subjects, or students – will no longer be suffi-
cient, because these associations involve relations perceived as un-
equal or hierarchical, with the anthropologist, teacher, or curator as
superior. Indigenous peoples want to be treated with equality, ex-
pecting it as a natural right, and are increasingly likely to demand it.
New relationships are evolving among Natives, anthropologists, and
museums, as indeed they must if anthropologists and their museums
are to keep pace with these developments.

Can we identify the directions of these changes? One obvious de-
velopment is in the resource bank relationship. Anthropologists and
museums, or at least some of them, are becoming important resource
centres for indigenous peoples. Some anthropologists hire them-
selves out to Indian bands as consultants – like academic mercenar-
ies, as it were, who have discovered the pleasant fact that Indians can
also be a useful financial resource. Other anthropologists barter ser-
vices. At the University of British Columbia Museum of Anthropol-
ogy, to give a local example, students and staff offer research or other
professional services in exchange for information or loans of materi-
als for exhibit.

Working partnerships with Native cultural organizations are be-
coming more frequent. The Ethnology Division of the Royal British
Columbia Museum (formerly British Columbia Provincial Museum)
devotes a major portion of its research resources to the documenting
of contemporary Northwest Coast Indian ceremonials, the results of
which then become a free data bank primarily for Native families.
The RBCM also loans contemporary ceremonial objects for use at pot-
latches, and has even donated some items (Ames 1981b and Chapter
6). The Museum of Anthropology co-sponsors programs and exhibi-
tions with local Native organizations and has collaborated with Na-
tive curators and cultural workers in producing shows.

During the past ten years a number of indigenous communities in
North America have opened their own museums and cultural cen-
tres, claiming, not surprisingly, the right to present their own images
of what they were and want to be (Doxtator 1985). This is not a recent
development. The North Carolina Cherokees apparently had a mu-
seum collection as early as 1828 (Hanson 1980:45). Prior to the 1970s,
however, the governments of Canada and the United States were not
interested in supporting such projects (Doxtator 1985:25).

The ways in which non-Native museums exhibit Natives may also
change. The standard exhibitions still found in most museums are
what might be called naturalistic and contextual (Ames 1983c and
Chapter 5). That is, indigenous peoples or their material attributes are
arranged like so many specimens of natural history, or as models in-

stalled in dioramas, usually miniaturized, that are designed to repre-
sent artificially the original cultural context as imagined by the
anthropologist or exhibit designer. A few fine specimens might also
be included in displays of 'primitive art.'

The new departure, pioneered by institutions in Washington state
and British Columbia, for Northwest Coast Natives was (1) to exhibit
better older pieces as examples of fine art which they claim to be on a
par with the other fine arts of the world; and (2) to exhibit contempo-
rary Native art as fine art on a par with modern white art. The North-
west Coast Indian is presented as an artist and his/her culture as a
world-class artistic resource (Chapters 6–7; Bill Holm 1965, 1983).

However, this has introduced a new set of problems for anthropol-
ogists and museums. After having the mantle of 'artist' bestowed
upon them, indigenous artists are saying they no longer want their
works to be 'relegated' to anthropological museums (Hill 1984). As
befits peers, they want their works to be collected and displayed in
Canada's major art galleries alongside the work of non-Native artists.
If Native art is good enough for government officials to present to
representatives of other nations (they typically use Inuit or North-
west Coast Indian carvings), then why is it not good enough for the
National Gallery? Participants in a Spring 1985 Canadian Museums
Association panel, appropriately entitled 'It's Indian Art: Where Do
You Put It?,' castigated Canada's art establishment for neglecting Na-
tive art and concluded 'that the racist/separatist label of "Indian"
should be removed from native art.' This would free it 'from its
purely ethnological fate and allow it to be appreciated and assessed
for its aesthetic/artistic attributes' (Anon. 1985e).

'Free Indians from their ethnological fate!' Indeed! Take the Native
out of the art, and what remains? Defining an indigenous creator or
craftsperson as an artist and his/her culture as an artistic resource
poses problems still to be worked out (Duffek 1983b, 1983d, 1989,
1991). What is this art, after all? How does it fit into the life of the
community to which the artist belongs? Into the broader society?
How should indigenous communities and their artists relate to those,
still mostly whites, who interpret and collect this work? How is the
authenticity of such work to be determined, and by whom? Who is to
validate the Native artist and his or her work: the museum, the critic,
the market, the anthropologist, or Native tradition as interpreted by
the elders or political leaders? Native artists, in their desire to escape
ethnological museums, may end up as captives of the art galleries
and *their* curators instead, and still be subject to the external validat-
ing procedures of the dominant society. To be considered indigenous,
must a work of art be derived from a recorded aesthetic tradition, and
should that tradition still be 'living,' whatever that means? Or is be-

ing Native enough, sharing in the indigenous experience? How are we to judge the artistic quality of a work – by its Nativeness, its intrinsic aesthetic merit (whatever *that* means)? Or more mundanely and perhaps more to the point, when is it art and when is it craft, and why do people usually associate the former with men and the latter with women? What should the artist expect to draw from his or her heritage or community, and what – a question asked less frequently but more urgently – should the artist give back to that community?

Who is the true culture hero, one who expresses to the wider society what excellence in one's own cultural tradition is all about, or one who, whether excelling or not in the outside world, pauses long enough to give something back to his or her own tribe?

These were some of the questions asked when Native artists, anthropologists, curators, collectors, dealers, and others from across Canada gathered in the town of Hazelton, British Columbia, for five days in August 1983 to discuss the state of indigenous peoples and their arts and crafts, how they wanted to see themselves, and how others, especially the art establishment, saw them.[2] This conference, well documented on film and on paper, reflected the energy generated by the issues being debated across Canada and the United States as Native intellectuals and artists, along with their politicians and administrators, continue to work towards freeing themselves from their 'ethnological fate.' (And what, one asks in sotto voce, will the anthropologists do when they no longer have their 'Indians'?)

In most cases, the appearance of North American indigenous contemporary art in art galleries is recent. Carol A. Phillips (1982), then director of the Mackenzie Art Gallery (Regina, Saskatchewan), was able to declare in her foreword to the catalogue of that gallery's 1982 exhibition, 'New Work By A New Generation,' that it was the first exhibition in a Canadian art museum 'to bring together a selection of works recently produced by artists of North American Indian ancestry who are applying contemporary art concepts, techniques and styles, but who retain, either imagistically or philosophically, connections to their personal heritage.' The key to this exhibition – and what sets it off from historical and anthropological displays, she suggests – was the selection of pieces 'in terms of contemporary aesthetic judgements and not ethnographic values.'

Leave aside for now her claim for the first contemporary indigenous art exhibition based on aesthetic criteria. British Columbia museums and galleries have been mounting shows of contemporary Northwest Coast Indian art as 'art' since the 1970s, and the National Gallery of Canada is said to have mounted the first North American exhibition of Indian art in 1927 (Cole 1985:285).[3] Also leave aside her notion that ethnographic values exclude aesthetic ones. Grant at least

that this phenomenon has only recently begun to attract serious criti-
cal attention.

Phillips refers to Native artists connecting to their heritage 'imagis-
tically' and 'philosophically.' The imagistic connection suggests a
kind of art that is traditionally inspired, but expressed through mod-
ern concepts (serigraphs, acrylic paintings, jewellery) and techniques
(the use of power tools). Haida artist Robert Davidson recently re-
ferred to some art and dance forms he was developing as 'an old song
and a new dance.' The imagistically-traditional-and-technically-
modern productions are usually what are now exhibited in museums
as 'contemporary Native art.' The philosophical connection, however,
hints at more personal expressions, linked perhaps only by the shared
experiences of the artists as minorities in their own land. It represents
a more recent and radical break with tradition – a 'Modern Indian' or
'Indian Modern Art,' one might say.[4] Indian modernism probably will
be accepted if the contemporary imagistic tradition is already estab-
lished; it is, in any case, only beginning to emerge as an identifiable
genre in Canada. The 1982 show at the Mackenzie Art Gallery may
indeed be the first Canadian exhibition of this philosophically mod-
ern form. The Vancouver Art Gallery scheduled a major exhibition of
Indian modernism for 1988, the first for public institutions in British
Columbia, though commercial galleries in Vancouver and nearby Se-
attle, Washington have been displaying and selling this work for
years.

More attention is paid to these modernist art forms in the United
States, where contemporary Native arts have received public, institu-
tional, and commercial recognition for much longer. The defining
characteristic of this second modernist wave, the philosophically or
experientially connected personal expression, may be taken from
George C. Longfish and Joan Randall's (1983) introduction to the 1983
'Contemporary Native American Art' exhibition at the Gardiner Art
Gallery in Stillwater, Oklahoma:

> The experience of the artists as Indian people are as rich and varied as
> the native American tribes and nations which remain on this continent.
> They approach each other seeking to share their differences and to com-
> pare their similarities. Through their art, which is a very personal form
> of expression, they do the same. The assumption among them is that
> they are Indian; they do not concern themselves with having their art
> 'look' Indian.

What are these modernist artists showing or saying in their works?
Consider the following, Longfish and Randall say:

Think of Tonto, *The Last of the Mohicans*, Mazola corn oil commercials, John Wayne westerns, Seneca apple juice and the Buffalo head nickel. Mix those images with Oklahoma Indian Days pow wows, pick-up trucks, pottery, jewelry, rugs and Northwest carvings, alcoholism and high mortality and morbidity rates among Indian people. Throw in scenes of Alcatraz, the Longest Walk, and the struggle in Navajo and Hopi land, the uranium mines in the Four Corners area, James Watt. Then switch the film to the young black-haired brown faces dancing in the Long House after their clan mother has given them their Indian names; and then see the sun dances in the Oklahoma summer's heat; flip to a Maidu dance with mysterious masked faces in the pines and red-woods; listen to the old women's stories during the quilt-making session or in the kitchens while cooking for yet another community event. Watch the brown young men strut in the sun while looking furtively at the group of seemingly uninterested young women off to the side. See the time clocks in the cities and the long dusty roads in the country. Stand on the back of the Turtle, our mother, and look at the land and wonder what it would have been like if Columbus would have been successful in his pursuit of India and avoided the eastern shore of this continent. Wipe your Indian hands on your Levi jeans, get into your Toyota pick-up. Throw in a tape of Mozart, Led Zepplin or ceremonial Sioux songs; then throw your head back and laugh – you are a survivor of a colonized people. Paint what you see, sculpt what you feel, and stay amused.

Destiny has made you an Indian and perhaps, has had something to do with you being an artist. Your children are Indians who learn the stories, the ceremonies, and a sense of profound difference with those in the dominant culture. They also learn to run computers, drive automobiles, watch Mazola corn oil commercials and make a living in a modern Indian world.

If you are able to make these considerations, perhaps you will find that the contradictions of Indian territory are authentically Indian.

To appreciate what is happening to Native art we must consider aboriginal history, Allan M. Gordon, art history professor at California State University, Sacramento, wrote (1981:4) in the catalogue of the 1981 modern Indian art exhibition 'Confluences of Tradition and Change/24 American Indian Artists':

In view of the historical realities – the irresolution of Indian economic and socio-political exigencies – the most viable alternative for the Indian artist must appear to be a repossession of the past, a resolving of the old self into a new, emerging self. This is not to be regarded as a regression

or retreat, but as a revitalizing confirmation which liberates the past. As such, it also frees the artist in order for him or her to make a more honest, disinterested interpretation of it.

A revitalizing repossession of the past will likely liberate it from its customary custodians and interpreters, especially anthropologists and museums. Canadian Native artists are included in the u.s. modern Indian art shows. Longfish himself is an Iroquois from Ontario (and a professor of Native American Studies at the University of California at Davis and director of the C.N. Gorman Museum). Occasional murmurs of interest in contemporary Native art may be heard from a few anthropologists and curators in Canada as well, though many still struggle within the limitations of Western art theory. Certainly there is a growing restlessness among Canadian Native artists. Seemingly it will only be a matter of time.

I do not know what all this adds up to, or what the future will bring. We – by whom I mean all students of indigenous peoples – are observers of change. We are also among the actors, and among the acted upon. Perhaps at this point it is sufficient to recognize where we are and to pay attention to the questions even if we are not sure about the answers.

Two things at least are clear. First, the current movement is not simply a 'renaissance' or 'revival' of earlier aesthetic traditions (Dutfek 1983b, 1983d, 1991; Wade and Strickland 1982), which many observers consider the only 'authentic' standard for indigenous arts. There are new developments as well. Aboriginal societies, like other societies, continue to evolve, and their forms of artistic expression constitute part of that evolution. As Wade and Strickland (1982:24) point out, the contemporary Native artist paints what she or he sees in the world:

> Change is not decline but the natural process of growth, an historic evolution consistent with the evolving world of the American Indian. The difficulty is that the Indian artist who moves into a white mainstream enters an artistic environment viewed by many as culturally and artistically stagnant. Still, this is the world, polluted or not, in which the artist and his tribe live.

Second, these new developments in indigenous art, which are part of the broader socio-political and cultural movements among indigenous populations, will certainly create some disturbances (ibid.):

> The rapidly changing definition and uncertain expectations of contemporary American Indian art confuses and disturbs many traditionalist

scholars and patrons, and some native artists. The worlds of Indian art are in collision; transition and accommodation will not be easy. Indian art no longer looks the same. It is no longer soothing and reassuring. Contemporary Indian art disturbs and is intended to disturb.

As Native intellectuals regain control over their own images and their own destinies, they will also claim the right to provide the answers. It will be wise to listen carefully, even if we might not always agree, because the growing intellectual autonomy of indigenous peoples will have considerable impact on how anthropologists and museums deal in the future with 'the natives.' More is involved than simply transforming specimens into examples of 'fine art,' the example considered in this chapter. The white's image of North American history will also be transformed. Europeans in North America, perhaps feeling the lack of a history and New World culture of their own, frequently appropriate the histories of the First Peoples as their own – '*our* native heritage' and '*our* native peoples,' as is heard in polite circles. 'The problem is,' Canadian author Margaret Atwood once observed (1972:104), 'what do you do for a past if you are a white, relatively new to the continent and rootless?' We adopt the Indians as our ancestors. Now that they are reclaiming their history, where will that leave us?

Although European nations have their own histories and cultures, they too have used the North American Indian, and indigenous peoples in general, as image markers for their concepts of proper history and the good society. Berkhofer (1979:27–8) says in his study of the white's image of the Indian that whites 'overwhelmingly measured the Indian as a general category against those beliefs, values, or institutions they most cherished in themselves at the time.' Europeans use counter-images of themselves to describe Indians, and counter-images of Indians to describe themselves:

> Since White views of Indians are inextricably bound up with the evaluation of their own society and culture, then ambivalence of Europeans and Americans over the worth of their own customs and civilization would show up in their appraisal of Indian life ... That Indians lacked certain or all aspects of White civilization could be viewed as bad or good depending upon the observer's feelings about his own society and the use to which he wanted to put the image. (ibid.)

To repeat the question with which we began: What will be the fate of ethnology when indigenous peoples free themselves from their ethnological fate? It has been said many times that anthropology is the child of imperialism, but the world has entered a new era. 'In its own

way, the reemergence of the Fourth World is as great a challenge to the West today as the reemergence of the Third World was during the period of decolonization ... (Berger 1985:178). Does that signify a rebirth for anthropology?

De-Schooling the Museum: A Proposal to Increase Public Access to Museums and Their Resources

How can museums make themselves more useful, particularly in rapidly changing societies?[1] This was the theme of the thirteenth international conference of the International Council of Museums, which met in London in July and August, 1983. The ICOM Council indicated that the answer may *not* be found by copying the classical idea of museums as it developed in Europe and North America. Something new is needed.

I would like to suggest a new approach to museum organization, borrowing from the concept of 'de-schooling' put forward by Ivan Illich in 1971 (Illich 1971). The relevance of museums in contemporary society, he suggested, likely will be determined by the degree to which they are democratized; that is to say, the extent to which there is increasing and more widespread participation in decisionmaking regarding administration (includes giving those administered a greater say in the organization and conditions of their own work); educational programming (includes reducing the role of educational intermediaries and increasing opportunities for independent and individual learning); collections management (includes making collections more accessible to the users); and increased opportunities for independent thought and action in cultural matters.[2]

The traditional museum, as it developed in Europe and North America, began as an élitist institution designed to limit access to the privileged classes. Though museums today serve a much wider clientele, they still retain many exclusive features. Most large museums, for example, grant public access to only a small percentage of their total collection – usually one to five per cent or less – and those objects that are made accessible are usually presented within the context of elaborate interpretations. Access is consequently, in the typical case, highly structured, predetermined, and controlled by museum profes-

sionals so as to be 'correct,' 'safe,' 'understandable,' and 'educational.'

The change in museums, especially during the past thirty years, has been towards increasing democratization and popularization of their operations. Museums now compete to serve wider populations in an increasing number of ways, and to make their collections more accessible and useful to the public. More space and greater detail and care are being given to exhibits, more temporary exhibits are mounted, more loans are made to other institutions, and more attention is given to repatriating objects that were illegally removed from other countries. All these strategies enhance the popular function of museums, and though they are frequently costly to maintain, they still grant access to only limited parts of the total collections and continue to serve only special segments of the public (see Kelly 1982).

Museum visitor surveys repeatedly show that museums cater almost exclusively to the more highly educated classes. Even though museum attendance may have increased over the past fifty years, it is more likely because the level of education has increased than because museums are catering to a broader spectrum.

Until recently the attempts to make museums more accessible have been limited to improving physical access and facilities and to constructing elaborate exhibits (Cameron 1982:179). Collections and the ideas associated with them were being 'edited down' to the 'lowest common denominator' (ibid.:180). 'What arrogance,' Duncan Cameron, one of Canada's senior museum administrators, wrote recently (ibid.): 'What arrogance to assume that we serve our visitors by offering intellectual access to less, not more, and the less to be of our expert choosing.' Museums were committed to democratization, Cameron continued, but 'we saw improved orientation and interpretation as the primary means to that end without realizing that we might be showing the visitors a superb menu and wine list without allowing him to come to the feast.'

Another form of democratization that is gaining momentum, one which is both simpler to execute and more radical in its implications, is the idea of increasing direct access to the collections and intellectual resources of the museum, principally by making the museum storage areas themselves open to the public. In some respects this represents an updated version of the older style of museum that displayed row after row of specimens, but it is quite a departure from the norm today. Does open storage help to make a museum more relevant or useful to the community?

I would like to describe examples of accessible storage developed recently in western Canada and to discuss some problems they pose.

Their attempts to increase public access are far from perfect, but they should at least provide a basis for further discussion. Other examples could be added. How useful these examples will be as models for rapidly changing societies is something to be determined. It is at least evident that the type of storage system adopted by a museum – relatively closed or open – has implications for more than public and scholarly access. The choice is likely to be related to how people conceptualize the proper role of museums and how knowledge should be constructed and disseminated.

VISIBLE STORAGE IN A UNIVERSITY MUSEUM: THE UNIVERSITY OF BRITISH COLUMBIA MUSEUM OF ANTHROPOLOGY

The University of British Columbia Museum of Anthropology's system of 'visible storage' was introduced in 1976 (Ames 1977). As a teaching museum associated with one of Canada's largest universities, it was considered desirable for the Museum of Anthropology to increase access to teaching collections as much as possible. A system of open or visible storage was devised whereby relatively non-light sensitive objects were arranged in locked glass-fronted cases in galleries open to the public. Books containing computer printouts for all the objects were provided as well. The system operates like a large library or supermarket, with the exception that customers can handle objects only under staff supervision; meanwhile, they have unhindered visual access to collections and to the catalogue data.

Interpretive and artistic exhibits are installed elsewhere in the museum, while teaching labs are placed adjacent to the visible storage galleries. Most of the clothing, textiles, prints, and other light-sensitive objects in the collection are not included in visible storage. A separate, less accessible study-storage system was designed for these materials, although it was only partly implemented because of lack of space (Ames 1981a; Lambert 1983).

The Museum of Anthropology visible storage system continues to work reasonably well for students and scholars, for whom it was primarily designed. It is less successful as popular entertainment, since it requires effort and some degree of knowledge on the part of the visitor to use the data books, which are not very informative in any case. Security has been improved by installing more secure locks and a closed-circuit TV surveillance system. Lighting has been modified by the use of filters (Clavir 1982–3), but lux levels are still high. (To reduce costs, fluorescent tubing was installed at the top of the shelf units, so that high objects receive more light than lower-placed ob-

jects.) Most of these problems probably could have been avoided by
using more elaborate cabinets, lighting, and computer-assisted infor-
mation systems, had there been sufficient funds.

VISIBLE STORAGE ADAPTED TO A COMMUNITY MUSEUM:
THE PORT ALBERNI EXPERIMENT

When visible storage was adapted to a small community museum in
Port Alberni, British Columbia, a town of 20,000 people, it initiated a
high degree of visitor participation.[3] The museum opened an en-
larged facility in March 1983 that included three public galleries: one
featuring artefacts from local Indian communities; a second, about
twice the size, holding historical materials from local European set-
tlers, the 'pioneers'; and a third small gallery designated for tempo-
rary exhibitions. The first two galleries are arranged in a modified
visible storage mode which combines, the Port Alberni director ex-
plained (Mitchell 1983), 'public access to collections normally held in
out-of-bounds storage areas with a simplified popular catalogue for-
mat. A series of interpretive orientation displays weave through the
total gallery/storage area to guide the visitor.'

Port Alberni Museum staff report that local visitors were especially
intrigued by the catalogue system because they often knew the ob-
jects or the previous owners, and therefore were able to offer their
own additional knowledge and thus related directly and personally
with the objects. Open storage in the context of this town thus be-
comes an opportunity for members of the community to participate
collectively in the recovery and documentation of their own history.
Artefacts and catalogue sheets serve as memory releasers and discus-
sion guides, and the museum staff serve as recorders. The museum
merges into the community of which it is a part. Public participation
is apparently high and enthusiastic, though the continued success of
this program will also require high levels of public involvement by
museum staff, something workers in larger museums usually try to
avoid. There is also the question of whether a small collection in a
community museum can provide lasting interest, or will the novelty
eventually wear off?

STRATIFIED STORAGE AT A LARGE URBAN MUSEUM:
THE GLENBOW PROJECT

The third example was an experiment in study/storage conducted by
a large urban museum in western Canada, the Glenbow-Alberta In-
stitute in Calgary, the fourth or fifth largest museum of history and

art in the country.[4] Duncan Cameron, the director of the Glenbow, wrote about the philosophy of this project (1982, 1983), and I draw upon his work.

The collections in public museums, Cameron reminds us, are held in trust for the public, and the public, therefore, has a right to have optimum access to those collections and what is known about them (Cameron 1982:179): 'The museum resource, for the visitor, must be a resource designed for access to the museum's totality – its collections, what is known about them, and the human resources of the musem – its curators and educators – whose mandate is to make those collections meaningful and intellectually valuable by every available means.'

Access, Cameron continues, means not only physical access to objects but also intellectual access to information about those objects, including, where necessary, curatorial decoding and interpretation. It is to be a stratified access, however, limited and controlled by the specific requirements of particular collections and by the intellectual interests of the visitor populations. Access is thus organized according to levels of increasing density of collections combined with decreasing levels of interpretation. First is the didactic exhibit where 'levels of interpretation [are] at their highest and the density of collection material is probably at its lowest' (Cameron 1982:187). The second level is publicly accessible study collections, and the third level, with the highest density of artefacts and minimal labelling, is controlled access to reserve collections. Strategically located between these three levels are education resource centres, study areas, and curatorial offices.

The principle of stratified access is to provide graduated access to collections and information, 'working from an introduction and the creation of interest to the exploration of study collections and, for those with the curiosity and desire, access to the human resources for serious study and research' (ibid.).

The location of curatorial staff represents an important departure from traditional museums that tend to isolate them from the public and the public galleries. In the Glenbow plan, curatorial staff are placed 'in a central position so that they have total command over the collections for which they are responsible . . . '(ibid.) and are, on occasion, accessible to the public.

The storage cabinets are modular and 'designed to accommodate everything from large clear spaces to open shelving and systems of drawers of varying proportions operating both vertically and horizontally' (Cameron 1982:189).

Information is to be provided in didactive orientation exhibits,

through computer terminals keyed to catalogue numbers of artefacts in accessible storage, in education resource centres, and ultimately by curatorial staff approached through appointments.

The Glenbow prepared a prototype of the system, using its Western North American ethnology collections to test its use. A stratified approach, with individually designed cabinets, micro-environments, and integrated information resources assisted by a computer system, was expected to resolve many of the criticisms levelled against other open storage systems. The Glenbow model is a more expensive system to create and to operate, however, and the division of collections into didactic exhibits, accessible storage, and controlled storage posed problems of artefact selection, assignment, and management. It also gives curatorial staff a more prominent screening or mediating role than do the other visible storage alternatives. Unfortunately, the Glenbow experiment never proceeded beyond the construction of a prototype case because of anticipated costs, insufficient curatorial resources to prepare artefact selection and documentation, and a belief that open storage systems would not be cost-effective.

CONCLUSION

One way to increase the relevance of museums is to increase public access to the collections and information they contain, so that people can become more familiar with the full range of their heritage.[5] It is important for a population placed at risk because of rapid change to have 'access to its past, to its traditions, to its culture in order to move into the future' (Appell 1980:14). People are then more able to 'evaluate their past positively and link up the past meanings of life, the past goals and purposes, with the evolving new life, with the evolving new purposes and goals, so that social change can be accomplished more productively, more creatively, and without ... painful dislocations' (ibid.).

Three types of accessible storage were considered: one designed for a teaching museum at a university, a second adapted to the needs of a small community, and a third proposed for a major urban museum. Other museums are also considering ways of making their collections more accessible; for example, the Canadian Museum of Civilization and the Burke Memorial Museum in Seattle, which are both showing collections on video disk, and the British Museum in London which designated a basement gallery as open storage for a collection of Roman sculptures. There are three main criticisms raised against the idea of accessible storage. It is said to (1) expose collections to increased environmental and security risks; (2) make it difficult to in-

terpret the objects properly (because so many are displayed); and (3) undermine the responsibilities and authority of the curatorial staff.

The first two problems are essentially mechanical and can be resolved by making use of modern technology. Light, humidity, air purity, and security can all be controlled in a variety of ways, and computer-assisted techniques can increase information flow. How far a museum can go towards resolving these mechanical problems is mostly dependent on how much money it has. The Port Alberni experiment demonstrates, however, that low-budget solutions are viable for certain purposes. The third problem – the change in the responsibilities of curatorial staff brought about by accessible storage – is a different matter. People are more difficult to change than mechanical systems, and it is apparent that accessible storage threatens some prerogatives and assumptions of the curatorial profession.

According to a popular view in museum circles, a museum should interpret or explain carefully chosen specimens, and 'preserve' the bulk of its collections in restricted storage. Various reasons are given for not displaying artefacts without the expert's interpretation: because it is a museum's mission to educate, because the public is believed to need guidance or to not be interested in uninterpreted objects in large collections, or because recreating the original context of the objects helps to justify, or to pay for, the fact that they were removed from their cultural context in the first place. To fail to create a cultural context within a museum exhibition is to commit the crime of 'decontextualization,' or worse, a blasphemy against the culture from which the objects were obtained.

To give a more concrete idea of the type of objections levelled against accessible storage, I report a number of attitudes attributed to staff of a large North American museum who were engaged in planning a new multi-million dollar facility for their institution:

1 Open storage confuses the visitor: 'A person would go crazy in there.' The first reaction would be boredom, seeing hundreds of axes or pipes when one would be enough. Then a kind of disorientation, leaving the visitor exhausted and none the wiser.
2 Through visible storage the museum staff avoid their responsibility to the visitor. It is the duty of the museum staff to present exhibits of the finest materials in their possession, arranged in an appealing and educational fashion. Just dumping all the collections out into the galleries is a basic negation of the museum's role. Many of the museum's collections were never meant for display, are only for study, and should never be inflicted on the public.
3 Visible storage is an invasion of staff privacy. The work place in the

museum, storage, is a private place where the public have no busi-
ness. Nobody wants to have people looking over their shoulder be-
fore they are ready. Open storage ultimately raises the possibility
of all the staff working behind glass. The collections are the work
place of the museum staff and the idle curiosity of the public has no
right there.

4 Who wants open storage anyway? Is there any real evidence that
the public want to have it or have asked for it? It seems that the
whole idea has been pushed by the education section of the mu-
seum. They always say everyone wants it but never give any evi-
dence. It looks like by putting everything out in visible storage they
will have to play a greater role in interpretation. Where does that
leave the curatorial people? Are education staff going to take over
the collections?

One of the consequences of the increasing professionalization of
museum work is that members of this developing profession begin to
consider it their special responsibility and privilege to control and
structure the relations between collections and the public, as the atti-
tudes cited above suggest. Curatorial staff who hold this view pres-
ent themselves as the necessary agents not only for the care but also
for the interpretation of heritage, just as teachers consider their cur-
ricula a necessary condition for learning (Illich 1971). They see it as
their responsibility to structure the experience of the visitor, princi-
pally by means of didactic or textbook exhibits which they assume –
though there is little evidence – are effective instruments for convey-
ing knowledge.

In contrast, the view that favours wider access to collections is
more likely to be associated with ideas about 'de-schooling' the mu-
seum enterprise by lessening rather than increasing institutional
arrangements between object and viewer (Rowan 1978). Museum ex-
hibits create artificial and stereotyped contexts that may obscure the
objects they are intended to feature (Halpin 1978). Access to heritage,
according to this view, is a democratic right, and that means access to
the objects themselves and to information about those objects (cata-
logue data) in addition to, perhaps even instead of, prepacked curato-
rial interpretations. Museum visitors are to be encouraged to pursue
their own investigations through independent learning, with various
aids to be provided by the museums, such as computer terminals,
small introductory exhibits, and the occasional availability of curato-
rial staff serving as resource people or 'librarians.'

It appears that attitudes towards storage techniques are linked to
more deeply felt notions about the role and use of knowledge in soci-

ety, such as the extent to which knowledge should be structured and mediated by professionals or liberated from institutional interpretations.

If museums wish to improve their social utility then they might consider sharing more of their collections and intellectual resources with the community. As long as access is restricted to structured and interpreted exhibits, which is now the prevailing custom in North American and European museums, then museums will cater only to the interests of those few among the educated strata who seek formal learning or tourist experiences (Kelly 1982). The more museums can democratize their operations and increase public access to their resources, the more likely they will appeal to wider audiences. Access can be enhanced by improving physical facilities and by opening up the storerooms and making catalogue data available so that people can explore beyond the one to five per cent of the collections curators arbitrarily decide the public should see.

Museums can also learn how to increase their usefulness by observing successful businesses. Take as one example the mass marketing of furniture by a company called Ikea. The firm originated in Sweden and has become quite successful in Canada, where it offers convenient supermarket-style shopping for people seeking medium-cost furniture. Perhaps there are ideas in such an example that museums might consider, ideas about how to make visitors comfortable and how to display as much as possible in meaningful but not heavily interpreted ways so that visitors can explore and experiment according to their interests.

Are Museums or Anthropology Really Necessary Any More?

Some years ago, Dr. Wilcomb Washburn, a senior curator at the Smithsonian Institution in Washington, DC, asked whether museums were necessary any more (Washburn 1968:1):

> I ask seriously whether, in the future, the museum object will not be converted into information that is as satisfactory for human purposes as the object itself. Should this occur, will it be necessary to preserve the object, let alone exhibit it? ... The object, removed from its context, distorted by the ravages of time and environment, can, conceivably, be a less accurate statement of itself than a description accurately recorded and readily available.

Social and cultural anthropologists – henceforth I follow museum tradition and refer to them as ethnologists – are not asking whether they are necessary. They like to assume that they are, of course. But they are asking about the future of the profession. 'Where are we heading?' Richard Preston asks (1983:294) in his review of the social structure of Canadian anthropology. We are heading towards a crisis, 'we are being challenged from many sides all at once,' states Marc-Adelard Tremblay, one of Canada's most distinguished anthropologists, in a paper published in the same volume as Preston's review (Tremblay 1983:332). (For similar laments in reference to American anthropology, see Hoebel, Currier, and Kaiser 1982.)

Anthropology, according to Tremblay, 'is undergoing a crisis that threatens its foundations by calling into question its traditional objectives' (ibid.). It is a crisis facing science as a whole:

> Can we claim that anthropology has achieved the scientific objects of its founding members? It has been incapable of demonstrating its utility ei-

ther to client communities or to bureaucratic power brokers, be they in government, in large public corporations or in private business. The crisis of anthropology has multiple facets and far-reaching consequences. It comes at a time of unprecedented theoretical fragmentation, when a confusing plethora of new methodologies are competing to be the anthropological breakthrough to the new science. In the meantime, programs in action anthropology are coming to a halt because of the questioning of the ultimate objectives of such endeavours and because the quest for knowledge has relied not only on scientific premises but also on ideological paradigms. (Tremblay 1983:333)

To make matters worse, as if we needed to, university enrolment in Canada was expected to decline by about 20 per cent during the 1980s because of the drop in the birth rate that followed the post-Second World War baby boom (Siminovitch 1979:11, 18), and this most certainly will lead to a reduction in academic opportunities for anthropologists as well as for others.

There were about 300 to 400 ethnologists working in the early 1980s in Canada, most holding positions in 35 universities across the country and others in museums or private practice (Burridge 1983:307). Burridge works that out to one ethnologist for every 90,000 people in the country, compared to one per 80,000 in the United States, one to 330,000 in the United Kingdom, and one to 120,000 in Australia (ibid.). No growth potential here.

Where, indeed, is Canadian ethnology heading, and is the situation much different anywhere else in the Western world? The newsletter for the American Anthropology Association reported in its September 1983 issue that 'over 40 per cent of anthropology doctorate recipients were still seeking employment at the time the doctorate was completed,' the highest percentage for all major fields and a dramatic increase over the 12 per cent registered ten years previously (American Anthropological Association 1983:6).

Questions are being asked with increasing frequency. Are museums really necessary any more? Does ethnology serve any useful purpose that could not now be more effectively performed by other disciplines, such as sociology, geography, or economics? Who needs ethnology besides the ethnologists themselves? Is any part of anthropology now relevant, science writer Christopher Hallowell asked in an article recently published in the journal of the u.s. Public Broadcasting Communications System (1983:46):

Social psychology and sociology, anthropology's nearest relatives, regularly hit much closer to home. Scientists in those fields tell us how we

can best get through life. They tell us how we deal with stress, what effect urban life has on us, and how scared we all are. They tell us about the effects of long-distance plane travel on our bodies and minds, which seems a bit more pertinent than learning [from an anthropological study] how stewardesses behave on planes.

The popular attitude towards anthropology is even more negative, though much of this criticism is directed towards the very idea of social science which, in the typical case, is accused of providing academically obscure interpretations of the obvious and the ordinary. As one outspoken critic, a retired magistrate who wrote a column in a daily newspaper in Vancouver, put it (Bewley 1983):

> An anthropologist, sociologist, psychologist, political scientist, or criminologist can for generations peddle, without being caught out, absurd and downright disastrous ideas about education, child-rearing, human relationships, government, and the reformation of crooks.
>
> With his fool ideas it is possible for him to ruin several generations of citizens and their families, destroy their peace of mind and their safety on the streets, and bankrupt national treasuries. By the time the facts catch up with and expose the catastrophic consequences of his teachings, the silly blighter has been appointed a professor emeritus and is too honoured, too white-haired, too old and too feeble, to be tarred and feathered and run out of town on a rail.

Fortunately, there are some encouraging responses to these challenges. Surely museums are necessary since so many new ones are built and old ones renovated every year. 'No statement about an object is as complete a statement about the object as the object itself,' Washburn (1968:9) of the Smithsonian said, so there will be a continuing need for museums to collect, preserve, research, and exhibit specimens. The more rapidly traditional crafts disappear along with the tribal populations that made and used them, the more important it is for museums to rescue some of the evidence.

It is becoming more widely recognized now that one role museums perform is to serve as symbols of status and prestige (Kelly 1983). Visiting an important museum is a highly acceptable and socially visible way of validating and demonstrating one's status in the community. According to social psychologist Robert Kelly (1983), who has been examining the status role of museums, a growing number of people who visit such institutions do so 'to attain a state of *having been there*' (emphasis in the original).

Museums have become the temples and palaces of modern society,

expressing in contemporary idiom – through both their architecture and their contents – the essential values of the community (Meyer 1979:130), which thus makes it possible for them to perform their 'status-conferring' role (Kelly 1983:12). Museums, such as national museums, also serve as political instruments of the state which are expected to present the authorized or established picture of a nation's history and culture or to serve as monuments to the benevolence and culture of the governing party itself (see Dickson's 1983 discussion of France's plans for a monumental new science museum in Paris). A large museum of art is a necessary part of a city's image of sophistication. When the art gallery in Vancouver recently moved into a newly renovated heritage building, for example, the city celebrated as if it had finally come of age. This move to the impressive old building with its modern renovations, the local newspaper proclaimed (McMartin 1983), 'places the city [of Vancouver] on an equal footing with the best the country has to offer.'

It took four evenings to celebrate the opening of the new Vancouver Art Gallery, with crowds of excited people each evening. The first to come were members of the local establishment, who rolled up in Rolls-Royces, Mercedes, Jaguars, BMW's, and Cadillac limousines, parking on lawns and sidewalks with 'bravado,' the local newspaper reported (McMartin 1983), 'where only the rich and powerful would dare.' Five hundred guests in formal attire attended on that first night, paying $250 each for champagne, dinner, and a string orchestra. The more ordinary members of the public visited the newly opened gallery during the next three days, the first two of these days by invitation only, and the last day for everyone else still interested.

For the first time in Vancouver's history, the local newspaper said (Johnson 1983), the city will have a 'real art gallery.' What is a 'real' art gallery? Vancouver actually had an art gallery for over fifty years, but until this move it was lodged in an ordinary building. It now has a facility of monumental stature, though the quality of its collections remain the same. A real art gallery, a newspaper reporter explained, 'is a gallery in a gracious and dignified building. A real art gallery displays entirely too much for anyone to see and absorb in one visit. A real art gallery provides that delightful experience, hitherto available only in more sophisticated urban centres, of visual overload' (Johnson 1983).

Towns also want their museums and galleries to preserve and display their own local histories and their own arts and crafts. Every self-respecting community needs a museum to contribute to that sense of self-respect. The more a modern society removes itself from its past and sees change as 'coterminous with progress' and innova-

tion as 'coterminous with improvement' (Shils 1981:4), the more the past is reduced to nostalgic memories, and people feel they need museums to store their nostalgia, those beliefs and values which, though they are still much admired, no longer serve as models for the future (Shils 1981:3).

Do museums play a significantly different role in those societies that continue to draw upon their past traditions as normative models for future action? What happens when a museum attempts to 'museumify' living traditions? The Special Committee on Antiquities in Sri Lanka described just such a problem in its final report published in 1959 (Special Committee on Antiquities 1959:17. Quoted in Bandara 1972:53):

> Archaeology in Ceylon has of necessity, to deal with the remains of religious edifices that pertain to two living religions – Buddhism and Hinduism. In this respect archaeological work in Ceylon is beset with certain difficulties that are not found in a country like Egypt or even in certain parts of India. The vast majority of people in Ceylon treat archaeological remains not as historical or scientific curiosities but as sacred sites and buildings. They are only secondarily significant to them as historical or scientific data. The people's wishes and emotions are primarily important, but it is absolutely necessary that a compromise must be found in this matter between the demands of religious fervour and scientific study, for these monuments are priceless and constitute indispensable material to the historian and the archaeologist.

Museum attendance continues to grow, outstripping even – it is claimed – attendance at professional sporting events. So those working in museums can answer loudly and clearly, 'Yes, museums are necessary, because the people want them!' But are they necessary for the right reasons? Does the increasing popularity of museums subvert them from their original mission as scholarly institutions, and therefore subvert the work of those employed within? Or, to look at it another way, are those working in museums today, especially ethnologists, adequately trained for the public roles unfolding upon them? In actual fact ethnologists are not trained for many of the duties they are now expected to perform in contemporary museums and galleries, and that is a problem.

Academic ethnologists are also inclined, naturally, to say that their ethnology is also necessary; but in their case they cannot claim it is because the people want it. On the contrary, to the dismay of the profession, ethnology appears to be declining in popularity, among students, in the general population, and – most embarrassing of all –

among those whom ethnologists traditionally study (Lurie 1966). Probably one of the greatest shocks an ethnologist can experience – and it seems to be occurring with increasing frequency – is to have the people studied read what was written about them, and complain both stridently and publicly about misinterpretation and distortion. The personal interpretation the ethnographic technique produces makes ethnologists particularly vulnerable to this criticism.

Under the circumstances we had better give more serious attention to the state of our profession, Richard Preston warns (1983:294) in his recent article on the structure of Canadian ethnology: 'With a promised decline in university entrance populations, inflation, recession, an ungenerous mood on the part of government and . . . the populace as far as university support is concerned, we are faced with the fact that the boom is finished, and strategic withdrawals . . . from the aspirations and expectations of the past decade must come.'

What has gone wrong? Museums are more popular than ever, though apparently more as status symbols than as the institutions of research and education their curators prefer. The academic version of ethnology, despite unparalleled growth in numbers and in the sophistication of theories and methodologies (Tremblay 1983), appears to be declining in popularity and public respect. Somehow ethnologists are missing the boat; those in museums grumble about their increasingly public role, while those in Academe lament their declining popularity.

Ethnologists who today work in museums and universities were all trained in a context where the importance of research and the principle of scientific freedom were held to be primary values, transcending even the responsibility to respond to public demands. The foundations for these ideas can be traced back to the Renaissance and the 'educational revolution' (Parsons and Platt 1973:3) that followed. Scholars have come to assume that the acquisition and free exchange of knowledge is accepted as common practice throughout the civilized world. 'The unhindered opportunity to conduct research, to freely discuss issues and to publish ideas, was seen as central to both the further development of science and to the improvement of human life, (Nason 1981:3). As democratization continues to evolve along its natural course, however, towards expanding the concept of equality to an ever-widening range of people and societies – the principle of scientific freedom is also, as it were, subjected to the pressures of democratization.

It is becoming more widely accepted as a characteristic of modern society that the public has a right to know about and to share in the benefits of scientific knowledge. In concrete terms this means increas-

ing public demands for demonstrable returns on taxpayers' investments in education and research (Manning 1983b; Loubser 1983). Museums, for example, must contend with growing public interest in how they collect and what they do with their collections. As museum anthropologist James Nason put it (1981:18), 'our ability to freely collect data, along with the notion that research work was an inviolable activity, has diminished in the face of new legal and social conditions.' Museums must now be more sensitive to national, ethnic, and local interests, and consider more carefully the prospects of 'repatriating' parts of their collections to the ethnic or national communities from which they were taken (Inglis 1979).

Given these circumstances, both the inevitable progress of democratic ideas and the continuing reluctance of scholars to give up their traditional academic privileges, how do we answer those questions with which I began? Are museums necessary? Is ethnology still necessary?

Museums can be justified by their traditional functions of collection, preservation, research, and public education, and by their roles as status symbols, status-conferring institutions, and national monuments. Some museums are trying to do more than this, however. Museums are making significant attempts to increase public access to their collections and their intellectual resources, for example. And museums are also beginning to play more active roles in the regeneration and promotion of cultural traditions, especially for those populations subject to high risk because of rapid social change. I give several examples.

First, the matter of increased public access. Most large museums in recent years claim that they serve an educational mission while following a policy of granting the public access to no more than one to five per cent of their total collections. Items from storage may be rotated with those on display, but only to a minor degree. It is also now customary to present museum objects in a heavily didactic context. Specimens are used as visual aids for educational messages. Public access thus means, in the typical case, access to a rigidly limited selection of objects lodged within a highly structured interpretive framework. Visitors cannot make their own selections nor are they encouraged to develop their own interpretations. What is interesting about this mode is the fact that there is little evidence to suggest that it achieves the purpose intended – the moral and educational uplift of the public. Some museums, therefore, are beginning to question this way of doing things and to explore alternatives.

'Whatever else our museums do well,' British museologist Brian Lewis (1980:151) noted recently, 'they most certainly do not provide

the general visiting public with a good educational experience.' The evidence, in fact, suggests that didactic exhibits are not effective educational instruments. Museum visitors typically stand for no longer than twenty to forty seconds in any one place, avoid reading most labels in an exhibit, and steadily reduce the attention they devote to exhibits and labels the closer they come to exit signs, a phenomenon referred to as the 'exit gradient' (Brown 1978). Whenever the learning outcome of exhibits is measured, the results are erratic and idiosyncratic, 'leaving museum personnel with the conviction that something is being acquired, but at the same time being unable to specify or demonstrate what' (ibid.:6). Exhibits are rarely compared with other instructional media, but there is no reason to think they would be as effective in conveying information as lectures, textbooks, or audio-visual presentations. (One study in Sweden [Arnell et al. 1976:50], comparing an exhibition with a video tape on the same subject and with similar contents, found the tape to be more effective in conveying knowledge and more preferred by the subjects. The subject group which saw the video tape first and the exhibit afterwards had the highest retention of knowledge, and the group that saw only the exhibit had the lowest.)

Since limited-access didactic exhibits are not fulfilling the educational purpose for which they were intended, some museums are considering alternative approaches, including various attempts to 'de-school' approaches by reducing formal and didactic exhibitions and programs and by increasing public access to their collections and information through open storage techniques (Ames 1983b and Chapter 9). These museums see themselves operating more as learning centres and cultural resource banks than as annexes to the school system.

Museums are playing more active roles in the regeneration and promotion of the cultural traditions and social histories of local communities, especially the 'populations at risk' who are undergoing rapid social change. In his review of the conflicts and disturbances that result from rapid change, George Appell (1980:14) noted the importance of planning that includes 'ethnographic research, the development of museums, the creation of archives that contain the oral literature, song, dance, and art of the population at risk, and the study of its social history and oral traditions.' These approaches, Appell continues,

> provide the opportunity whereby the members of the population at risk
> can evaluate their past positively and link up the past meanings of life,
> the past goals and purposes, with the evolving new life, with the evolv-

ing new purposes and goals, so that social change can be accomplished more productively, more creatively . . . It is important that a population have access to its past, to its traditions, to its culture in order to move into the future.

Successful adjustment to rapid change requires that the past be conceived of as a meaningful and an important experience on which to build. There is an obvious role here for museums to play (Appell 1980).

When I say that museums actively engage in cultural programming for populations at risk, I do not mean simply the promotion of traditional handicrafts and customs as they used to be performed, reconstructed with the assistance of the ethnologist. The purpose is not to preserve crafts or tribal customs as living museum curiosities. This is a static view of tribal culture that some museums and ethnologists fostered in the past, perhaps with good intent but to the detriment of the peoples concerned. Although it is the business of museums to preserve artefacts and to recover the past, it is not their business to preserve living peoples in an ethnologically reconstructed image of the past. It is just as natural for artistic and craft traditions, and a people's interpretation of its own social history, to evolve over time as it is for language, kinship, or economic patterns. Museums can play a useful role by encouraging experimentation with these traditions, by recording the changes as they occur, and by helping to develop critical standards by which people can judge their experiments with their own cultural forms. Museums could assist, for example, in the introduction of synthetic fibres, the use of power tools and machines, the application of traditional designs to modern media such as limited-edition serigraphs or acrylic painting, experimentation with design itself, the development of new cultural performances inspired by traditions and comparison with other styles, and the exploration of new markets for fine arts as well as for inexpensive souvenirs.

If museums are necessary because of the continuing acceptance of their traditional functions and because of the newer functions they perform, especially for those communities exposed to risk because of rapid social change, by providing increased public access to their collections and intellectual resources and by actively supporting the continuing evolution of crafts, traditions, and cultural performances, what about ethnology outside of museums? Is that also necessary?

Ethnologists can always think of uses for ethnology, but the challenge is to convince others. When it is said that the public in a democratic society claims a right to know what is being done with its money, that does not mean research should always serve the public

in an immediate and applied sense. It does mean, however, that ethnologists need to communicate more effectively and to larger audiences the significance of what they do if they wish to justify continued public support. 'Most anthropologists just don't know how to communicate or don't choose to communicate to the general public,' science writer Chistopher Hallowell stated (1983:47) in his discussion of the United States television documentary 'Nova: Anthropology on Trial.' We need a more interesting insight into their work.

One way ethnologists can achieve greater public recognition for themselves is to give more recognition to the practical uses of their own discipline. Applied anthropology has a long history, but it is considered by most academics, in North America, at least, to be second class, and consequently is poorly understood and underappreciated (Salisbury 1983:196–7). Perhaps some anthropologists have rejected applied anthropology because of its earlier association with colonialism; it is, nevertheless, one aspect of the discipline that could be readily understood and appreciated by the public.

The opportunities for practical work are immense and are only partly exploited by ethnologists. For example, the most common form is applied anthropology in the traditional sense – 'client-sponsored' research.[1] Studies for colonial administrations, impact assessments for government agencies and private corporations, and historical research for indigenous populations are well-known examples. (Reviews of applied research in Canada are found in Manning 1983a and Weaver 1981.)

Client-sponsored research is also conducted in museums and schools. Anthropologists use ethnographic and survey techniques to assess the performance of particular programs or exhibits and their subtle or hidden messages (Halpin 1978). The late Robert Wolf (1980), who was associated with the Smithsonian Institution in Washington, talks about 'naturalistic-responsive' evaluation techniques, which are essentially ethnographic ones. Similar methods are now widely used in educational research as well (Guba and Lincoln 1983). 'Accountability,' Wolf says (1980:39), 'is sweeping across the museum world today as it has swept over public, social and cultural institutions during the last decade.' Evaluation research has thus become a rapidly growing field and one in which ethnologists are only beginning to make their presence felt.

There are two other kinds of practical anthropology less frequently practised, but possibly more important in the long run both to the profession and to society. The first is the anthropological study of anthropology itself, a reflexive mode. The principle is simple: we study ourselves as we customarily view others, we treat ourselves as if we

were the natives. We are our own clients. Examples include studies of recruitment into the profession, how we organize our work, and how we construct our theories (Scholte 1969; Ames 1979, 1981b). The continuing debate in India over what constitutes a proper 'Sociology of India' is another good example, and one that ethnologists in other countries would do well to emulate.

Another form of reflexive anthropology is the use of anthropological knowledge and technique in administration, a form of 'working anthropology.' Ethnologists who become administrators usually discover very quickly how their anthropological perspective is useful in eliciting the point of view of the other, in uncovering hidden meanings and background assumptions, in identifying cultural and ethnic nuances, in recognizing symbols of power and authority, in assessing realistic alternatives, and in generating respect for differences of opinion. Anthropologically derived insights directly assist in making practical decisions and in weighing the costs and benefits (functions and dysfunctions) of those decisions.

The second alternative application of ethnology is to use it as a form of social criticism. I have in mind here ethnologists in the role of intellectuals who critically interpret their 'society and its culture to their own countrymen and world' (Green 1977:39), what Laura Nader (1969:293) once referred to as 'writing ethnography for the "natives,"' so they have the information they need to improve their lives. 'By helping members of a community to comprehend social reality more explicity and generally,' Dell Hymes wrote (1969:54) in his introduction to *Reinventing Anthropology*, 'one may help people to employ what C. Wright Mills called "sociological imagination" . . . and to be in greater control of their own destinies.'

Ethnologists could certainly contribute to an understanding of how power and responsibility are exercised in modern societies. Indeed, there is a certain urgency to the kind of anthropology that is concerned with power, Laura Nader observes (Nader 1969:284):

> the quality of life and our lives themselves may depend upon the extent to which citizens understand those who shape attitudes and actually control institutional structures. The study of man is confronted with an unprecedented situation: never before have so few, by their actions and inactions, had the power of life and death over so many members of the species.

Social critics, sociologist Ralf Dahrendorf (1970:55) once said, are the 'court jesters' of modern society, whose role is 'to doubt everything that is obvious, to make relative all authority, to ask all those ques-

tions that no one else dares to ask.' The task of intellectuals as critics is to voice the uncomfortable as well as the comfortable truths about society, and thus to create opportunities for understanding and change.

In 1971, William Burns, then director of the San Diego Natural History Museum, advocated a critical role for museum curators, saying that they should act like canaries (Burns 1971:217). The canary was used by underground miners to warn them of noxious fumes before they are overcome. The curator-as-canary serves as an early warning signal for society, informing the public through the arts about dangers that lie ahead.

The curator-as-canary is the 'Curator-with-a-Social-Conscience' (Burns 1971:219) and is, in practice, as rare a bird as the ethnologist in the role of intellectual court jester. Questioning accepted values and institutions is not a comfortable or popular undertaking, and is frequently subjected to public criticism and ridicule (Dahrendorf 1970). Museums are predisposed more towards a positive view of history than a critical one, in any case. The dinosaurs, aborigines, and pioneers depicted in exhibits are all typically presented as noble creatures who in the distant past struggled heroically but (except for the pioneer European settlers of the New World) ultimately unsuccessfully against the brute forces of nature. Rarely will a museum exhibit imply a criticism of the past or the present, though admittedly it is fashionable in North American museums to present a muted criticism of European pioneers for destroying the traditional cultures of Native peoples in North America. But North American museums would never dare to subject Native peoples themselves, or the contemporary establishment, to objective scrutiny or critical assessment. Native people are sacred to museum ethnologists and are consequently removed from virtually all critical comment. Given the tenuous financial basis of museums it is understandable why they also would shy away from being too critical of mainstream society.

University departments of anthropology, at least in North America, where academic freedom is more protected than in museums, are not much more productive as locations for the critical spirit. Native peoples, especially those living close enough to be reported in the local press or to visit one's office, are equally sacred to academic ethnologists, who want to avoid the embarrassment of being criticized by the people who traditionally served as their subject matter. Academic ethnologists also have not contributed much to the public discussion of social and cultural policies or to the critical assessment of major social institutions, though there are a few notable exceptions (for example, Nader 1980a, 1980b, 1983).

The applied anthropology that has flourished the most is the client-sponsored form. The reflexive and critical versions remain underdeveloped, and they may be the perspectives the most needed. We need more court jesters and canaries.

Over fifty years ago Malinowski (1929) called for a more concentrated effort to bridge the gap between theoretical anthropology and its practical applications, for there existed, he said, an 'anthropological no man's land' between the two. Practical people need the knowledge anthropologists can provide, but academic anthropology is dominated by 'sensational or antiquarian interests.' The anthropologist, said Malinowski, 'still tries to close his eyes to the surrounding reality and reconstructs laboriously a savage who does not exist any more – who, in Melanesia ceased to exist a generation ago, in Africa some two generations ago, and in North America perhaps one hundred years or more' (ibid.:37).

That bridge between theory and practice, between academic interests and socially responsive performance, still needs to be constructed if anthropologists hope to convince others of their value and their necessity. Ethnologists working in museums and in universities have a common interest here and could usefully pool their talents in the search for solutions.

Museums continue to be necessary because their social utility continues to be recognized – their traditional functions of collection, preservation, research, education, and status enhancement, and their more recent efforts to serve populations at risk. But what about the profession of anthropology? Is that also necessary? Looking at the condition of the world around us, we can only say 'yes' because of the need for the special kind of knowledge anthropologists can provide. But we need to make this knowledge more accessible if we are to make our utility more visible.

World's Fairs and the Constitution of Society: The Ideology of Expo '86

How do intellectual, artistic, and material productions enter into a society's construction of an image of itself, the development of what Shils (1972) refers to as a 'collective self-consciousness'?

I selected world's fairs as an opportunity to explore this question for four reasons: (1) Expo '86 landed in Vancouver, so I decided to take advantage of it; (2) the study of the public culture of our own society is relatively new for anthropologists; (3) popular events and institutions, such as fairs, shopping malls, and fast-food chains – the 'museums of popular culture' – perform important ideological work, as I attempt to show here and in Chapter 12; and (4) an analysis of Expo '86, which has now been relegated to memory, may suggest ways to interpret future expositions, including the controversial 1992 celebrations in North America and at the world's fair in Spain in honour of Christopher Columbus's voyage to the New World 500 years ago. 'For Native people it is time for 500 years of suffering to come to an end' (Harjo 1991:32).

The first question to be asked is, How might one think anthropologically about world's fairs? What kind of anthropological attitude might one take towards Expo '86? I began with the growing literature on the critical analysis of cultural institutions such as museums and galleries – those 'managers of consciousness,' as Hans Haacke (1986) calls them – which has been examining their ideological or imagemaking roles in society and how they 'work in the vineyards of consciousness,' moulding and channelling it (ibid.:67). Through their cultural work in exhibitions and programs these institutions order history, nature, and societies, thereby helping to structure the way people think about such matters. Ideas of power and place, time and nature, art and fact are formulated and entered into social constructions of reality. In the process certain ideas are objectified and made

to appear common sensical while others become mystified or suppressed.

As this literature is extensive and growing, there is no need to summarize it here. For recent statements the reader may consult George W. Stocking's (1985) *Objects and Others: Essays on Museums and Material Culture* and Gould and Schiffer's (1981) *Modern Material Culture: The Archaeology of Us.* For my own thinking I have drawn upon Milton Singer's discussions of cultural performances and semiotics (1959, 1977, 1984); writings on museums, public culture, and tourism by writers such as Graburn 1976, Harris 1978 and 1981b, Hall 1981, MacCannell 1976, Winner 1980, Carol Duncan 1983 and 1985; Duncan and Wallach 1978 and 1980, and Donald Horne's 1986 *The Public Culture* (which I discovered only after most of this chapter was written). Useful parallels may also be found in examining advertising (Williamson 1978), organized sports (Hargreaves 1985), consumer behaviour (McCracken 1986, 1988) from 'structuralist' and 'semiotic' perspectives, and Jameson's Marxist analysis of the cultural logic of late capitalism (1990, 1991). The transition from looking at museums and galleries as 'ideologically active environments' (Duncan and Wallach 1978) to examining the ideological content of world's fairs is made by Burton Benedict in his (1983) *The Anthropology of World's Fairs,* and by Robert Rydell in his (1984) *All the World's a Fair,* among others.

The thesis proposed is that cultural work gets done not only in the established heritage institutions but also in the more popular 'museums' of everyday life, such as marketplaces, shopping malls, and especially world's fairs, those 'illustrated encyclopedia of civilization' as Rydell (1984:45) calls them. Through the repetitive display and promotion of material objects and the social relations in which they are manifested, ideas from the centre of society come to be seen as ordinary and common sensical, thus to be taken for granted as part of the natural world. Markets, malls, and fairs reproduce at the general or popular level what heritage institutions attempt for more élite audiences. Symbols, languages, and styles of presentation may differ, but the messages are frequently the same. As Rydell (1984:2) says about fairs, they all function as 'ideologically coherent "symbolic universes"' that confirm, extend, and reconstitute the authority and values of the centre of society. In the act of confirming they create and recreate; that is their cultural work.

Forms of popular culture thus engage in important ideological work. Exhibiting ourselves to others and others to ourselves also structures or conditions the way we see the world around us. This is not a novel idea, of course. The task in this chapter is to apply this notion to analyzing specific examples, such as Expo '86, Expo '85 (held

in Tsukuba, Japan), and the Commonwealth Institute in London, England, where nations also exhibit themselves. I demonstrate how certain ideals and social relations embodied in specific exhibitions may connect to broader economic and political issues. These are only casual illustrations of a developing attitude or 'theory' about the ideological role of world's fairs and other public ceremonies. The examples do not 'prove' any argument, which is far too difficult to achieve at this point. Instead, they serve as discussion points or indicators of how the situation might be, or as hypotheses about the kind of facts to be collected. 'All those behind-the-scenes processes and deals' (Anderson and Wachtel 1986:3) that led to Expo '86's creation will not be considered nor will the questions of what people were primarily responsible for its messages or projected ideologies or how those messages were received by visitors. These are certainly important, but go beyond the intent of this chapter.

My primary concern here is to consider how Canada and several other nations exhibit themselves and thereby constitute themselves as socio-political entities. When it comes to exhibitions, nations today share a need to define themselves, both to their own people and to others, as socially progressive, morally virtuous, and technologically sophisticated states. This pattern runs throughout world's fairs. Each nation presents its history, culture, and technology in a positive, progressive light. Each pays homage to the importance of science and economic development as the foundations of the good life, especially at world's fairs with technological themes, such as Expo '86's 'Transportation and Communication.' Yet there are also differences among nations, and certainly between Canada and Third World countries, which form my examples. They all construct images of themselves that reflect their separate values as well as their common interests as modern nation states. Though they all may wish to appear sophisticated, virtuous, and progressive, what they imagine it takes to embody those qualities varies from one country to another. To borrow a concept from literary historian Philip Fisher (1985:9), every society has its own special 'privileged settings' or 'symbolic landscapes,' which provide 'vanishing points toward which lines of sight and projects of every kind converge.' Whoever may be in charge of producing world's fairs – politicians, designers, or academics – their work likely reflects the dominant ideological convictions of their societies.

This chapter illustrates only a few of these ideological vanishing points: (1) how nations are classified through the ways they are presented; (2) how they deal with their pasts; and (3) how they come to terms with nature. It concludes with a discussion of two principal icons of Expo '86 which manifest a populist Canadian ideology and

illustrate through that manifestation the important 'cultural work' (Fisher 1985) that popular culture gets done.

CLASSIFICATION OF PEOPLES AND CULTURES AND THE WORTH OF NATIONS

Benedict (1983:52) has pointed out how the display of people is a display of power, 'a symbolic performance demonstrating power relationships.' What and who are and are not displayed at a world's fair, where and how, to whom and by whom are all statements about the relative worth and power of different ideas, traditions, and cultures. World's fairs may be political instruments of sponsoring governments and corporations which they use to express their ideas about how the world is and should be. Participants compete for recognition and favour. Nations, peoples, and ways of life are ranked according to the size, splendour, and location of their exhibits. Such fairs may be seen as grand ceremonies for presenting and portraying the values, images, and ideas of the ruling powers (Benedict 1983, 1986, 1985; Margaret Holm 1986; Rydell 1984).

The worth of nations is gauged by the size and splendour of their pavilions. How much money can they afford to spend on themselves? Eight South Pacific nations were allocated $120,000 by the Canadian government and Expo '86 to design and install exhibits at Expo '86 describing their nations. World's fairs customarily finance the participation of selected 'developing nations' who otherwise could not afford to attend. How were they to present their countries? In fact, for budgetary reasons these nations had little to say about the matter. Expo '86 hired a Vancouver architectural firm to design a pavilion and the University of British Columbia Museum of Anthropology to collect and install exhibits. Expo '86 granted at least a dozen of the smaller nations invited (most likely those receiving Canadian foreign aid) a unit pavilion (which rented to wealthier nations for $250,000) plus $60,000 to $100,000 for exhibit design and installation. In contrast, General Motors spent some $10 to $11 million on its pavilion. What does this say about the relative worth of developing nations and large multinationals? The subject nature of small countries – 'We are glad to be here, thanks to Expo and the Canadian government,' said the representative of a small South Pacific state at his country's national day celebration – contrasts sharply with the independent power of multinationals such as General Motors, free to install their own exhibition and to promote their own messages.

The federal government's Canada Pavilion was the most expensive at Expo (and it was not even on the main site but a ten minute ride

across town) with a budget of some $78 million, including $40 million for exhibits, $5.7 million for on-site entertainment, $5 million for marketing and public relations, $1.7 million for janitorial services during Expo, and $14 million to dismantle the exhibits at the end of the fair six months later (Hamilton 1985c). Its principal competitor in size and for prestige was the provincial British Columbia Pavilion, comprising three buildings and costing some $65 million, including $28 million for temporary exhibits (Hamilton 1985d). Both government pavilions were intended to be permanent, whereas most of the others were torn down after the fair. The third largest pavilion on site was the government of Ontario's, estimated to cost $25 million (Kettner 1986b). Some other figures: Telecom Canada Pavilion, $14.5 million; IBM, $13.5 million, and Canadian Pacific, $11 million (Anderson and Wachtel 1986:16-17; Hamilton 1985d).

What will a nation show of itself when it can afford the very best (e.g., Canada, British Columbia, Ontario, the USSR, the United States, and China)? What will large multinationals show of themselves (e.g., General Motors, Canadian Pacific, Air Canada)? In both instances their exhibits were modern, slick, high tech, and obviously expensive. The messages these pavilions conveyed appeared uniform: 'Look how scientifically advanced we are, with our sophisticated machinery and electronic presentations!' 'Look how glamourous, powerful, and beneficial all this technology is!' Works of art were occasionally displayed amidst the technology, as if to say, 'look, we have *culture,* too.' The Canada Pavilion, for example, actively integrated art and culture with technology so as to deny 'the classical separation between art and industry' (Nathalie Macfarlane, personal communication, May 1986). At both the Canada and British Columbia pavilions art displays and performances were typically fun, funky, ethnic, or folksy. According to Peter Day, a Toronto art consultant hired by the Canada Pavilion to help commission art works for display, the focus was to be on 'popular icons' inspired by folk art (Godfrey 1986): 'We found there are a lot of young people . . . and a lot of repeat visitors. People "do" pavilions, they dash through them like they were running a race, so you have to involve all the senses and give a sense of color. We tried to create something fun, a carnival feeling that would make creativity look like an enjoyable process.' Referring to the folk art commissioned for the British Columbia Pavilion (rated in newspaper surveys as one of the most popular at the fair), its president David Podmore remarked (ibid.) that 'people don't come to an Expo to look at contemporary works of art. They want to be entertained and they are not particular about how you do it.'

The more traditional forms of Canadian 'high art,' such as paint-

ings, were displayed either off-site (mostly at the Vancouver Art Gallery, though, in fact, it featured imported European art more than Canadian works, and at the University of British Columbia Museum of Anthropology) or in the VIP lounges at the British Columbia and Canada pavilions where it could be seen only by dignitaries during their cocktail parties. The primary mandate of these pavilions was not to display art, but to convey their ideological messages to the public in 'an entertaining manner.'

What will a nation show about itself when it cannot afford to show very much and when most of its modern technology is imported? What do Pakistan, Sri Lanka, Senegal, Ivory Coast, Costa Rica, Brunei Darussalam, the Eastern Caribbean states, Kenya, and Barbados show? (The Sri Lanka '86 pavilion displayed a photograph of honorary citizen and resident, the scientist Arthur C. Clarke, wearing a halo of satellites). What does the world's smallest nation, the Pacific island of Nauru, with a population of 7,000, squeezed into the South Pacific Pavilion along with seven other island nations show? The smaller nations each worked with a display budget of thousands rather than millions of dollars. (Nauru's share of the design budget, assuming it was divided equally among the eight nations, was $15,000.) In developing nations virtually all their modern technology is imported and their indigenous modes of transportation and communication (Expo's theme) are non-technological. The smaller countries tended to highlight history, nature, art, and culture. Pakistan began with photographs of 5,000-year-old Mohenjodaro and the establishment of Islam. 'Pakistan Pavilion Zooms Through the Ages,' read the headline in a local news-sheet (Dharamsi 1986). The Eastern Caribbean Pavilion contained seven kiosks, one for each member island. 'We want to show the color and beauty of our islands,' High Commissioner Asyll Warner told reporters (Farrow 1985), in a kiosk which also featured a snack bar that sold tropical fruit punches and peanuts and which had a performing steel band. 'Peru's pavilion will be small but its contents will be precious,' its commissioner general reported (ibid.), adding what could be the slogan for all of the less developed national participants: 'We may not have technology but we have a lot of history.' Peru displayed over three hundred gold and other treasures from the privately owned Museo de Oro del Peru.

The importance given to modern technology separated the larger from the smaller nations at Expo '86. Those nations with their own technology could easily demonstrate their modernity, presenting the triumph of the nation and its people as the triumph of its technology. History, culture, and the arts were, by implication and in their presence, relegated to second place. They were/are what a nation shows

as a complement of science and industry, as products of modern society, or as substitutes for the lack of modern technology. If a world's fair is a microcosm of the world, 'an illustrated encyclopedia,' then the hierarchy of values presented here, reinforced by the glitter and gloss of the fair, became a model for the world beyond. The supremacy of science and technology was affirmed; culture was defined as fun, history as whimsy, and Third World societies as exotic, underdeveloped, dependent upon Western science, and essentially powerless (if not worthless).

World's fairs are also arenas for competition among nations (Benedict 1985). 'The superpowers are fighting it out at Expo '86,' announced a newspaper reporter (Kettner 1985). 'Ours is the biggest, but we are not having a competition,' she quoted a Soviet representative talking about his government's pavilion. 'The spirit is not competitive,' said the director of the United States of America Pavilion. He then pointed out that the u.s. presence was actually larger than the Soviet one if the Washington, Oregon, and California state pavilions were counted along with the national one (ibid.). 'The space race between the global superpowers has been renewed on the British Columbia shore at the 1986 world's fair,' reported Toronto *Globe and Mail* correspondent John Cruickshank (1986a): the Chinese were mounting a space rocket and communications satellite; the Americans, hanging Mercury rocket capsules; and the Soviets, suspending a 35-tonne space complex from its pavilion.

ATTITUDES TOWARDS THE PAST

How a society deals with its past says much about what it tries to be in its present form (Lowenthal 1985). In reconstructing our past we reconstitute ourselves according to current values and beliefs. How then do different nations portray their histories at a world's fair and thereby reveal their present dispositions or 'vanishing points'?

The Japanese appear relatively comfortable combining the wisdom of their past with their more recent technological achievements while also readily acknowledging foreign influence. 'Numerous encounters with foreign cultures and the strength of tradition brought Japan to technological maturity,' the Japanese government stated in the brochure handed out at its Tsukuba Expo '85 History Pavilion. A label in Japan's Expo '86 pavilion announced: 'Particularly in the last one hundred years, Japan has fused the latest technology learned from Western nations with that of its own tradition.' In the orientation film, *Pulse of Change*, that greeted visitors, 'our ancestors' are credited with laying the foundations of what was presented as an obviously

technologically sophisticated nation. 'Transportation developed because our ancestors had courage and intelligence, and civilization flourished,' the film's narrator stated. Later the narrator says: 'Westerners opened the eyes of the Japanese people to the outside world. Through our ancestors' hard work, transportation has been important in our lives.'

In Japan itself the visitor is constantly confronted with the past and the present in juxtaposition. 'Japan isn't all temples,' one tourist brochure announced. 'When you've seen the past, come and enjoy the future at NEC's unique computer and communications showroom.' Another pamphlet described the equation from the other side. 'Visitors will better appreciate the ultra-modern Tsukuba Expo '85, if they relate it to Japan's ancient cultural background, to which nearby Nikka has made historical contributions.'

The point both these brochures made, reinforced by the Japanese government pavilions at Expo '85 and '86, is that the past is still a vital force. In the Japanese self-image history complements modernity. Not only was it the strength of tradition – the 'courage and intelligence of our ancestors' – that made modernity possible, but the past is still there to be experienced, appreciated, and respected along with modern technology.

Compare this with the treatment of history by the Canada Pavilion at Expo '86. In a design brief prepared for the exhibitions (Canada Pavilion 1985), designers were advised to emphasize the individual's confrontation with nature and technology. History was to be presented in 'a witty and humorous' manner, celebrating heroes and heroines who 'used their creativity to create unique solutions to domestic problems' and whose achievements in transportation and communication 'symbolize great moments in Canadian history.' One label in the Great Hall read: 'Wind Tunnels Help Us to Get More Lift. Ever since Wallace Rupert Turnbull built the first wind tunnel in Canada in 1902, Canadian scientists have stood at the forefront in aerodynamic research.' Bush pilots were exemplars of heroic Canadian adventurers. The introductory label to this section of the Great Hall read: 'Bush pilots open up the north. Their exploits are remarkable stories of human achievement and perseverance in the face of great odds.' The adventures of individual pilots were then described.

Canadian history was presented as a set of discrete problems or tasks to be transcended or overcome by creative individuals, their episodes described in a whimsical or romantic manner. History was seen as a celebration of pioneer individualism, of great individuals who heroically overcame the inanimate and frequently hostile obstacles of time, distance, and nature. The contributions of institutions,

collectivities, or social, political, and religious policies were scarcely noted. History is governed by the genius of individuals who are typically men. (In a survey of 12 North American and European pavilions, plus China, at Expo '86, University of BC Museum of Anthropology researcher Diane L. Bennett counted 889 images of men and women, of which only 21 per cent were of women. Most women depicted the traditional female roles of nurses, stewardesses, keyboard operators, and so on [Bennett 1986]. There were no images of women as scientists in these pavilions, though both the United States and Canada pavilions showed women as astronauts.) When interpreting the messages of a fair – or of any other event or institution for that matter – it is important to note what is excluded or not mentioned as well as what is included. Silences also speak.

Canadian history was not presented with any depth at Expo '86. Though passing reference was made to the age of the continent and deference given to the Indians and Inuit – typically referred to as 'our native peoples' – for being here when the Europeans came, the focus was on recent times.

The Ontario Pavilion, for example, promised to 'take you through 5,000 years in a matter of minutes.' Our way of dealing with history is to compress it into minutes. 'Get ready,' the brochure advised, 'to walk past entire centuries to the first encounter of the European settlers with our native peoples.' Setting it straight regarding when real history began, the brochure added that 'each [exhibit area] offers a unique view of our nine million people who, *since the first settlement more than 200 years ago*, have journeyed to Ontario from more than 100 nations.' (emphasis added). Before the Europeans, the Indians and Inuit evidently did not have settlements. Their histories have been excluded, silenced, or 'whited out' (see M. Wallace 1985:47).

The same attitude towards Canada's Aboriginal peoples recurred in several other Canadian pavilions at Expo '86. In the first gallery of the Alberta Pavilion a painted Sarcee skin tipi liner (modern replica) and a one-minute film re-enacting a traditional Plains Indian buffalo hunt were presented. Thus represented as 'first peoples,' they then dropped from sight. Contemporary Indians, as Indians, presumably do not exist, except as occasional performers along with other 'folk artists' at the pavilion's outdoor stage. In the BC Place newsletter *Update* (Spring 1984), False Creek, the site of Expo '86, 'languished in obscurity before its discovery by European explorers ... ' Or, as an Evergreen Press ad in a 1984 souvenir brochure for the BC Place Stadium stated: 'Once it [False Creek] was a silent wilderness of towering trees and gentle waters. Then came the settlers who discovered the fertile flatlands, fished the rivers and made this new land their

home.' Toronto *Globe and Mail* reporter John Cruickshank (1986b), commenting on Vancouver's centennial (also celebrated in 1986), observed how 'this city [was] wrested so recently from the wilderness.' The fact that Salish Indians inhabited the area for thousands of years is conveniently ignored. 'All the Centennial does,' Chief Ernest Campbell of the Musqueam Salish remarked to Cruickshank (ibid.), 'is remind me that they've been sitting on our territory for 100 years without compensation.'

Before the pioneers, then, there was no history except wilderness and a few Indians. Since it was wilderness, the Indians, by definition, were not really using the land effectively or extensively so they did not make history (and therefore, it has been argued, they have no justification for land claims either). History properly begins with European settlements. We do not even recognize the history Europeans brought with them, except perhaps as 'folk arts' or 'multiculturalism,' the categories for everything Canadian that is not of French, English, or Aboriginal origin but still has some political clout. Canadians find it difficult to assimilate either Aboriginal or European histories into a composite picture of Canada. Canada begins as pioneer land without a past; it sees its future as its history. There were exceptions, of course, as there are to all others cited in this chapter. Both the Northwest Territories and Yukon pavilions at Expo '86 made more determined efforts to include Native peoples and their histories as integral parts of their territorial histories. 'Thirty thousand years ago Indians laid the foundations for transportation,' states the narrator of the Yukon's slide show. 'The white men came to discover our land but to the Inuit it was us that discovered them,' a Spence Bay Inuk was quoted as saying in the NWT pavilion. General Motors's *Spirit Lodge* show, one of the hits of Expo '86, was also an exception in that the designers collaborated with a First Nations organization (Rogers et al. 1986). And the Canada Pavilion acknowledged the contributions to modern society of 'the traditions of our country's original peoples ... ' It also made a determined effort to avoid an evolutionary or chronological presentation of history (Nathalie Macfarlane personal communication, May 1986):

> History, art and technology are presented cheek to jowl, intentionally avoiding any notions of progress and development over time. Thus, the Haida canoe is as present as the futuristic Hystar. Historical artifacts are found throughout the sequence of high tech exhibits behind the sloping mirrors. The objective is to provide viewers with Canadian historical antecedents to whatever the most contemporary technology might be.

Asian nations, by contrast, spoke of continuous histories stretching back for thousands of years and incorporating equally indigenous peoples and the long series of immigrant groups. They all become part of one historical amalgam, their achievements the common inheritance of those living today.

Some of these differences between Canadian and Asian attitudes towards the past were reflected in the 1985–6 exhibitions by Canada and India at the Commonwealth Institute in London. Compare the opening statements for the two exhibitions:

Canada's Exhibit at the Commonwealth Institute

(1) First Panel:

The Beginning

The Indian and the Inuit were Canada's first peoples ... Evidence that they first came 75,000 to 80,000 years ago across the Bering Straits.

Today there are 575 registered Indian bands, 300,000 people. 1.5 million Métis; 23,000 Inuit.

(2) Second Panel:

The People

Today, 45% of Canadians are of British origin, 28% are French origin, 1% are native, and 26% other.

India's Exhibit at the Commonwealth Institute

(1) First Panel:

A Whole World in Herself

'India ... A society of the same magnitude as our Western Civilization ... a whole world in herself.'

– A. Toynbee

India is a land of continuity and change.
As ancient as her 5,000 years of culture and civilization.
As young as the children who make up half her population.
A traditional country, deeply rooted in the past.
India is also a modern nation, among the major industrial countries in the world.

India is a rich country. Rich in traditions and skills, resources and manpower. But burdened with problems of poverty inherited from the past.

India is striving today to bring the benefits of science and technology to her 600 million people.

India is the world's largest democracy. A free and secular society with room and respect for many faiths, ideas, and ideologies.

Timeless India, yet always changing.
Building the future on 5,000 years of history.

(2) Second Panel:

A Pageant of Peoples

India lives in many centuries. There is room for the bullock cart and the supersonic jet, ancient Vedic learning and space-age technology, the sari and the jeans, traditional crafts and sophisticated machinery. The old and the new, the traditional and the modern, exist side by side in a state of gentle flux.

Canada's first panel began with the standard reference to 'first peoples,' but by the second panel they dwindled to statistical insignificance – only one per cent of the total population. The remainder of the exhibition dealt with contemporary issues, such as government, industry, resources, climate, technology, arts and culture, sports and recreation, education, and the 'average Canadian family' (Dad works as an engineer and Mom as a dental assistant, while son and daughter attend school). The 'First Peoples,' after their initial brief appearance, have once again 'disappeared' from the story. The 75,000 to 80,000 years of Native history, though noted, is not discussed nor are any lessons drawn from it. India, by contrast, is 'rich in traditions' and 'burdened with problems . . . inherited from the past,' and the country draws strength from this complex history: 'India lives in many centuries . . . The old and the new, the traditional and the modern, exist side by side in a state of gentle flux.' Indians are 'building the future on 5,000 years of history,' whereas Canadians, presumably, have transcended their past and made it irrelevant.

Non-Western nations seem more willing to recognize their past and to connect it with the present and future. As noted earlier, Japan paid its respects to the 'courage and intelligence of the ancestors.' Pakistan's Expo '86 pavilion, like India at the Commonwealth Institute, began with a reference to the 5,000-year-old Mohenjodaro civilization and a thousand years of Islam to show how history and religion have provided the foundation for a modern state. In Kenya's Expo '86 Pavilion the first label read: 'Kenya, a modern nation, still values the multitude of traditional ways of life and the vast areas of unspoiled scenery it possesses.' Another stated: 'Here the past is alive

and becomes part of the present. Rich traditions combine with contemporary technology including transportation and communication to make the fascinating country which is Kenya.'

Saudi Arabia's pavilion at Expo '86 described the historical rootedness of Arabian society and how the Islamic religion was a major force in its evolution. The first objects displayed were replicas of statuary taken from an excavation of a 1300 BC urban settlement and a reproduction of an eighth-century AD signpost from an early Islamic pilgrimage road to Madinah (Medina) and Makkah (Mecca). 'Many modern Saudi cities,' a nearby label stated, 'owe their origins to commercial activity that took place in ancient times on the Arabian Peninsula ... In some areas one can still trace the tracks trade caravans used over 2000 years ago.' The impact of Islam was then noted: 'The coming of Islam in the seventh century revived Arabia religiously and made it possible for great economic, commercial, social, and intellectual advances.' And further: 'The new religion lead to the transformation of civilizations throughout the known world.' The next gallery displayed examples of these transformations, including the development of highway and telecommunications networks, industrial cities, energy industries, civil aviation, mass transit, space exploration, agriculture, and water resources. These led the visitor to a third gallery devoted to Islam, where the historical origins of Islam were again acknowledged:

> The origins of Islam are firmly rooted in the country now called Saudi Arabia. It was in the region of Makkah that the Prophet Mohammed (praise be upon him) was born around 570 AD. He grew up in the traditions of that era, experiencing both the city life and the pastoral ways of the herdsman and Bedouin. As a merchant, he travelled widely in the region, learning about the traditions, cultures, and beliefs of the societies he encountered.

This gallery concluded with a discussion of 'Islam in the World Today,' pointing to its rapid growth ('The fastest-growing religion today and second largest in the world'), its compatibility with Christianity and Judaism, how it provides a 'complete life system' for the Muslim, and continues to be a principal source for human creativity, welfare, and peace. The Saudi Arabia Pavilion was one of the largest foreign nationals at Expo '86. Other non-Western nations expressed abbreviated versions of comparable sentiments. In the final gallery of the Expo '86 Indonesia Pavilion, for example, a figure of the ancient Hindu monkey god Hanuman was shown flying through space holding an Indonesian satellite in his outstretched arms. The label states:

In Hindu mythology Hanuman, or the Monkey God, could snare the moon with his tail while staying firmly on the ground. Able to cover vast distances in a single leap, Hanuman symbolizes the ties between yesterday, today and tomorrow. Here he is holding *Palapa*, the Indonesian satellite that also connects yesterday with tomorrow in modern-day Indonesia.

ATTITUDES TOWARDS NATURE

Nature played different roles in Canadian and Asian pavilions. Though all nations must come to terms with their environments and try to maximize the benefits from natural resources, and all industrializing states aggressively exploit natural resources, they nevertheless express different attitudes towards nature. For Canadians, nature may be not only beautiful and bountiful and a resource bank to be exploited but also threatening, hostile, rugged, and to be mastered or dominated. In the Great Hall of the Expo '86 Canada Pavilion, for example, the following introduction to exhibits of 'micro environments' appeared:

> *Survival.* Canada's multiple environments, its extreme northern climate, and varied terrains test the endurance of the human body.
> Equipped with technology's skins, eyes, ears, hands, and feet, we go where we have never been before.

Asian pavilions, in contrast, view nature more like an equal partner or force to be cultivated and respected even while exploited. Consider the following remarkably succinct statement in Japanese and English at the entrance to Japan's History Pavilion at Expo '85 in Tsukuba:

> From the mountain came rivers
> From the rivers, rice
> To harvest rice, tools forged from iron
> And our culture sprang from this environment.

The independence of nature was not lost sight of even in the technologically sophisticated atmosphere of Expo '85. The Mitsui Water Theatre illustrated its theme, 'Man and Science, Man and Nature – a Wonderful Relationship' ('man, machine, and nature must work together in harmony'), in a film in which a youth representing humanity and a robot representing science rescue from a raging river a baby skunk, which of course symbolizes nature (Japan 1985:62-3). After

they return the skunk to its family, it raises its tail and sprays them. Placed at the centre of the technologically sophisticated exhibition on transportation in Japan's Expo '86 pavilion was a small room through which people passed, the walls lined with life-sized murals of cherry trees in blossom coupled with the sounds of birds singing. The Canada Pavilion at Expo '85 featured three audio-visual films with the same message: Canada is a land of beautiful, smiling people and of bountiful, exploitable, and marketable supernatural resources. After the third film ended, attendants distributed fir seedlings from British Columbia to the audience.

The same theme was repeated at both the Canada and British Columbia pavilions at Expo '86: Canada is a supernatural wilderness that has only gradually been tamed, controlled, and exploited. Nature is to be mastered and processed as a commodity or to be used as a recreational 'supernature.' At Expo '86 a small forest with a running stream was constructed at the entrance to the BC Discovery exhibit area, a more elegant tribute to nature than Japan's photo murals. However, either exit of this area led to arenas where brawny men demonstrated logging, 'logging sports,' and 'boom boat ballet' (boom boats are used to herd logs into log booms). The introductory label to one exhibit (Discovery Tree 1) in this area stated: 'The Origin of Innovation and Invention in British Columbia: The evolution of the province's transportation and communication systems as a creative response to a *rugged* natural environment is explored' (emphasis added). The same attitude was projected onto the future (Discovery Tree 3): 'The innovative spirit of British Columbia, while developing a modern and sophisticated economy in a rugged environment, is now being applied in such areas as satellite sensing, science, and medicine.'

Exhibit guidelines prepared for Expo '86's Canada Pavilion (1985) expressed a similar attitude towards mastering a potentially hostile nature: 'From icebreakers to snowmobiles, fast trains to urban buses, invisible communications networks to fibre-optic cables, the Canadian landscape is characterized and identified by the unique patterns that humans have *imposed* upon the natural patterns of the landscape.' And further: 'Man's increasing ability to work *in hostile environments* has led to the development of sophisticated remote manipulating devices, which are the latest generation of robotic technology' (emphasis added). Compare these notions of mastery or domination over rugged and hostile natural forces to the nurturing attitude suggested by a label in the 1986 Indonesia Pavilion: 'Transportation and communication systems evolved based on need and the surrounding environment. The Indonesian tropics *have given birth* to unique forms

of transportation and communication methods. Bamboo bridges, for instance, and horse back riding' (emphasis added).

KEY SYMBOLS OR ICONS OF EXPO '86

The great world's fairs of the past are remembered for unusual architectural features, exhibits, or technical innovations (Wachtel 1986:29–31; also Alaton 1984; Fulford 1984; D. Wilson 1985). The 1851 London fair introduced the Crystal Palace, McCormick's reaper, Colt's revolver, vulcanized rubber boots, Antoine Sax's 'serpentine brass instrument,' false teeth, and chewing tobacco; the 1854 New York fair introduced Otis's elevator; Alexander Graham Bell's telephone and a dishwashing machine appeared at the 1876 Philadelphia exposition; the Eiffel Tower was built for Paris's 1889 world's fair to celebrate the centennial of the French Revolution; the demonstration of the electric light bulb and alternating current along with George W. Ferris's Ferris Wheel appeared at the 1893 Chicago fair; wireless telegraph, ice cream cones, hot-dogs, and iced tea were all introduced at the 1904 fair in St. Louis; Picasso's *Guernica* was intended as a mural for the Spanish Pavilion at the 1937 Paris exposition; television, home air-conditioning, nylons, and a prototype of a rocket for the stars appeared in New York, 1939; a nuclear reactor and atomic clock were introduced at the Brussels 1958 fair; the world's first monorail transit system, a space tower, and family play rooms that could be converted into atomic fallout shelters appeared at the 1962 Seattle fair; new film techniques and the Habitat housing complex were built for Expo '67 in Montreal; the 40-metre wide and 25-metre high Sony Trinitron TV screen and robotic demonstrations were featured at Tsukuba 1985.

What will be remembered about Expo '86? There were notable structures, such as the geodesic dome of the Expo Centre, the glass-walled and roofed BC Discovery exhibit area, the Saskatchewan Pavilion symbolic of the prairie grain elevator; the 61-metre hockey stick leaning against a 71-metre flagpole, installed to mark the way to the Canada Pavilion which was on a different site; the cosmonaut ascending into the heavens from the USSR Pavilion, propelled by what look like rockets coming out of his legs; the 'Goose and Beaver show' at the Canada Pavilion (Dykk 1986), ostensibly representing the French-English Canadian split personality; and McBarge, the floating McDonald's restaurant. There was the Ramses II exhibition, widely marketed as a star attraction, providing an ironic comment on the origins of Expo '86. The fair was initiated by British Columbia Premier Bill Bennett and his government, some say as a political instrument,

while Ramses II was little more than a second-rate Egyptian despot best known for having constructed monuments in his own honour. Expo '86 was not a monument in honour of a despot, but rather a monumental expression of an ideology reflected in different forms by two key icons: Jimmy Pattison and mass merchandizing by business.

The first and most prominent icon of Expo '86 was 'Mr. Expo' himself, Jimmy Pattison, the president and chair of the board of Expo '86. He took a dollar-a-year salary 'as a way of repaying the province that has been so good to him' (Kelly 1986:18) and possibly because of his close friendship with the Social Credit government then in power. In 1986 he was undoubtedly the most popular person in British Columbia, credited for turning Expo '86 around from what appeared to be an uncertain future under Michael Bartlett, an American theme park expert (suspect for being American and for preferring low-brow theme parks), to what subsequently was acclaimed as a great success. Pattison stands as the exemplar of the free enterprise system. He is Canada's Horatio Alger (beginning as an eight-year-old selling seedlings door to door) and True Grit rolled into one. He is like the frontier 'lone gun,' political scientist Paul Tennant was quoted (Anon. 1985d) as saying, who cleans up the town (by firing those who do not work?) and gets things done efficiently. A civic leader, introducing Pattison to a meeting in a BC town, described him as a man who 'epitomizes all the values we hold dear – he's very hard working' (Kettner 1986a).

Pattison has also been described as a 'hard core capitalist' entrepreneur (Kelly 1986) who owns more corporations with more annual revenue than anyone else in Canada – some thirty companies with $1,300,000,000 in annual sales. 'You can't live a week in BC without putting money into Jimmy's pocket,' it has been said (ibid.:16), for he owns the largest private company in the province, selling everything from groceries to cars and magazines to radio time. His empire at one time or another has included a 91-ship fishing company, Air BC, CJOR radio in Vancouver, the Ripley's Believe It Or Not TV, comic-strip, and museum chain, real estate, and a Swiss bank. He is said to wear two watches (one with two faces) and carry a pocket watch in his jacket, with the times set to Vancouver, New York, London, and Geneva (Hamilton 1985b). 'Business is fun,' Pattison is quoted as saying (Gill 1986), 'and money is a way of keeping score.'

Pattison's significance derives from the fact that he applied his talents as a successful frontier entrepreneur to public affairs. His style exemplifies the ruling ideology. 'The way things are done in BC,' Tennant said in reference to Pattison's role (Anon. 1985a), 'private busi-

ness success stories are seen as the model for public business.' 'And while Pattison may be too flashy for the eastern Canadian attitudes,' Tennant continued, 'he's somewhat of a local treasure here because he's made so many millions.'

A second key icon at Expo '86 was the mass merchandising style of business. Numerous fast food outlets – Boston Pizza, McDonald's, taco houses, hot-dog stands – and souvenir shops dotted the four-kilometre length of the fair, like series of friendly beacons. They represented a basic populist point of view.

Expo '86 was presented as a people's fair, with something for everyone. It was brought to us through the initiative and financial support of the provincial and federal governments working with private enterprise and the labour force. It was the 'Ikea of world's fairs,'[2] *Vancouver Sun* columnist Pete McMartin (1986) observed shortly after Expo '86 opened, 'marketed to appeal to a common denominator in tastes ... McDonald's and the Boston Pizzas and the execrable Expo Ernie [a robot mascot] are there because people like them.' 'The hodge-podge of pseudo-NASA nachos stands, cavernous pre-fab pavilions filled with anthropological momentos and entrepreneurial corporate mansions,' proclaimed critic Alan Twigg (1986), 'has the cumulative aura of an outdoor shopping centre complete with video arcades and McBarge burgers.'

The Expo Corporation's aim was not to be crass, as intellectuals sometimes suggested, but to be popular by 'giving the best value for the dollar.' This objective was achieved. (In a newspaper survey of 1,000 visitors to Expo '86 [Hartline 1986], only 7 per cent expressed disappointment whereas 92 per cent said they would recommend Expo '86 to others.) Mavor Moore (1986) wrote in *Connoisseur:* 'What awaits you in Vancouver, is not so much your predictable blowout of national colossi, intimidating technology, high art, and low food but, rather, an organic experience seemingly designed by a single, pixilated imagination.' It was evident to anyone familiar with the history of world's fairs that science and technology would not be enough to attract and entertain large crowds. Every large North American city has its own science museum and the media regularly report the latest technological achievements from around the world. What can a fair show that is truly new or exciting? The icons of science and technology – satellites and rockets, boats, cars, trucks, trains, and planes – can be displayed, but they are not enough. As Benedict (1983) and others have noted, over the past one hundred years the 'serious and frivolous' have been growing more and more integrated at world's fairs (Wachtel 1986:36). According to Ron Woodall, Expo '86's creative director, a 'key design decision' was made in August 1984 to

shift the focus of the fair 'from technology to whimsy, from building a museum to creating a celebration' (Hamilton 1986a). (Frivolity and whimsy presumably refer to the same phenomena, though 'frivolity,' unlike 'whimsy,' expresses the intellectual's traditional disdain for popular entertainment.) Nations and corporations designed their own pavilions and many featured technology in one way or another. The whimsy was provided by the Expo Corporation under Woodall's direction, which was reponsible for the overall site, outdoor plazas, exterior graphics, food kiosks, and street buskers.

The marketing of Expo '86 was designed to promote its mass appeal. A 'bazooka approach' costing some $12 million (Godfrey 1985) was used to reach 93 per cent of Canada's TV audience twenty-five times. Another $15 million was devoted to blanketing American markets with a 'tidal wave of advertising' (Hamilton 1985a). (Anderson and Wachtel [1986:8] say $20 million was planned for advertising in California alone.)

The creation of Expo '86 was a monumental example of the Canadian version of state capitalism at work. The provincial and federal governments through their borrowing powers create business opportunities for a competitive private sector, and success is assigned to the entrepreneurs. After the provincial government-financed Expo Corporation established a number of food and merchandise concessions on site, for example, they were turned over to the private sector to operate. Pattison announced (Ann Rees 1986a): 'The policy of the Corporation is based on the belief that the private system will be more efficient and there is also less risk for the Corporation.' Pattison, who managed his own empire as well as Expo '86, became the supreme exemplar of this philosophy. His management style served as a model for public business. 'Competition is what Expo is supposed to be about,' said Stanley Kwok, the president of BC Place, when reporters pointed out that Expo had sold exclusive rights to one firm to sell novelties on site and equally exclusive rights to another firm to set up outside the gates (Hamilton 1985e). In fact, everything at Expo '86 was for sale after the fair, not only the souvenirs and food, but also the exhibits, equipment, and building materials. It was described as Vancouver's 'largest garage sale' (Hamilton 1986b). Interested in anything? 'Write me a letter' or 'Make me an offer,' were the replies. Deals were being considered even before the fair closed. 'We are not going to waste anything,' Kwok said (Hamilton 1986c:A2).

According to a provincial government brochure, Expo '86 is 'a perfect marriage of public and private enterprise.' The implication is that the common good is best served by using public funds and resources to facilitate private profitmaking. Thus the heroic individual success-

fully struggling to master a rugged wilderness in the interests of scientific progress serves as the Expo metaphor for the triumph of competitive individualism in a state-sponsored free market society.

THE IDEA OF CULTURAL WORK

The radical work of popular cultural institutions and performances is to make profound ideas – through simplification and repetition – seem ordinary or commonplace, so that they become taken for granted (Fisher 1985). Because these popular images become incorporated into the common language of perception and moral analysis, we do not realize their role in altering the categories of reality. By making certain ideas familiar, Fisher says, the unimaginable becomes, finally, the obvious. 'Culture, in this sense, does work that, once done, becomes obvious and unrecoverable because it has become part of the habit structure of everyday perception' (ibid.:3).

Jimmy Pattison's philosophy of populism is an example of this cultural work. Intellectuals may ridicule the philosophy of McDonald's fast food chain and even reject the idea of eating in its outlets, yet they will unthinkingly use the same moral assumptions when judging intellectual or artistic work. How popular is it? Does it 'reach the people'? Does it communicate'? This Big Mac philosophy (named after McDonald's Big Mac hamburger) has entered into our common understanding of our social world, so we take it as natural that we should judge the worth of everything by its common or mass appeal and consider merit to be something individually achieved through competition. 'Making familiar or making ordinary is the radical "work" done by popular forms' (ibid.:19). Expo '86 reproduced at the concrete level of common sense the essential features of a modern capitalist society.

In conclusion, the perspective that was developed at the beginning of the chapter around the analysis of museums and galleries, seen as 'ideologically active environments,' was one that was also applied to world's fairs. It might be applied with equal utility to department stores, markets, and shopping malls, the true museums of everyday life. In the marketplaces of society the important cultural work gets done. Culture becomes a commodity to be bought and sold, happiness is defined as organized recreation and mass consumerism, all marketed to consumers individually by business chains. People come to identify with what they consume. 'I buy, therefore I am,' Columbia University arts specialist Joan Jeffri told a Vancouver audience (Wyman 1986). Thus the values of individual consumption, capitalist production, and conglomerate distribution, all ruled by the principle of

profit management (the 'bottom line approach'), are worked into the daily act of shopping. They become accepted as the normal or common sensical way of seeking fulfilment in modern society, becoming the universal standards for determining what is truth, beauty, and the good life.

The Big Mac Attack and
the Anthropology of Everyday Life

Archaeologists track the geographical distribution of prestige goods through prehistory as indices of trade and socio-political distinctions (Frankenstein and Rowlands 1978).[1] Ethnographic studies show how objects are used in non-Western societies to communicate information about social organization, status and role, and norms and values. In modern industrial societies consumer goods rank among the more important vehicles for prestige distribution and social communication. Therefore, it is not surprising that anthropologists, along with other social scientists, are now turning their attention towards the study of these materials of consumption and their relationships to lifestyles. 'I buy, therefore I am,' as one critic bluntly put it (Chapter 11). Or, as a 1984 TV commercial for Renault put it more succinctly and in terms people with totemic ancestors would surely appreciate, 'You are what you drive.' As the actor spoke he transformed himself into the automobile whose virtues he had been praising (Leiss, Kline, and Jhally 1986:23).

Given that the most popular consumer goods are mass produced and widely consumed, it may be through them that one can study the semiotics of modern society (see McCracken 1988). To illustrate, I choose the lowly hamburger, the Big Mac, perhaps as widely maligned by intellectuals as it is consumed by ordinary people. Let us see how, along with the pickles, relish, special sauce, and cheese, it conveys an ideological message that has entered into our common sense understanding of the world around us. What I wish to present, therefore, is an exercise in the anthropology of common sense. Its purpose is to start to deconstruct that common sense and to repeat the process outlined in Chapter 11: to identify the serious cultural work a popular institution accomplishes as it goes about its ordinary work.

I would first like to explain how I became interested in the Big Mac as something good to think about rather than good to eat. I never gave much thought to hamburgers, other than as a food, until a few years ago, when a Nova Scotian museum colleague sent me an article by museum educator John Hennigar Shuh, published in the *Nova Scotia Journal of Education* in 1982, entitled 'Teaching Yourself to Teach with Objects.' Shuh included a photograph of a McDonald's hamburger container and a list of '50 ways to look at a Big Mac box.' Smell it, taste it, feel it all over. Does it make a noise? What are its measurements? Height, weight, diameter? Are all McDonald's boxes the same size? How much has the box's shape been determined by the material used, the method of construction and the box's function? What raw material was used to produce this material? Is this a renewable resource? What does this say about attitudes towards conservation in our society? Is the box well designed? How might the design be improved? If someone fifty years ago set about to design a container for a hamburger, how might they have done it differently? What might the hamburger container of the future be like? What does the Big Mac box tell us about the people who use it? About our society? If you showed the Big Mac box to as many people as you could in a ten-minute period, how many would not recognize it, and what does this tell us? And so on (Shuh 1982). This leaves us with some questions. Is the Big Mac a work of art? Is it an ethnographic artefact? How does it become an archaeological specimen?

Intrigued by the idea of looking at the Big Mac from different perspectives, I passed Shuh's article to several museum students. In 1983 they produced a travelling exhibition, 'Show and Tell: The Story of the Big Mac Box.' They used the box, a common object recognized by everyone, to demonstrate how one can look seriously at an artefact – by, for example, inspecting its visual characteristics, the contexts in which it appears, its predecessors and contemporaries, and its uses and misuses. (As we know, academics can complicate anything if they study it long enough.)

That was about as far as I got with McDonald's – other than to eat a few more of their hamburgers now and then – until a world's fair, Expo '86, went up in Vancouver. Two events associated with Expo '86, each simple enough, raised again the question about the wider implications of the Big Mac. The first was a 1985 press conference called by Expo '86 president Jimmy Pattison to announce that McDonald's had signed a contract to operate five restaurants on the fair site. 'McDonald's,' Pattison told reporters (Anon. 1985b), 'stands for everything that Expo stands for – quality, service, and cleanliness.' His parallel between the government organization he represented,

Expo '86 Corporation, and the operating philosophy of a business struck me as provocative.

The second was a pattern that developed throughout the run of the fair: the high level of success achieved by the five McDonald's restaurants. They were soon catering to a third of all visitors and by the middle of the summer became the busiest outlets of the 9,500 McDonald's worldwide, serving some 30,000 meals per day (Rees 1986b). Business was so good, in fact, that one outlet installed the world's first 'walk through' service, allowing customers to pre-order as they entered and to pick up their orders by the time they reached the cash register. This same outlet continued to operate on the site for some time after the fair closed. (Fame can be short lived in this business, however. By August 1990 the chain's 'biggest and busiest in the world' was the McDonald's restaurant near the Kremlin in Moscow [Canadian Press 1990c], with 50,000 to 55,000 people lining up daily.)

What does all this mean? Is McDonald's just another expression of popular, mass-produced, and disposable American culture not worthy of our serious attention? Or does its very popularity mean that we should take it seriously? I think the latter. Behind McDonald's mass appeal lies an idea or principle of considerable importance: the marketplace also provides a proper model for the non-commercial aspects of life. The power of this idea is deceiving. Because the values of the marketplace seem economically self-evident, and are at least as ubiquitous as the hamburger itself, we do not easily notice how they infiltrate and help to construct our common sense understanding of the rest of the world around us.

What does it mean when the president of a government corporation says that a successful, mass-market consumer industry 'stands for' the same values as a government enterprise? What significance does this ideological equation have for our own work as teachers and researchers? I will approach these questions from a descriptive and a theoretical direction.

First, the descriptive approach, for which I select the McDonald's fast food chain, the largest organization in the world and one which has touched – or, more correctly, fed – virtually everyone in North America. An estimated 96 per cent of all u.s. consumers ate at a McDonald's in 1986 (Koepp 1987:58); more than a third of the u.s. population live within a three-minute drive to a McDonald's restaurant (Love 1986:3). The 'Golden Arches,' symbolizing predictability, have now become a standard feature of that American invention the 'everywhere community,' based on shared patterns of consumption and experience in standardized environments (Helphand 1983:40–1). The everywhere community is summed up by the Holiday Inn slo-

gan: 'The best surprise is no surprise' (ibid.). The average
McDonald's customer goes twenty times a year (Koepp, 1987:58). It is
said that McDonald's has already sold so many hamburgers – some
8,000 every minute – that if someone was to line them up, they would
circle the earth nineteen times (Chalmers and Glaser 1986:86), provid-
ing a worldwide halo of hamburgers. McDonald's is one of the con-
tinent's largest employers, larger than the u.s. army; with up to 100
per cent turnover per year at the outlet level, it probably prepares
more young people for the labour force than any other North Ameri-
can organization. By 1982 McDonald's also became one of the world's
largest owners of real estate. (Information is taken from Love 1986
unless otherwise noted.)

McDonald's thus touches all our lives one way or the other. Ronald
McDonald, the clown, is probably as widely recognized as Santa
Claus and likely exceeded only by Mickey Mouse. Other McDonald's
characters are also achieving popular recognition, such as the Ham-
burglar and the hamburger police (or is it Mayor McCheese?). The
symbolism of the latter is surely quite complex: is the hamburger
shaped like a police officer to convey an image of law and order – we
are under the hegemonic control of hamburgers, or something like
that – or are we simply to think of hamburgers whenever we see the
police? In any case, it is reasonable to say that the McDonald's ham-
burger is one of the most widely recognized icons of North American
culture.

My second approach is theoretical and partly derives from recent
works in the New Art History, critical theory, semiotics, and the
study of popular culture (Chapters 4, 10; Bernstein 1978; Bocock 1986;
Chambers 1986; Duncan 1985; Fay 1975; Hall 1981; Jameson 1990,
1991; Leiss, Kline, and Jhally 1986; Lohof 1982; Rees and Borzello
1986; Schroeder 1977; Singer 1984). I particularly want to draw atten-
tion to what literary historian Philip Fisher (1985) describes as the
radical work performed by popular ideas and images. The power of
popular culture is based on the fact that it takes very simple ideas
very seriously, and through repetition transforms them into common
sense. Through the repetition and frequency of distribution these
popular forms enter our daily vision and contribute to the way we
look at and understand the world around us (Chambers 1986:69). In
standing for reality these images gradually and quietly become a
taken-for-granted part of that reality (ibid.). Thus a set of ideas and
images, what might be called an 'ideology,' which originates in one
sector of society, may gradually through repetition or popularization
come to be considered normal for other sectors of society. The ideol-
ogy originating in one constituency is then said to exercise hegemony

over other constituencies, to have become an all-encompassing world-view generally accepted as 'common sense' beyond the boundaries of its origins (Bocock 1986).

I heard no expressions of surprise in British Columbia when Jimmy Pattison drew his analogy between the philosophy of private enterprise and the management of public business. Nor has anyone publicly taken issue with his often-repeated assertion that the private sector can do most things better than government organizations. Most people seem to accept that as a statement of common sense. There is also a growing acceptance of the notion that business enterprise also provides a proper model for the management of cultural and educational affairs. Here I explain the connection between the popular hamburger and the less popular areas of social life, such as education and other cultural pursuits: the ideology of the hamburger is poised to encompass or exercise hegemony over education and culture. Let us reconsider our case study, the McDonald's empire.

In 1954, a travelling food equipment seller, Ray Kroc, visited a small Pasadena restaurant managed by brothers Richard and Maurice McDonald, curious to find out why they were ordering so many of his milk shake machines. Impressed by the efficiency, economy, and popularity of their operation, he offered to sell franchises for them. Within six years Kroc had built up a network of 228 stores, with annual sales of about $38 million, and in 1961 he bought out the McDonald brothers and the rights to their name for u.s. $2.7 million. In 1987 there were over 9,500 outlets, 7,000 in the u.s. and the rest distributed through 42 other countries. Japan has the largest number of foreign McDonald's (about 550 in 1986), followed by Canada (503). A new restaurant opens every 17 hours and annual sales are more than $12 billion (Koepp 1987:58).

One key to McDonald's success over other chains, some of which had head starts on Kroc, appears to have been the high level of operating efficiency and predictability achieved through assembly-line procedures and standardized products, combined with promoting of local initiative in advertising and product development. Franchises control advertising through regional co-operatives. Ronald McDonald, the clown, for example, began as a local initiative of franchises in Washington, DC. Local operators are also encouraged to experiment with new products, the successful ones being subsequently incorporated into the system. The Big Mac was introduced in 1967 by a Pittsburgh franchise operator. The Egg McMuffin was first developed at a Santa Barbara outlet in December 1971 and became so successful that it changed American eating habits, causing muffin sales to grow twice as fast as the baking industry as a whole (Love 1986:4). Chicken

McNuggets appeared in 1983, the McDLT in 1986, and other franchises test-marketed McPizza and prepackaged fresh salads (Koepp 1987:59). Standards of production and service are rigidly controlled by roving inspection teams who grade outlets on the QSC scale – Quality, Service, and Cleanliness. Low grades result in more frequent inspections. Some outlets have night crews they call 'Internationals,' who roam the streets around each outlet after midnight to retrieve all McDonald's trash. Since McDonald's itself owns or leases most of the plots on which franchise operations are located, it has the economic power to enforce its standards.

McDonald's impact on society has not only been at the service end of the industry. McDonald's made a science out of preparing the hamburger, French fries, and milk shake. It revolutionized the French fry, creating, through research and experiment, a virtually foolproof method for producing a consistent fry in every franchise around the world. It forced equipment manufacturers to produce more efficient cooking equipment and pioneered new methods of food packaging and distribution – including our Big Mac box. In its search for improvements, McDonald's has even moved back down the food and equipment chains to the sources of production (Love 1986:119–30). Through its massive purchasing power, McDonald's has changed the way farmers grow potatoes, dairies process milk, and ranches raise beef.

As mentioned earlier, McDonald's is also a major training ground for the labour force, where young people first learn the importance of the standardized product, the discipline of routine shift work, the ethic of customer service, and the necessary subordination of individual workers to the sophisticated mechanism of the automatic assembly line (Lohof 1982:80).

My theory of the hamburger, to return to the theoretical approach, runs as follows. The success of McDonald's provides a model for other consumer industries and also enters into our common sense understanding of what constitutes success in any endeavour. The essence of McDonald's philosophy, which is typical of the marketplace, is that if it sells, it is good; if not, it is bad (see Schroeder 1977:2). The criterion is quantity: more is always better (Gablik 1985:121). The radical work of such popular cultural forms is to fashion unpopular culture in their own image, by making it seem common sense to apply the same popular standards to other matters. Through this means popular forms colonize our common sense.

The ideology of Ronald McDonald defines success in terms of mechanized production, uniform standards, and mass consumption of similar products widely marketed and individually accessible.

This system fosters the idea that society is a collection of individuals free to manifest their separate identities through consumption. We may each assemble our meals from a list of standard products. Will it be a Big Mac or a cheeseburger?

Success or goodness is defined by numbers of the marketplace: numbers of franchises, numbers of people served, numbers of happy customers. Perfectibility becomes profitability and profitability is based on head counts and bottom line accounting. The underlying message of the marketplace, New York art historian Carol Duncan has suggested (1985:10), 'is the idea that happiness is a feeling best sought not in work, not in public life, but in the [individual] consumption of mass-produced commodities.' The road to happiness, one might say, is paved with goods and services (Leiss, Kline, and Jhally 1986:66).

The hegemonic function of the hamburger derives from the fact that business success is offered as a model for success in other areas of life. McDonald's, Jimmy Pattison tells us, 'stands for everything' to which a government corporation should aspire. The ideology of business enterprise is extended beyond the marketplace, and the marketplace itself becomes a testing ground for individual worth and social value.

This same thinking is applied to assessing non-economic areas of life, including – to bring it closer to home – the work of scholars and artists and their institutions. A rhetoric of means and quantification enters into the definition of problems and solutions, theories, and methods (DiMaggio 1985:34). Quantity, popularity, mass appeal, customer satisfaction, and majority opinion become the criteria for determining success and goodness, fact and value, art and craft. Thus we see how the ideology of competitive individualism and commodity consumption batter down the marketplace walls to march triumphantly through the streets of everyday life. Ronald McDonald and his hamburgers are but the vanguards of this commodification of everyone.

Cannibal Tours, Glass Boxes, and the Politics of Interpretation

The film *Cannibal Tours* (O'Rourke 1987), a sardonic portrayal of a group of European tourists travelling through Papua New Guinea villages, also parodies anthropology. It opens with the statement: 'The strangest thing in a strange land is the stranger who visits it.' There too lies the irony of anthropology and the anthropologist as professional tourist, for when we attempt to make others less strange to us, we make those others strangers to themselves.

The problems involved in representing others to ourselves, as Virginia Dominguez notes in her paper 'On Creating a Material Heritage,'[1] are common to the entire discipline of anthropology and beyond, not just to the museum branch. The following remarks therefore should be taken in that broader, discipline-wide sense, even though the examples are specific to museums. If there is a need to reconstruct anthropology – and a good case can certainly be made for that (as for other disciplines) – then there is an opportunity here for museum anthropologists to play leading roles because of the ways museums are embedded in the social, economic, and political complexities of contemporary society. Because public criticisms frequently have immediate implications for museums, museum anthropologists are frequently more inclined than their academic colleagues to seek immediate, practical solutions. Thus critiques of museum anthropology usually also provide assessments of the broader discipline of which it is a part and suggest directions for general reconstruction. Considering Parezo's (1988) observation that vastly more people learn about anthropology from museums than from universities, what museums do will drastically affect the rest of anthropology. The future of anthropology in museums, therefore, may very well be central to the future of the discipline as a whole.

Most of the criticisms of museums flow from the simple fact that

they are the self-appointed keepers of other people's material and
self-appointed interpreters of others' histories. They circle around the
question of who controls the rights to manage and interpret history
and culture. Parezo, for example, indicates that many of the methods
of museum collecting, especially during the nineteenth and early
parts of the twentieth centuries, would be questionable by today's
moral standards. And museum exhibition techniques continue to im-
pose academic classifications – our 'glass boxes' of interpretation –
upon diverse cultures. The sizes and shapes of these boxes have
changed with the theoretical fashions within anthropology – ranging
from progressive technology exhibits, comparative, cultural displays
of family and work groups, and dioramas or stage sets to demonstra-
tions and performances. They always remain anthropological boxes,
however, 'freezing' others into academic categories and to that myth-
ical anthropological notion of time called the 'ethnographic present.'

Those boxed in, especially the indigenous peoples who have
served as the primary subjects of anthropological study, were never
terribly happy about their museumification and often objected. What
is significant is that by the 1980s, after one hundred years and more of
boxing others, museums (and their academic counterparts) are only
now beginning to hear what the objects of classification, especially
those same indigenous groups, have been saying all along: they want
out of the boxes, they want their materials back, and they want con-
trol over their own history and its interpretation, whether the vehi-
cles of expression be museum exhibits, classroom discourses, or
scholarly papers, textbooks, and monographs. Since those who con-
trol history are the ones who benefit from it, people should have the
right to the facts of their own lives. This is surely a cornerstone of
postmodernist ideology and one of the central political implications
of interpretation.

The criticisms are encouraging museum professionals and those in-
terested in museums to reconsider and re-evaluate the very founda-
tions upon which museum work is based. Witness the five papers
presented in the 'Objects of Culture' symposium at the 1988 annual
meeting of American anthropologists: the three by curatorial special-
ists (Parezo, Jacknis, and Welsh) and two by interested non-museum,
academic anthropologists (Dominguez and Errington) are all, in one
way or another, critical of anthropology. How then do we proceed?
Criticizing our past is the first step; reconstructing for the future is
perhaps the next. Criticism also needs to be placed in perspective,
and with some limits placed upon it, for museums alone cannot
shoulder all the burdens of the past. Although there is much that mu-
seums have done wrong, or did not do at all, they also do some things

right. Thus, when mounting criticisms it helps to recognize not only the bad and the ugly but also the good and the useful, to give credit where credit is due, and to build upon the good examples.

These papers suggest some ways we might break the glass to liberate indigenous peoples from the hegemony of our systems of classification and in turn liberate ourselves from an unwelcomed over-dependence on other people's material. Jacknis points to the importance of considering 'the historical contextualization of the collecting process,' recording what might be called the 'social patina' (Inglis 1989) that accrues over time as an object moves from maker to user to collector to preserver to exhibitor. Tom McFeat (1967), when he was chief ethnologist at the National Museum of Canada, proposed the formula: 'Objects + data = specimen.' Jacknis would have us look at these data as embodying an evolutionary development of meanings which have been superimposed one upon the next as objects are continually recontextualized throughout their careers. 'The character . . . of an ethnological phenomenon,' Jacknis quotes Franz Boas (1887:66) as saying, 'is not expressed by its appearance, by the state in which it is, but by its whole history . . .'

The object as palimpsest? Milton Singer quotes the late Jawaharlal Nehru's metaphor to describe the civilizations of India, a task which may appear rather different from the one considered here, but which shares some epistemological problems. Nehru wrote in *The Discovery of India* (1946:47, quoted in Singer 1988:13) that Indian civilization is 'like some ancient palimpsest,'

> on which layer upon layer of thought and revery had been inscribed, and yet no succeeding layer had completely hidden or erased what had been written previously. All of these existed together in our conscious or subconscious selves, though we might not be aware of them. And they had gone to build up the complex and mysterious personality of India.

Is a museum also a palimpsest, Singer asks (telephone conversation, Dec. 1987)? If we follow Dominguez, yes it is, just like the object. (And why not, to make a fair trade, use 'living museum' as a metaphor for the civilization of India?)

Jacknis's reference to process combined with the palimpsest metaphor suggest at least two levels of analysis: (1) the social history of the object from origin to current destination, including the changing meanings as the object is continually redefined along the way; and (2) the museum itself as layered object and machine for recontextualization or, to borrow Dominguez's term, 'objectification.' The Heard Museum's 1988–9 exhibition, 'Exotic Illusions,' described in Peter

Welsh's paper, which dealt with how we interpret objects from other cultures – as art, exotic curios, commercial souvenirs (our perceptions changing according to the context of representation) – illustrates these levels. The first level concerns the way objects are recontextualized when they are collected; the second, with how museums actively assist that redefinition, sometimes directing it and other times confirming it, through their acquisition and interpretation programs.

Jacknis and Dominguez suggest that anthropologists need not limit themselves to studying the first or original meaning of the objects (that is, to the makers and initial users) or to spending all their energies on attempts to reconstruct that early meaning – the archaeology of objects, as it were. They can also explore the evolution of meaning over object careers and the history of the institutional mechanisms that produce and reproduce those meanings. Anthropology, the late Harvard anthropologist Clyde Kluckhohn liked to say to his students, was the study of others in order to understand ourselves (see also Rowe 1965). Tracking the semantic career, the acquiring of social patina, of objects and museums – the 'anthropology of museums' (Chapter 4; Broyles 1988) – illustrates how people over time reveal themselves through the ways they interpret or recontextualize others.

Another illustration of a museum 'doing it right,' by presenting both sides of the interpretive equation (one's own and the other), is the Native-operated Woodland Indian Cultural Education Centre (Brantford, Ontario), whose 1988 exhibition, 'Fluffs and Feathers,' drew a connection between white stereotypes of Natives expressed in history books, literature, art, and the media – 'the Myth of the Savage' – and their own self-images. 'Every culture creates images of how it sees itself and the rest of the world,' curator Deborah Doxtator (1988a:13–14; see also 1988b) wrote in the exhibition Resource Guide. 'Incidental to these images of self-definition are definitions of the "Other."' Stereotypes, the exhibition suggests, institutionalize forms of privilege, empowering those who are exalted and disempowering those portrayed as the 'Other.' 'What then happens to a culture whose symbols are chosen by outsiders, by those who do not understand its deepest beliefs, structures and ways of life?' Joanna Bedard (1988), executive director of the Woodland Centre, asks in her Foreword to the Resource Guide. Stereotypes of the Indian, Doxtator notes (ibid.:14), 'often operate as a form of social control, [justifying] why it is all right to deny other racial groups access to power and financial rewards.' Every society creates its own images about itself and other people connected to it, Doxtator (ibid.:67–8) continues:

> The non-Indian use of Indian symbols operates within a hierarchical society that is based on the principle of economic and social inequality.

From the day children start school, they are ranked and judged according to their academic performance, their athletic abilities, their creative talents. It is not surprising, then, that non-Indian images of Indians are either at one extreme of the 'ranking' spectrum or the other – either Indians are depicted as 'savages' below Euro-Canadian 'civilization' or as 'noble savages' who are more moral, faster, stronger, kinder than any Euro-Canadian. Rarely have Indians been treated by Canadian society as equals.

This one fact alone is probably the key factor in understanding the destructive effects of the images created by non-Indians. It is not right that anyone should define someone else, tell them who they are and where they 'fit in.' You cannot do this to someone if you think of them as your equal.

The introductory panel in the 'Fluffs and Feathers' exhibition asks visitors to think about their own images of Indians. What it is really asking, Doxtator continues (ibid.:68), is, 'How do you see yourself?'

The Heard's 'Exotic Illusions' and the Woodland's 'Fluffs and Feathers' expose those who collect and classify the works of others. To reiterate Virginia Dominguez's point (1988), museums provide fruitful information about people's continual struggles to control their worlds (including alien worlds) through their objectifications or classifications. 'Our own processes of objectification provide us not just with the objects but also with the categories by which we may see some things and not others as objects,' she continues. Museums are not only machines for recontextualization; they also document the process itself, through their histories and the collections they appropriate over time. Through our objectifications we study the objectifications of others. Dominguez says cultural institutions are 'continuous sources of data about their varying constituencies' objectifications of the world and their struggles for control.' They are 'objects of culture, objects of heritage, objects of power made possible by particular combinations of social, ideological, cognitive, economic, and political conditions.' They recall for Dominguez Foucault's thesis on the emergence of 'Man' in the nineteenth century,

> when, he argued, the idea of human beings as actors or doers (subjects) converged with the idea of human beings as objects of knowledge and study. The awkward duality of being both subject and object generated enormous creative tension then, giving birth to most of the 'human sciences' – both 'natural' and 'social.'

This view brings the study of museums in line with other theoretical interests. Objects, like people, have social lives, Appadurai (1988:5)

tells us in his discussion of commodities (objects with economic value), and this life history (Nehru's palimpsest process) needs study:

> We have to follow the things themselves, for their meanings are inscribed in their forms, their uses, their trajectories. It is only through the analysis of these trajectories that we can interpret the human transactions and calculations that enliven things. Thus, even though from a *theoretical* point of view human actors encode things with significance, from a *methodological* point of view it is the things-in-motion that illuminate their human and social context [emphasis in the original].

The object as commodity, as artefact, as specimen, as art, as someone else's heirloom, treasured cultural heritage, or sacred emblem: these are different ways of seeing the same thing. They are all properties or values of the object, all phases in its life. Values may be imposed by those wishing to possess or appropriate the object, and others asserted by those claiming moral jurisdiction. These transformations of meaning and use during the objects' careers could be better represented in museum interpretations. The longer the career of an object, however, the more segmented its history becomes, and the more knowledge about it becomes fragmented, contradictory, differentiated, and fodder for commodification (Appadurai 1988:56) and dispute.

Dominguez and Appadurai remind us that objects are, along with everything else, expressions of power relationships. Reconstruction involves repowering the object, investing it with the authority and privilege of those currently possessing it, who then impose upon it (and upon those whom it represents) their own histories. The process of reconstruction thus entails a shift in power and status of the object and of those formerly and presently associated with it. Once an object has been acquired by a museum, Balfe (1987:4) says in reference to 'art' objects, that context attracts the power plays of status seekers who appropriate art to their own ends:

> Not surprisingly, like individual patrons, both corporations and governments seek the reflected glory, the gilt by association, with artworks supposedly beyond price and above politics. At the same time, such sponsors seek to re-embed the decontextualized art in wider systems of meaning which they (more or less) control. The less aesthetically aware the audience, the more likely the recontextualizing is to occur according to the sponsors' agenda.

Here are a number of issues to resolve: an object's checkered, com-modified, disputatious, palimpsest-like career; competition for power and status; appropriation of others; the tensions between viewing and being viewed; the mixed and contradictory messages; and the presence of different audiences not all equally aware of what is going on nor all seeing the same thing. In both his paper and the 'Exotic Illusions' exhibition he curated, Peter Welsh (1988) provides an example of the competing objectifications, the realities or illusions – which, given the layered nature of objects, may amount to the same thing – museums construct for different constituencies. He calls these the 'visiting audience' (those who come to view) and 'the constitu-ents' (those whose cultures are being viewed).[2] Shelly Errington (1988) describes the 'magic realism' or 'hyper-realism' that has be-come a prominent, almost standard form of museum objectification ('mystification' would be more compatible with her perspective, though that probably amounts to the same thing): the artificial con-struction of a real world diorama or stage set. Like the emperor and his new clothes, when the hyper-realistic dioramas are identified as the imaginary fabrications they are, rather than the realistic portray-als they are meant to be, will museums continue to create them? Probably. And will visitors care if they are told that the exhibits are artificially made to depict an arbitrary realism? Probably not. Welsh's classification of audience types, each expecting something different, each entering with a different knowledge, suggests a way of under-standing such conundrums.

The question of audience leads to other issues. Museums serve multiple audiences, including the visitors and constituents Welsh identified, each of whom can be subdivided into very different groups. Many are anything but indifferent to museums and some are hardly benign. Museum visitors expect, and will frequently demand, to be educated and entertained, whereas those whose cultures are be-ing exhibited (Welsh's [1988] constituents who are our 'originating populations') express concern over how they are being used for oth-ers' entertainment: 'What, or whom, exhibits represent, and to whom it, or they, may be represented,' Welsh notes, 'is the question that concerns us here.'

At 'Preserving our Heritage,' a 1988 conference of indigenous peo-ples[3] and museum workers held in Ottawa (Blundell and Grant 1989; Canadian Museum Association 1989; Townsend-Gault and Thunder 1989), Tommy Owlijoot, who was director of the Eskimo Point Cul-tural Centre in northern Canada, said that whites have benefited from the display of Inuit culture for a hundred years or more, and it

was time to redress the balance. As Parezo observed, anthropology provided a past for a new, expanding country by appropriating the past of the recently subjugated Native Americans. Once seemingly reasonable, it is no longer acceptable appropriation. Owlijoot and many other Native Americans are calling upon museums to start repaying their 'debt' by balancing the scales. At the same conference, Christopher McCormick (Watts 1988:16; Assembly of First Nations 1989:11), spokesperson for the Native Council of Canada, said:

> Today, Native people are talking about reconquering our homeland ... We are not talking about a violent reconquest, a war of peoples. We are talking about taking control over our own lives, our cultures, and most importantly, the interpretation of our cultures past and present ...
>
> The pattern in Canada, as in the United States, has been to assume our imminent demise, take our sacred objects and lock them up in mausoleums for dead birds and dinosaurs ... It is not surprising then that the cultural professionals – anthropologists, archaeologists, museum directors – have often been the handmaidens of colonialism and assimilation.

The politics of representation – who can represent whom, how, where, and with what, Dominguez's 'questions of authenticity, authority, appropriation, and canonization of knowledge and meaning' – have become central for museums and for all students of culture. Who controls history, who has the moral right to control it, and who benefits? The traditional museum privilege is being challenged. 'The new project is the reconquest,' McCormick continued (Watts 1988:17):

> We *were*, we *are* and *will be* the First People. We will refuse to allow people to appropriate or interpret our Cultures for their own ends. It will be our elders, our specialists, our historians and our anthropologists, our scientists who from now on will be the interpreters of our Culture. That is what self-determination means and we will have no less.

'We are well aware that many people have dedicated their time, careers, and their lives to showing what they believe is the accurate picture of indigenous peoples,' Georges Erasmus, national chief of the Assembly of First Nations, co-sponsors of 'Preserving Our Heritage,' said in his opening remarks (Assembly of First Nations 1989:2). 'We thank you for that,' he continued, 'but we want to turn the page.'

If representations of others – our 'magic realisms' – are inventions, Dominguez (1988) asks, how should we judge the inventors? 'Should

they be viewed as unethical, manipulative, opportunistic, normal, creative, unaware?' Are museum curators the cultural imperialists and missionaries of the postmodern age? The controversy surrounding the Glenbow Museum's 1988 exhibition, 'The Spirit Sings: Artistic Traditions of Canada's First Peoples' (Harrison et al. 1987; Halpin 1989), mounted in association with the Calgary Winter Olympics, demonstrated how cultural interpretation and political interest can become inextricably entwined in the minds of the public, professional, and Native communities, and how those involved on *all* sides of the controversy, both Native and non-Native, viewed the others and were viewed, interchangeably, as *both* unethical and creative, *both* manipulative and normal, *both* victim and aggressor. The Lubicon Lake Indian Band in northern Alberta called for a boycott of the Calgary Olympics and of 'The Spirit Sings' to call attention to its long-standing land claims. Many individuals and organizations supported the boycott. In the process public debate shifted from land claims to questions about the propriety of a museum mounting an exhibition of Native artefacts in the face of Native political protests and while the major corporate sponsor of the exhibition was drilling on lands claimed by the Lubicon. The exhibition went ahead and so did the boycott (see Chapter 14 and Harrison, Trigger, and Ames 1988; Harrison 1988; Trigger 1989; Ames 1989). The Lubicon land claim was still unresolved when representatives of museums and Native organizations met in Ottawa in September 1988 and later in November to discuss the political implications of heritage management and interpretation highlighted by the exhibit and its boycott; it remained unresolved when the exhibition closed in November 1988 (and remains unresolved as of December 1991). A joint First Peoples-Canadian Museums Association Task Force was established following the November 1988 meeting. After meeting over several years it produced recommendations on how to improve relations between First Nations and museums (Nicks and Hill 1991).

Additional examples of disputed interpretations were cited at both national Canadian conferences and at a third in October associated with the 'Fluffs and Feathers' exhibition (Doxtator 1988a). Native delegates on all three occasions made it clear that museums were expected to repatriate artefacts and histories and to allow Natives to represent themselves or at least to share control. Minorities and indigenous peoples everywhere are making similar demands, of course. To give one example, Maori scholar Sidney Moko Mead stated (quoted in McManus 1988:12): 'Maori people are taking charge of their heritage. No longer will they tolerate other people speaking for them and about their *taonga* [treasured cultural possessions].'

There is a natural move everywhere towards self-determination, for the benefits of democracy are self-evident. Interesting, for museums at least, is a growing public sentiment, both among anthropology audiences and within the profession, favouring this move among indigenous peoples, at least towards self-interpretation if not towards full economic and political self-determination. This call is made to art museums and galleries as well as to anthropology and history museums. It should be noted, however, that the 'art' problem is in some ways the reverse of the 'artefact' problem. Anthropology and history museums control indigenous histories by *including* in their collections and exhibitions heritage materials they classify as 'artefacts' or 'specimens'; art museums and galleries control more by *excluding*, by not collecting or exhibiting indigenous 'arts' except for those that fall within the hegemonic domain of the Western theory of aesthetics (Blundell 1989), Appadurai's (1988:28) 'aesthetics of decontextualization.' Indigenous artists (in Canada many are represented by the Society for Canadian Artists of Native Ancestry) call for acceptance of their work by the art establishment, while Native elders, religious groups, and politicians challenge the traditional recognition provided by museums. This is no contradiction, simply the quest for some control in two different cultural arenas – to be included in one and emancipated from the other.

Let the art establishment take its lumps at another time (Phillips 1988; Balfe 1987). Museums and anthropology are responding to these initiatives, though how effectively remains to be seen. 'As representatives of a kind of institution whose short history can be traced directly to colonial expansion and domination,' says Welsh, echoing Dominguez's consideration of appropriation and domination and McCormick's castigation of the professional handmaidens of colonialism, 'some of us are, understandably I think, concerned with the shape of museums in the future.' And with actively shaping that future, we might add.

If museums empower people to speak for themselves, will they consequently lose their own institutional or professional voices? Welsh contends they need not. He rejects the relativist thesis that museums should only allow constituents to speak; self-representation is not the only appropriate representation. Museums and anthropologists can continue to speak about others, though of course no longer *for* them (a right they once may have assumed but never really had). They can speak jointly with those whose materials they keep or study. They can continue to speak about cultural encounters, the careers of objects and institutions, and the complicated objectifications that occur during them. Anthropologists can continue to explore with

others the 'symbolic mediation of cultural diversity' (R. Phillips 1988:60) in an increasingly complex world. They can speak more frequently about the cultures of their audiences, as 'Exotic Illusions' does so well. Important roles for museums remain. In this world of 'mixed-up differences,' Clifford Geertz (1988:147; quoted in R. Phillips 1988:60) concluded in his recent analysis of anthropology literature, there is a persistent need to facilitate conversation across the ubiquitous divisions of ethnicity, class, gender, language, and race. The task for anthropology, he continues, is 'to enlarge the possibility of intelligible discourse between people quite different from one another in interest, outlook, wealth, and power, and yet contained in a world where, tumbled as they are into endless connection, it is increasingly difficult to get out of each other's way.'

In this tumbled world remains the museum's problem of having multiple responsibilities to diverse audiences. What, Welsh asks (1988), happens to the educational and scientific missions when a museum honours the constituents' demand for privacy ahead of the visitors' desire for information? 'What do visitors need to know?' he continues, 'and how do we let visitors in on the fact there are things we do not feel it appropriate to tell them?' Can we serve the needs and meet the standards of colleagues and scholars if we withhold information from exhibitions and publications? The rights to privacy always need to be balanced with the rights to know. The challenge for museums is not to present the 'facts' about cultures, Welsh (1988) concludes, but rather 'to find ways to educate visitors about the very nature of facts. About the fact that information is not only power, but also a responsibility and is deserving of respect.'

We might conclude with Welsh and Dominguez, using the latter's words, that museums are 'prime participants in the much broader sociopolitical arena which conceptualizes and reconceptualizes OBJECTS.' Having these meaningful things around, she says, 'remind us vividly of the power and the limitations of representation – that when all is said and done, we human beings will still (and probably always) have to grapple with ways to relate to, signify, employ, and dispose of things we see, touch, smell, and feel that play some role in our lives.' Turning the page and empowering people to speak for themselves, however worthy a project, will not dissolve this inventive quality of objectification. Indigenous peoples are equally prone to 'inventing culture,' of course, and they should have equal rights to do so. One task for anthropology is to make that process – 'the very nature of facts' – more visible, comprehensible, and accessible to all the audiences. Our purpose is not just to identify the careers of objects and institutions, like collecting and arranging so many butter-

flies, but also to use this information to liberate dominated peoples from the hegemonic interpretations of others so that they can speak for themselves. It is part of the struggle for control over the production of common sense understandings of our world (Gruneau 1988:23), a task to which a critical theory of museums can contribute (Ames 1989).

What we can learn from 'The Objects of Culture' (a comfortable academic symposium) and 'Preserving Our Heritage' (a nervous meeting between indigenous peoples and museum professionals) is that the interconnected circumstances of a tumbled world in which museums, anthropologists, and their audiences work are changing in complex, tangled ways and will continue to do so. Museums, therefore, need to chart their futures with care and sensitivity since they are very much an integral part of the larger picture and play some part in its production and reproduction. As Georges Erasmus (Assembly of First Nations 1989:1) told delegates in Ottawa at the November 1988 conference, 'We are embarking on the beginning of a different kind of relationship.' The time has come to break a few old glass boxes to make room for new ones, and never mind the cannibals.

Museums in the Age of Deconstruction

THE 'ETHNIC QUESTION' IN THE AGE OF DECONSTRUCTION

Problems relating to ethnicity appear to be occupying an increasing part of public discourse.[1] The 9 April 1990 issue of *Time*, for example, refers to the 'Browning of America,' suggesting that if present trends continue the average u.s. resident will be non-European by the middle of the twenty-first century (Henry III 1990). White pupils are already a minority in California schools. Independence, 'ethno-nationalist' or 'ethno-cultural' movements among indigenous and minority communities around the world receive regular media attention and scholarly debate. Under the circumstances it is hardly surprising that anthropologists also direct attention to ethnic phenomena, asking how ritual and aesthetic expressions, cultural performances, and political activities contribute to group identity formation, economic adaptation without cultural assimilation, and political separatism. As Williams (1989:401) notes in his review of ethnic studies: 'The concept of ethnicity has become a lightning rod for anthropologists trying to redefine their theoretical and methodological approaches and for lay persons trying to redefine the bases on which they might construct a sense of social and moral worth.'

My interests are not in ethnicity per se, but in the social anthropology of cultural institutions, such as museums and art galleries, and in the anthropology of public culture. Obviously, these institutions are involved in ethnicity, whether by default or by intent. Instead of looking at how such public forums help manifest ethnicity, I want to turn the question around: what is the impact of ethnicity on those institutions and on the public expressions of anthropology? Might we expect to see a gradual 'browning of anthropology'? At the very least

visible and other 'minorities' or underrepresented populations are demanding more space or 'voice' in the mainstream institutions.

The public concern with ethnicity seems like a natural outgrowth of our current disputatious times, which might be described as an 'Age of Deconstruction.' I do not know whether French philosopher Jacques Derrida invented or borrowed that term, nor do I know what he meant by it (he was not inclined to define it, and the term itself may soon go out of fashion after a brief run through literary circles). It nevertheless sounds like an apt term to summarize the past decade or so in the world of cultural affairs. Traditional standards of literacy were attacked for ethnocentric bias; traditional modes of scholarship in the social sciences and humanities were placed under siege by radical and feminist critiques from both the left and the right; the authority of cultural and educational institutions was questioned; and the traditional canon was criticized for its Eurocentric and male-oriented biases.

Not only did the Berlin Wall and the Soviet Union start to crumble in the early 1990s but so did the barriers between disciplines and around public institutions. The past few years have seemed like an age of deconstruction, reconstruction, and self-construction, where everything is questioned and almost anything goes, at least for awhile. Someone coined the term 'postmodern' to refer to such adventures, though the terms 'deconstructing' and 'reconstructing' come closer to describing what actually has been happening.

How have these issues of voice and self-representation impinged upon public museums and art galleries? Cultural institutions frequently serve as playing fields upon which the major social, political, and moral issues of the day are contested. Not only are the definitions of truth and beauty subject to debate, as one might expect, but so are other thorny issues, such as what constitutes public taste and who has the right to determine it, what kind of knowledge is deemed to be useful – indeed, even what constitutes proper knowledge, and who has the right to control its production and dissemination. Lying behind the rhetoric of these debates and controversies are larger questions about what kind of society we want to live in, how much social and cultural diversity we can tolerate, and how we wish to represent ourselves and others.

Thus, the activities and institutions dealing with 'art and culture' – subjects often considered secondary to the important things in life, such as earning a living – are, to the contrary, deeply implicated in the major issues confronting contemporary society. Museums also strongly affect the public understanding of anthropology, another reason to pay attention to what they are doing and what is being done

to them. Public response to museums helps to redefine those disciplines they represent.

I will briefly review some of the controversies surrounding displays in public places to see what wider lessons can be learned. (Collecting controversies is a hobby of mine.) Cultural institutions certainly play paradoxical roles, sometimes reflecting popular opinion and at other times guiding it, sometimes reaffirming dominant ideas and at other times opposing them. In the cases to be considered here, and in all others I know about, one constant or recurring factor is the embeddedness of cultural affairs in political relationships, that is, relationships involving status and power. Art, artefacts, and their institutions have politics, including the politics of representation (the 'ethnic question' again). Other common threads may emerge as we proceed through the review.

PUBLIC ART: 'THE FIRST GREAT CANADIAN'

Stationed on a hillock overlooking the Ottawa River that runs between Ottawa, Ontario, and Hull, Quebec, and commanding a majestic view of five important Canadian landmarks – the Canadian Museum of Civilization, the National Gallery of Canada, the Parliament Buildings, the National Archives of Canada and the classic Chateau Laurier Hotel – stands an equally majestic bronze statue of Samuel de Champlain, described on the accompanying bronze plaque as 'The first great Canadian.'

Who is publicly proclaimed to be 'The first great Canadian' says much about who is considered a part of history and who is not. Crouching below the feet of de Champlain, who holds aloft an astrolabe as if to signal his territorial ambitions, is a scantily clad Indian, one-third the size of de Champlain, and presumably a representative of the peoples whose land de Champlain has claimed.

Ironically the Indian looks towards the new Canadian Museum of Civilization and has turned his back on the equally new National Gallery. This is an unintentional, but dramatic statement about the relations between indigenous peoples and white society and about how museums and art galleries deal with indigenous peoples' culture – by dividing and separating it into art and artefact, the separate and jealously guarded realms of art historians and anthropologists, each armed with their own particular 'astrolabes' of theory, method, and language. This division is contested by many indigenous peoples. From an academic point of view it is simply a matter of how to order the works of others through classification. From an indigenuous perspective, it is a problem of how cultural patterns, which

they view holistically, are being divided and segregated according to alien systems of conceptual domination.

Indigenous artists ask why their art is not collected and displayed in the National Gallery and other art museums and is always subjected to artificial contextualization by anthropologists. 'Free us from our ethnological fate,' they say (Chapter 8).

What is to be done with the contemporary arts of indigenous peoples has become increasingly problematic (Duffek 1989; R. Phillips 1988). Anthropologists query whether it is really authentically indigenous, since it does not always look like earlier material, and art historians wonder whether it is authentically art since it does not always correspond to what white artists do, either. Probably most art curators and art historians still practise what Canadian art critic John Bentley Mays advocates: define what is art in terms of post-Renaissance Western experience. As Mays (1990b) suggested in his review of an exhibition of Inuit carvings at Toronto's Art Gallery of Ontario:

> If it is to be useful, the word *sculpture* will surely be kept as an historical term applied restrictively to products of a certain practice, namely, the Western inquiry into plasticity, volume and visual meaning that has descended from the Greeks, through Rodin, to Duchamp and Carl Andre and beyond. Applied like a kind of honorary title to whatever we happen to like or think beautiful, the word *sculpture* is merely a grunt of approval, not a description of a class of related objects.

In contrast, the indigenous peoples view their creative works, contemporary and earlier alike, as neither art nor artefact but both or, even more likely, more than both. Deciding what is 'art' is not only a matter of academic tradition, semantics, or personal preference, it is also a political act. The label determines what is to be admitted into that inner sanctum of the cultural establishment, the prestigious gallery of art. To deny serious consideration of the art of indigenous peoples, that is, to exclude it from mainstream institutions, a reader (Millard 1990) wrote in response to Mays's newspaper review of the Inuit exhibition, is 'to collaborate in the suppression of their identity and in their continuing exclusion from the full life of this country.' There is always an 'on the other hand' to these issues, of course. As Susan Sontag remarked during the 1986 International PEN conference (Ozick 1989:125), 'Genius is not an equal-opportunity employer.' That is to say, there may be standards that transcend ethnicity, in which case works would be included or excluded according to merit rather than ethnic origin. But how then is genius defined?

Some major art galleries and museums in North America, Australia, and New Zealand have begun to recognize contemporary indigenous arts. They are following the lead of smaller institutions and commercial galleries, however, and the great divide between art and artefact continues to be a part of mainstream thinking and institutional practice in universities as well as in museums.

To make it more complicated, consider women's works. They are usually assigned to the lower status categories of 'craft' and 'decorative arts.' One example is Haida artist Dorothy Grant's 'Feastwear,' designer clothes for special occasions. If it is fashion, can it be art? And if it is not traditional, how can it be Haida? However, Haida art has always been usable and adaptable. Adapting Robert Davidson's Haida graphics to her elegant clothing allows Grant another way to express her creativity while also taking her culture into a broader arena (Fried 1990:10).

Beyond the question of where does one put it is the problem of how to interpret it. Do non-Natives any longer have the right to interpret Native creativity? And even if they do have a right, will they get it right? Will they have sufficient inside knowledge of, or intimacy with, the culture in question?

There is an 'irony,' noted First Nations writer Kerrie Charnley (1990:16), 'about people who claim to want to get to know who we are through the stereotypes they themselves have created about us rather than being receptive to who we are in the way that we express ourselves today.' Once scholars begin to debate their own social constructions of other peoples' lives, as they are prone to do, the people themselves are gradually dropped from sight. They become the 'disappeared' of the scholarly world.

The debate goes beyond cultural institutions and the question of ethnographic authority, of course, for it affects all systems of representation. This was illustrated by the controversy over W.P. Kinsella's 'humourous' stories about fictional residents of the real community of Hobbema, home of four Cree bands seventy kilometres south of Edmonton, Alberta (Lacey 1989). Some Hobbema residents objected to Kinsella's use of their community's name. Authors have the right to appropriate stories from another culture, Kinsella replied (Canadian Press 1989a): 'If minorities were doing an adequate job [of telling their stories], they wouldn't need to complain.'

Ojibway writer and storyteller Lenore Keeshig-Tobias also criticized Kinsella's appropriation. 'When someone else is telling your stories,' she said (Greer 1989:14), 'in effect what they're doing is defining to the world who you are, what you are, and what they think you are and what they think you should be.'

Do artists, scholars, or curators any longer have the right to claim free access to the world of knowledge, or should there be some limits to cultural trespassing? Shirley Thomson, director of the National Gallery of Canada, has said (Bennett 1990:12): 'Ideas don't recognize geographical boundaries. Why should the professionals who work in the institutions that house them?' York University (Toronto) professor of literature Terry Goldie offers the other view. We have hit an evolutionary moment, he says (Drainie 1989), at which it is no longer good enough for white writers to claim a spiritual kinship with Natives: 'Their culture is one of the only valuable commodities natives own in this country, and for white writers to keep telling their stories is inevitably appropriation.' People like Kinsella, writing stories about fictional Indians in a non-fictional Hobbema, are committing 'cultural theft, the theft of voice,' according to Keeshig-Tobias (Greer, ibid.). Stories are not just entertainment, 'stories are power.' They reflect and transmit cultural values. When non-Natives appropriate Native symbolism and monopolize the media, she continues, the Native voice is marginalized, or it has to be redefined to fit the format established by others: 'They are trivializing our gods' (Vincent 1990).

THE NATIONAL GALLERY: 'FIRE THE CURATORS'

The National Gallery of Canada faces other challenges to its curatorial prerogatives besides those presented by indigenous artists, and though they may not involve ethnic or minority issues, they still involve contests over the rights of representation. For example, the gallery's 1989 purchase of Barnett Newman's abstract *Voice of Fire* for $1.8 million (Canadian Museums Association 1990:1-2) was denounced. A National Gallery spokesperson (Hunter 1990) described the painting as an 'electrifying . . . 18-foot punch.' Director Shirley Thomson said, 'We need something to take us away from the devastating cares of everyday life,' reminding us, as Toronto art critic John Bentley Mays noted (1990a), that art museums 'exist to serve the life of the mind.'

Those explanations were not enough to persuade everyone. 'Well, I'm not exactly impressed,' was the response from Manitoba Member of Parliament the Honourable Felix Holtmann (Canadian Press 1990a), who also chaired the House of Commons culture committee and was promising a committee inquiry into the purchase. 'It looks like two cans of paint and two rollers and about ten minutes would do the trick.' Others complained that public funds were being used to purchase a work from a deceased foreign (U.S.) artist rather than to

support living Canadian artists. They should fire 'the irresponsible curators,' Canadian poet and editor John Robert Colombo (1990) wrote to a Toronto newspaper, for paying such a hefty amount for the work of a foreign artist who is 'a spent force.'

Perhaps what the National Gallery needed was to explain its purchase of an abstract painting in language ordinary citizens could understand and appreciate – but that is not what cultural experts are well trained to do.

INTO THE HEART OF AFRICA?

The theft of cultural or ethnic copyright or cultural trespassing is also what Afro-Canadians in Toronto accused the Royal Ontario Museum of committing in its 1989 exhibition, 'Into the Heart of Africa' (Da Brco 1989-90; Drainie 1990). This exhibition, curated by anthropologist Jeanne Cannizzo (1989), is an example of good intentions gone wrong or being misconstrued.

Cannizzo's mission was to show the origins of the ROM's African collection within the context of white Canadian imperialist history. It was first an exhibition of nineteenth-century Canadians *in* Africa and Canadian attitudes *towards* Africans. What may have been for some a passing comment on the questionable adventures of an earlier generation became for others a painful reminder of a history of oppression. Some Afro-Canadians picketed the ROM in protest, claiming that it was extolling colonialism when it should have recorded the great achievements of Africa. But how can an imperialist society talk about its own history without using imperialist emblems?

The protestors may have misread the intent of the exhibition, and/or it was too subtly stated. In any case, they found parts of it a painful, therefore offensive, reminder of colonial subjugation. Those picketing the ROM asked that the exhibition text be changed or the exhibition be closed. The ROM did neither, referring to the judgements of critics and the response of museum visitors who thought the exhibition provided a useful insight into Canada's imperialist past (Blizzard 1990; Freedman 1989). One is left to ponder how offensive it is permissible to be in the exercise of free speech and scholarly interest; if it matters who is offended; how offensive may the offended be in their protest; and whether a curator's good intentions count for anything any more. (The exhibition ran its course at the ROM, but its projected North American tour was cancelled when those museums scheduled to receive the exhibition bowed to protests by Afro-Canadians. Museums do not want to be offensive.)

THE QUESTION OF AUTHENTICITY: THE CANADIAN
MUSEUM OF CIVILIZATION

When the new Canadian Museum of Civilization opened in June 1989 it was immediately and widely criticized for costing too much and for showing too little too poorly. The CMC was obliged by government decree to open before construction was completed. It did cost more than originally estimated (so far, about C$256 million), with a cost overrun of about C$9 to $12 million. Less than half the exhibition space was finished (at a cost of C$35 million), and it has been estimated that many millions more will be needed to complete the museum as planned (Jennings 1990). It probably will become, if it is not already, the most expensive public building in Canada and the largest museum in the world. But is it any good?

The CMC was accused of substituting Disneyland-style pyrotechnics for educational substance and for presenting, not artefacts, but contemporary reconstructions smelling like a lumberyard – 'Disneyland on the Ottawa, with the emphasis on illusion rather than on the real artifact' (Canadian Press 1990b). Even the design by Alberta architect Douglas J. Cardinal did not escape criticism, being described by another architect as 'prairie gopher baroque.'

The illuminated Parliament Buildings in the background of the cover photo of MacDonald and Alsford's (1989), *A Museum for the Global Village: The Canadian Museum of Civilization,* fills in quite nicely for Fantasyland Castle. It was also appropriate, even if unintentional, that during the same week in 1987 when the then U.S. vice-president, George Bush, visited Prime Minister Brian Mulroney, someone dressed as Mickey Mouse visited Speaker of the House John Fraser and made him an honorary citizen of Walt Disney World (Canadian Press 1987:A5).

In the debate about cost overruns and the Disneyland-Global Village references by CMC director George MacDonald, what has tended to get lost are his and his staff's attempts to restructure the very nature of the museum enterprise. For example, they systematically integrate theatre and art gallery functions and associated disciplines with anthropology and history displays; consult with indigenous peoples and others on how they are to be represented; increase access to information about collections through electronic technology; develop marketing plans based on the concept of cultural tourism; borrow management and display techniques from theme parks; and substitute the authenticity of the visitor experience for the authenticity of the 'real' object.

The way the CMC is redefining the traditional concept of authenticity is particularly significant. Museums pride themselves on being the

last refuge for the 'real thing,' the 'authentic object,' MacDonald has said, but they fail to portray the real cultures from which those real objects derive. North American curators, MacDonald notes (1988:29),

> are 98 per cent white Euro-Americans whose knowledge of North or South American Indian, African, Japanese or Chinese culture is definitely second-hand. Most curators, even in anthropology, spend at most a few years in the cultural milieu of their 'specialty.' In fact, they have the cultural credibility and often linguistic competence of a four-year-old child from that culture ... They have never been cultural participants and will never have the credibility of 'the real thing.'

Collections become an expensive burden to museums because of the mandate to preserve and exhibit them even though so little is known about them that it is difficult to present them authentically:

> Most museum directors now feel like directors of geriatric hospitals whose budgets are devastated by patients whose survival for another day depends on expensive, high technology support systems. Conservators in museums are like a host of relatives who guard the wall plug of the life-support machines. Sixty per cent of most museum budgets are spent on life-support systems for the 'reserve' collections, and conservators constantly battle to increase that amount. There is no apparent solution to this dilemma. The museum is the final repository of 'the real thing.' (MacDonald 1987:213-14)

According to MacDonald museums should give more attention to presenting real experiences with the assistance of people from those cultures being represented, and redistributing reserve collections to regional museums. The authenticity of the experience, rather than the authenticity of the object, becomes the objective, and the use of replicas, simulations, performances, and electronic media intertwined with real objects – techniques in which theme parks excel – help recreate, reconstruct, or rerepresent near-authentic experiences (MacDonald 1988). The 'real thing' is the experience of the visitor, not the object or its interpretation by a curator.

One reason why proposals like MacDonald's are controversial within the museum community (Ames 1988b) is their implied shift of power and status away from curator, registrar, and conservator towards those more directly involved in public programming, performance, promotion, marketing, other public services, and revenue generation. These changes respond to growing pressures on museums to generate more of their own operating costs. The curatorial professions are, in a sense, coming under siege, their prerogatives in-

creasingly encroached upon, even though they have been actively professionalizing or upgrading their own standards of work over the past decade. Unfortunately, this professionalization has been mostly oriented to behind-the-scenes collections management and has become costly. Registration, cataloguing, condition reporting, insurance reports, conserving and caring for the object, and so on, are all labour-intensive activities. Further professionalization, as presently envisaged, typically calls for even more labour. Museums are heading for a crunch. Curatorial staff want more support for backstage object-centred work while their programming colleagues try to expand frontstage activities to enlist more public support. Traditional museological notions about object care are being increasingly confronted by the seemingly more 'commercial' values of public service and cost-effectiveness. The bottom line is coming to the top of the agenda, making many uncomfortable.

If museums do not become more commercial and popular they may not survive in any useful form. Yet people continue to criticize museums like the CMC for sacrificing integrity and authenticity on the alter of populism (see Gray 1988; Thorsell 1989). But how is integrity to be judged? The answer from MacDonald and the Canadian government is straightforward: if about 80 per cent of the population rarely visit museums, new approaches must be tried to attract them; entertainment seems to be the way to do it. The fact that half a million people visited the CMC during the first few months, the then secretary-general of the National Museums, John Edwards (1989), said, demonstrates that they must be doing something right, despite what the critics are saying. 'The Canadian Museum of Civilization turned one year old Friday and its director says it's on its way to becoming the popular people's museum it was meant to be,' reported the Canadian Press (1990b) on the CMC's first anniversary. Integrity, from this point of view, means serving the public first, not the objects (or the curatorial professions).

THE POLITICS OF ART: 'THE SPIRIT SINGS' AND THE LUBICON BOYCOTT

The Glenbow Museum's 1988 exhibition 'The Spirit Sings: Artistic Traditions of Canada's First Peoples,' like 'Into the Heart of Africa,' also caused protest over messages stated, implied, and presumed – another example of good intentions leading to mixed results (Harrison 1988; Harrison et al., 1987; Harrison, Trigger, and Ames 1988; Trigger 1989; Ames 1989).

The Glenbow's six curators wanted to demonstrate the richness, diversity, and adaptability of indigenous peoples during the first years

of contact with Europeans, but their exhibition got caught in the crossfire of a political campaign to support a land claim by the Lubicon Lake Cree in northern Alberta. The Lubicon called for a boycott of the 1988 Calgary Winter Olympics to draw attention to their fifty-year dispute with the Canadian government over land claims. Attention gradually shifted from the Olympics (and to some extent from the land dispute) to the Glenbow and its right to mount an exhibition of Native arts during the Olympics over the objections of a Native group not represented in the exhibition. Probably many would have agreed with Alberta Native artist Joane Cardinal-Schubert (Patterson 1988:8) who found the Glenbow exhibition 'so offensive': 'It shows 300-year-old stuff, which only serves to reinforce the lack of attention paid to the contemporary problems of tribes such as the Lubicon. Not only that, but the work itself, all taken from the Indian, is removed from its life involvement.'

The museological defence that some works displayed were gifted or sold by indigenous peoples rather than 'taken'; that museums have always been expected to preserve and represent the past (otherwise who would?); and that most of the 300-year-old materials probably only survived because they were removed from 'life involvement' sounds self-serving when placed against the poverty of these peoples whose lands have been expropriated and lifestyles almost destroyed. Whether they like it or not, museums have become a part of the discourse about endangered peoples. The question is whether they will have anything useful to say or do about the matter. Can museological principles be bent towards worldly concerns?

The strategy of those who proposed a boycott of the Glenbow was to disseminate criticisms of it and the proposed exhibition, effectively turning a debate about land claims into a moral critique of museological prerogatives. As Robert Paine (1985:190) noted about other indigenous protests: 'Much of Fourth World politics is about turning physical powerlessness into moral power and then putting that to good political account.' The 'politics of morality' become 'a politics of embarrassment' (ibid.:214) directed against the authorities and their sometimes hapless wards. The campaign against 'The Spirit Sings' received widespread attention and sympathy, including the support of many Canadian anthropologists (though it did not resolve the land claims dispute). We see again how the authority of cultural experts and cultural institutions is contested. The Glenbow Museum was challenged on a number of points that have wider implications, including its right to:

1 borrow or exhibit Native artefacts without their permission, even though those artefacts are legally owned by other museums;

2 use money from corporations involved in public disputes (the exhibit was sponsored by Shell Oil, which was drilling on land claimed by the Lubicon);
3 ignore contemporary political issues, such as land claims, even when presenting an exhibition of the history of indigenous peoples;
4 employ non-Natives to curate an exhibition about Native culture; and
5 claim neutrality in public disputes.

The broader issues underlying these challenges affect more than just the privileges of anthropology. Who should decide what constitutes knowledge about a people's history – scholars or the living descendants of those studied? When should moral and political claims outrank legal obligations (such as the Glenbow's agreements with donors and lenders)? And what should be the costs of public association with those accused? Some Lubicon supporters wanted 'The Spirit Sings' closed down because Glenbow curators did not change the exhibition text and because it was sponsored by Shell Oil and the federal government. (Interestingly, there was no attempt to boycott Shell products or government agencies. Perhaps the Glenbow offered a better opportunity to define the issues in moral terms and was thought to be more easily embarrassed.) The 'fire the curators' syndrome, adding punishment to criticism, appears again. Lubicon supporters made a claim for the higher ground by redefining an academic museum exhibition as a morality play between good and evil. Once evil is identified, it has to be exorcised if goodness is to triumph.

THE POLITICS OF PUBLIC TASTE: PORNOGRAPHY AND BLASPHEMY

Possibly the biggest single debate in the arts community in North America in 1989 and extending into the 1990s, was over the question of who has the right to decide public taste. What sparked the debate were two controversial exhibitions, one of the works of photographer Robert Mapplethorpe, some of whose photos were said to be pornographic and homophobic; and the other by photographer Andres Serrano, whose photos, especially his *Piss Christ*, were called blasphemous trash.

'Fine Art or Foul?' read the headline to a *Newsweek* cover article (Mathews 1990:46). United States Congress representatives and senators threatened to cut the budget allocation to the National Endowment for the Arts for financing such 'shocking' and 'abhorrent'

materials in the name of 'art' and to deny future funding to those galleries that displayed 'obscene' works (Alaton 1990; American Association for State and Local History 1990:1). Senator Jesse Helms told the u.s. Senate (Vance 1989:39): 'I do not know Mr. Andres Serrano, and I hope I never meet him, because he is not an artist, he is a jerk. Let him be a jerk on his own time and with his own resources. Do not dishonor our Lord.' The Mapplethorpe exhibit continued to circulate through u.s. art galleries and got into trouble again in March 1990 in Cincinnati, Ohio, where the director of the Centre for the Contemporary Arts was charged with obscenity for showing the exhibit.

Earlier in 1990 the Mendel Gallery in Saskatoon, Saskatchewan, was also temporarily besieged by the Saskatoon City Council and others for housing the National Photography Gallery's travelling exhibition 'Evergon,' which also included sexually explicit imagery (Lacey and Vincent 1990; Milrod 1990). 'We have laws to clean up pollution in our rivers,' one city councillor was quoted as saying, 'so we should have laws to ban filth like this.' He was perhaps repeating *Washington Times* columnist Patrick Buchanan's metaphor (cited in Vance 1989:41): 'As with our rivers and lakes, we need to clean up our culture: for it is a well from which we must all drink. Just as a poisoned land will yield up poisonous fruits, so a polluted culture, left to fester and stink, can destroy a nation's soul.'

People called for Mendel director Linda Milrod to be fired and the gallery's budget to be cut. (After weeks of debate, in council and through the local media, city council voted to continue normal funding for the gallery. Milrod subsequently resigned but for reasons unrelated to this controversy.) When Andres Serrano attended the 'Art and Outrage' conference on art and censorship at the Winnipeg Art Gallery on 31 March 1990, a Winnipeg councillor described him as 'a lunatic who should be in an asylum, not in the Winnipeg Art Gallery.' Anthropologist Carol Vance suggested at the same Winnipeg conference that the good people of Saskatoon and Winnipeg were experiencing a 'sex panic,' projecting upon people like Serrano, Evergon, and Mapplethorpe their anxieties about changes in family and gender relations, abortion, child abuse, and so on. (The Winnipeg conference was reported by Enright 1990. See also Vance 1989, 1990; Wallis 1990.)

Whatever the reasons, it is interesting to note that arguments which first seemed to centre around pornography, blasphemy, artistic freedom, and censorship, gradually began to encompass broader issues (see Robertson 1990) such as what is art, who is it for, who pays for it, and who calls the tune? We have returned to the politics of representation and the question of voice:

(a) What is art? Counterbalanced are two views about the purpose of art (and of exhibits, and even of anthropology, one might add): to be inspirational and supportive of mainstream values or to be critical, oppositional, or even sometimes offensive.
(b) Who is it for, the élites or everyone?
(c) Who pays for it? The debate here is over how much governments should support art or exhibitions that do not support the state or are not supported by the public 'in the marketplace.'
(d) Who calls the tune? Who should decide how taxpayers' dollars are used – legislators, panels of experts, peer review, or special-interest groups through public protest?

Without the freedom to offend, British author Salman Rushdie once said (Findley 1990), there is no freedom of expression: 'Without the freedom to challenge, even to satirize all orthodoxies, including religious orthodoxies, it ceases to exist. Language and the imagination cannot be imprisoned, or art dies, and with it, a little of what makes us human' (Rushdie 1990:6).

'It is perhaps in the nature of modern art to be offensive,' American writer John Updike (1989:12) wrote in response to the Mapplethorpe controversy. 'It wishes to astonish us and invites a revision of our prejudices.' What is more (1989:13): 'if we are not willing to risk giving offense, we have no claim to the title of artists, and if we are not willing to face the possibility of being ourselves revised, offended, and changed by a work of art, we should leave the book unopened, the picture unviewed, and the symphony unheard.' (Might one make the same claim for anthropologists that he makes for artists?)

On the other side – and there is always that other side in these matters (and usually more than one) – is the question of setting limits out of respect for community standards or the sensitivities of others. At some point it is necessary to stop and think about the people who might be offended. u.s. Senator Jesse Helms has frequently spoken out against the use of tax dollars for art he considered offensive. Let people be offensive at their own expense, he says. 'Should public standards of decency and civility be observed in determining which works of art or art events are to be selected for the government's support?' asked *The New York Observer* art critic Hilton Kramer (1989:1). Or, stating the issue another way, he continues, 'is everything and anything to be permitted in the name of art? Or, to state the issue in still another way, is art now to be considered such an absolute value that no other standard – no standard of taste, no social or moral standard – is to be allowed to play any role in determining what sort of art it is appropriate for the government to support?'

Canada's revenue minister, Otto Jelinek, referring to a Canada Council grant to a theatre that produced a play about homosexuals, remarked (Dafoe 1989) that 'some of these ridiculous grants are enough to make me bring up' and that his government should review the arms-length status of the Council.

We have returned to the marketplace as an arbiter of public taste (see Chapter 12). Public appeal is the test of virtue. As Senator Helms said in reference to the Mapplethorpe/Serrano controversies (Parachini 1989:3): 'I have fundamental questions about why the federal government is involved in supporting artists the taxpayers have refused to support in the marketplace.' Thus, the debate about the purpose of art becomes a language for examining broader questions about what constitutes a proper society, including the contest between the moral visions of the conservatives and liberals (Alaton 1990; Vance 1990). 'The fundamentalist attack on images and the art world,' Vance (1989:43) argues, 'must be recognized not as an improbable and silly outburst of Yahoo-ism, but as a systematic part of a right-wing political program to restore traditional social arrangements and reduce diversity.'

CONCLUSION: SOME COMMON THREADS

If we examined each case in detail we would find many differences and some similarities. I want to focus on the similarities here, especially those that lie behind the differences.

One pattern extends beyond these cases: the widespread inclination to question the authority of cultural agencies, such as museums and universities, and their professional representatives, to make decisions that go against those moral standards that are claimed by some to represent either the public's interest or the concerns of underrepresented populations.

This is not new. Sociologist Alvin Gouldner, in his 1970 *The Coming Crisis of Western Sociology* (1970:115-16, passim), noted a long, continuous series of 'revolts' against the idea of applying empiricist methodologies to the study of society and its expressions. In his classic 1947 paper, 'The Expansion of the Scope of Science,' Leslie White suggested that the scientific or naturalistic perspective would appear latest, mature slowest, and receive the most opposition in the psychological, social, and cultural areas of our experience 'where the most intimate and powerful determinants of our behavior are found.' There have been renewed assaults on the notion of a scientific study of society during the past several decades, from within the disciplines as well as from outside, identifying the limitations, fallacies, and

male-centric orientation of the naturalistic approaches. Some, per-
haps buoyed along by a postmodernist enthusiasm, reject the possi-
bility of any objective knowledge about society, opting for the equal-
ity of insider perspectives. Everyone is his or her own authority, just
as the customer is always right. Consumerism and postmodernism, it
would seem, share similar ideological foundations. The possibility of
positive knowledge cannot be totally extinguished, however, no mat-
ter how often attacked by those claiming higher moral grounds.

Resistance and rebellion against naturalistic or empirical interpre-
tations might be seen as recurring features of intellectual history,
though their labels change from one age to the next – 'postmodern-
ism' being one of the more recent – and though intellectual discourse
never totally succumbs to those onslaughts. Other features in our
cases seem to be more emergent than repetitive.

One emergent feature concerns the type of morality that appears to
be gaining ascendency – or, to use another trendy word, gaining 'he-
gemony' – in contemporary society. It is that populist/postmodern-
ist/consumer ideological orientation referred to earlier and includes,
in one form or another, the radical democratic idea that in the market-
place of ideas, customs, and morals, as in the marketplace of prod-
ucts, the customer is always right. As the Member of Parliament the
Honourable Felix Holtmann noted in an interview (Godfrey 1990): 'I
basically believe the people are always right. The customer is king.'

Another illustration of this view is Canadian economist Steven
Globerman's (1983:37) argument that claims for government subsidy
by the cultural sector based on the assumption that some tastes are
better than others 'is an unacceptable basis for government action in a
democratic society.' Good taste is popular taste. Or consider British
Columbia's former premier Bill Vander Zalm's response (Moore
1987) to those concerned about the impact of free trade with United
States on Canadian culture: 'What is culture? I'm not sure Canadians
are all that concerned by what is traded away in culture ... I don't
think there's much wrong with the marketplace determining what
people want in culture.'

There are other examples one could cite, but these will do for now
(see also Chapters 11 and 12). In the broader philosophy (see Marchak
1988: Chapters 1 and 8), of which these are individual expressions,
there is a tendency to view citizens as consumers, to redefine cultures
as commodities, to measure value by public opinion polls, referenda,
head counts, and sales receipts, and to believe that justice is probably
best determined by the play of so-called free market forces. In fact,
the marketplace is typically represented as an ideal paradigm for or-
ganizing social as well as economic relations.

The second emerging feature, ambiguously related to the first, is the increasing public recognition of social and cultural pluralism. Contemporary society is not composed of an anonymous mass of consumers but rather – to borrow from the language of consumerism – of various 'market segments,' each with its special tastes and vested interests. What is significant about this pluralization or taste segmentation of society is not its existence, which is not new, but its growing visibility and acceptance, even if that growth is slow, frequently petulant, agonizing, and uneven. The implication for cultural institutions, such as museums and universities, is that they are increasingly being expected to meet the multiple demands of ethnically and socially diverse publics. In this new world order the minorities expect the same rights and privileges as the majority. For anthropologists that especially means giving consideration to the interests of Third World peoples and visible minorities. The introduction of third and fourth voices (worlds) – the traditional subjects of anthropological research – has been unnerving for anthropologists, who find themselves being publicly criticized and rejected by the very people they have tried to represent!

Fueling the assertion of minority rights is the idea of equality, which must be one of the most revolutionary ideas in all history. It is difficult to think of any other single principle that has had such an impact on social arrangements and personality formation, that throughout history has been as oppositional, confrontational, or destructive of traditional relations, and as transforming, emancipating, or liberating for individuals and groups. The belief that one has a natural right to be the equal of others is surely one of the most powerful of beliefs. Perhaps its most radical version is the assertion of collective (ethnic) rights over those of the individual and, thus, the right to be different as equal to the right of everyone to be the same.

The growth of cultural and ethnic pluralism and ideas about the equality of groups as well as of individuals in a consumer-oriented, postmodernist, deconstructing society raises several questions about the status of the anthropological perspective. First is the question of voice. In a plurality of tongues what happens to scholarly speech? Naturalistic interpretation, rooted in empiricism, has traditionally claimed cognitive superiority over those based on moral, communal, or popular considerations. But who can claim superiority in an equalitarian society? Is anthropology only to be regarded as one more voice among many, perhaps even inferior to the self-interpretations of underrepresented peoples? Has anthropology become just another story, yet another mythic 'discourse,' now that its colonial and sexist origins have been fully exposed? It is not just museum exhibits that

are being criticized here, by the way – it is the very idea of studying others, never mind representing them, that is challenged. The contest is over the essence of anthropology. How, then, is anthropology to be reconstituted during this age of populist deconstruction?

The second question is about action. How will anthropologists and other cultural workers help people come to terms with the growing multicultural and multivocal realities – discordant realities, one might even say – of contemporary society? Will anthropologists in museums and elsewhere have the authority and public respect, not to mention the courage, to speak out? Or will they be lost in the cacophony of voices, reduced by public criticism, populist sentiments, funding restrictions, and the forces of the marketplace to bland pronouncements and tangled rhetoric?

Notes

CHAPTER 1: INTRODUCTION

1 The British Museum's Museum of Mankind's 'Students' Room' is certainly an idea other museums would do well to copy. It is also worth noting that curators in most large public museums are typically hard to find. This always seems strange to me since university faculty, who can be just as busy, are customarily expected to maintain regular public office hours.

2 'Native' in this sentence is used in the generic anthropological sense of participant or 'actor' in a community being studied. From this point of view everyone is a native at one time or another. Elsewhere in this book the term refers more specifically to the Native or First Peoples of North America. For a further comment on the 'naming of the Other,' see the Preface to the Second Edition.

3 This and the next three paragraphs are taken from a short note published in the British Columbia Museums Association newsletter *Round Up* (Ames 1991).

CHAPTER 2: DEVELOPMENT OF MUSEUMS IN THE WESTERN WORLD

1 This chapter was first presented as a Special Lecture to Section 8: Anthropology and Archaelogy, LXXI Indian Science Congress, Ranchi, 4 January 1984.

2 Most of the information for this account was drawn from Key (1973:36–8).

3 Text of the inscription on the front of the Royal Ontario Museum, Toronto.

CHAPTER 3: DILEMMAS OF THE PRACTICAL
ANTHROPOLOGIST

1 I would like to thank Margaret Meikle, University of British Columbia Museum of Anthropology, for information that assisted in the preparation of this chapter.
2 Evel Knievel is an American daredevil who earned several million dollars during the 1970s riding his motorcycle over buses and canyons.

CHAPTER 4: ANTHROPOLOGY OF MUSEUMS AND
ANTHROPOLOGY

1 An earlier version of this chapter was presented in a paper to the annual meeting of the Canadian Ethnology Society, Vancouver, 11 May 1982.
2 Unfortunately for the title of my paper, Ridington changed the title of his to 'Mirrors and Masks' when he published it (1979).
3 I use the terms social anthropology and ethnology interchangeably to refer to the socio-cultural branch of anthropology, which is customarily distinguished from archaeology, physical anthropology, and linguistics. Ethnology is frequently used in the museum context and social anthropology almost never.
4 In making this distinction I draw heavily upon an unpublished note prepared in 1982 by the Museums Assistance Programme of the National Museums of Canada, entitled 'Exhibitions Assistance Programmmes and Museums of Human and Natural History, Science and Technology.'

CHAPTER 5: HOW ANTHROPOLOGISTS STEREOTYPE
OTHER PEOPLE

1 Earlier versions of this chapter were presented in a paper to the Royal Society of Canada, June 1983, subsequently published in *Transactions of the Royal Society of Canada*, Series IV, Volume XXI, 1983, and to the Commission on Museums of the International Union of Anthropological and Ethnological Sciences, August 1983, both in Vancouver. It is reprinted here by permission of the Royal Society of Canada.

CHAPTER 6: HOW ANTHROPOLOGISTS FABRICATE
CULTURES

1 An earlier version was read at a session on 'Museum Ethnology' at the sixth annual meeting of the Canadian Ethnology Society, Banff, 24 February 1979, and was subsequently revised and published in *BC Studies* 49 (1981) under the title 'Museum Anthropologists and the Arts of Accultura-

tion on the Northwest Coast.' Grateful acknowledgment is made to Carole Farber, Marjorie Halpin, B. Ann Krahn, Peter Macnair, and Lynn Maranda for generously providing information for this paper. The author is alone responsible for any errors and omissions, however. It is reprinted here with the permission of the editor of BC *Studies*.

CHAPTER 7: DEFINITION OF NATIVE ART

1 Originally published under the title 'Bill Holm, Willie Seaweed and the Problem of Northwest Coast Indian "Art": A Review Article,' BC *Studies* 64 (Winter 1984–5):74–81, reprinted by permission of the editor of BC *Studies*. For a discussion of the use of the terms 'Indian,' 'Native,' etc., see Preface to the Second Edition and Note 2, Chapter 1.

CHAPTER 8: NATIVE VIEW OF HISTORY AND CULTURE

1 Earlier versions of this chapter were presented to the Faculty of Environmental Design, University of Calgary, Alberta, 9 October 1985 and to the conference, 'Making Exhibitions of Ourselves: The Limits of Objectivity in Representations of Other Cultures,' British Museum, London, 13–14 February 1986. An abbreviated version was published as 'Free Indians from their Ethnological Fate,' *Muse*, Journal of the Canadian Museum Association, 5 (1987):14–25, and is reprinted here by permission. The term 'Native' in the title refers to the indigenous First Peoples or First Nations of North America, usually referred to in Canada as Indians, Inuit, and Métis. It can also be taken in the broader anthropological sense to mean those who are the subjects of anthropological inquiry. See Preface to the Second Edition and Note 2, Chapter 1.
2 'The National Native Indian Artists Symposium' was co-ordinated by Doreen Jensen, a Gitksan artist, and Reva Robinson, an anthropologist associated with the University of British Columbia Museum of Anthropology. A report was prepared by two other anthropologists (Farber and Ryan 1983) and a one-hour video produced from sixteen hours of tape. (The video can be obtained from Video Inn, 261 Powell Street, Vancouver, Canada.)
3 David Bell (1982:29) says Santa Fe, in the southwestern United States, has been a 'fulcrum for the development of Native American art since the early 1900s.'
4 The first three of Wade and Strickland's (1982:24–5) four categories of Native art – historic expressionism, traditionalist, and modernist – seem to be mostly subsumed by Phillips's imagistic type (drawing upon identifiably Native imagery). Their fourth type, individualism, is only partly included with Phillips's philosophical connection, for it extends to where a Native

work of art may be 'totally indistinguishable from mainstream contempo-
rary art.'

CHAPTER 9: DE-SCHOOLING THE MUSEUM

1 Revised version of an article from *Museum*, Journal published by UNESCO,
 37, no. 1 (1985). Published here by permission of UNESCO. Presented earlier
 to Ranchi University, January 1984 and to the International Committee of
 Architecture and Museum Techniques of the International Council of Mu-
 seums, London, August 1983.
2 I limit my remarks to museums of history, culture, and art because they are
 more familiar to me.
3 I would like to thank John Mitchell and Nathalie Macfarlane, who were
 director and curator of the Port Alberni Museum when it instituted its
 open storage system, for their assistance in obtaining information about
 their program.
4 I would like to thank Duncan Cameron, director of the Glenbow Museum,
 for his assistance in obtaining information about the Glenbow proposal.
5 Grateful acknowledgment is made to Stephen Inglis for information that
 assisted in the writing of this conclusion.

CHAPTER 10: ARE MUSEUMS OR ANTHROPOLOGY NECESSARY?

1 The concluding section of this chapter is drawn from a paper presented to
 the first annual meeting of the Society for Applied Anthropology in Can-
 ada, 11 May 1982, and subsequently published in an Occasional Paper of
 that Society (Ames 1983a).

CHAPTER 11: WORLD'S FAIRS

1 Earlier versions of this chapter were presented to the annual meetings of
 the Canadian Ethnology Society, Edmonton, 16 May, and the Canadian
 Museums Association, Victoria, 23 May 1986. Work on it benefited consid-
 erably from discussions with a number of people, especially Diane L. Ben-
 nett, Brenda Berck, Julia D. Harrison, Margaret Holm, David Jensen,
 Nathalie Macfarlane, Bill McLennan, Ron Woodall, and officers of the Brit-
 ish Columbia Pavilion at Expo '86. I gratefully acknowledge their contribu-
 tions, though they bear no responsibility for what is written here. A shorter
 and somewhat different version of this chapter was presented to a confer-
 ence on American popular culture in Canada (Ames 1988d).
2 Ikea is a Swedish owned furniture and houseware chain designed like a su-
 permarket with open storage areas. See Chapter 9.

CHAPTER 12: THE BIG MAC ATTACK

1 First presented to 'The Anthropology of Popular Culture,' annual meeting of the Canadian Ethnology Society, Quebec City, 16 May 1987. An earlier, longer, and somewhat different version was first presented to the Western Canada Art Association, Regina, 25 April 1987, then to the British Columbia Museums Association annual meeting, Kimberly, BC, 7 October 1987, and subsequently published in *Parachute* 49 (1987, 1988):22–7, and is reprinted here in revised form by permission.

CHAPTER 13: THE POLITICS OF INTERPRETATION

1 A shorter version of these remarks was presented as a discussion of the five papers presented at the special symposium, 'The Objects of Culture,' chaired by Peter H. Welsh and Nancy J. Parezo, the American Anthropological Association annual meeting, Phoenix, 19 November 1988. The authors and their papers: Virginia R. Dominguez, 'On Creating a Material Heritage'; Nancy J. Parezo, 'A Glass Box for Everyone: Displaying Other Cultures'; Ira Jacknis, 'Franz Boas and the Object: Artifacts, Texts, and Museums'; Shelly E. Errington, 'Objects of Power'; and Peter H. Welsh, 'Exotic Illusions: Museum Exhibits and Cultural Interpretation.' I am indebted to Nancy J. Parezo for helpful comments on a draft of this chapter.

2 For a similar distincion between audiences, but with different labels, see Ames, Harrison, and Nicks 1988. We used the terms 'constituents' or 'taxpayers' for those who normally visit museums (Welsh's 'visiting audience'), and 'originating populations' (Welsh's 'constituents') for those from whose cultures museum collections have originated.

3 No single term for the Aboriginal peoples of North America is universally accepted. The terms 'Native American,' 'Native peoples,' indigenous peoples, and 'First Nations' are used here to refer to Indian, Inuit, Métis, and others who designate themselves as First Peoples. 'First Nations' and 'First Peoples' are being used increasingly by Natives and their organizations in Canada in preference to white labels such as 'Indian.' See also Preface to the Second Edition and Note 2, Chapter 1.

CHAPTER 14: MUSEUMS IN THE AGE OF DECONSTRUCTION

1 Earlier versions of this chapter were presented to the Plenary Session 'Recent Developments in Canadian Anthropology' at the seventeenth annual meeting of the Canadian Anthropology Society, Calgary, Alberta, 2 May 1990, and to the University of Washington 'Seminar on Ethnicity, Nationality, and the Arts,' co-ordinated by Professor Simon Ottenberg, 8

May 1990. I am thankful for those opportunities. I am also indebted to Dr. Jeanne Cannizzo, research consultant of the Royal Ontario Museum, Lina Jabra, then director of the Burnaby Art Gallery, and Dr. Judith Mastai, director of Public Programmes at the Vancouver Art Gallery, for supplying information on a number of the case studies discussed here. This chapter is also to be published in a series edited by Professor Ottenberg. Materials from this chapter were included in a report to the Taonga Maori Conference, New Zealand, 20 November 1990, entitled 'Biculturalism in Exhibits' to be published by the government of New Zealand, also published in *Museum Anthropology* 15(1991)2, and reproduced here by permission of the American Anthropological Association.

Bibliography

Adams, Marie Joanne
 1981 Mediating our Knowledge. In A.E. Cantwell, J.B. Griffin, and N.A.
 Rothschild, eds., *The Research Potential of Anthropological Museum
 Collections.* Annals of the New York Academy of Sciences
 376:289–300
Alaton, Salem
 1984 Too Long at the Fair. *Globe and Mail,* 10 August, 13
 1990 Liberals and Conservatives in Row over u.s. Arts Body. *Globe and
 Mail,* 9 June, D3
Alexander, Edward P.
 1979 *Museums in Action: An Introduction to the History and Functions of Mu-
 seums.* Nashville: American Association for State and Local His-
 tory
Alexander, Robin
 1981 The Evaluation of Naturalistic, Qualitative, Contextualist, Con-
 structivist Inquiry in Art Education. *Review of Research in Visual
 Arts Education* 13:34–43
American Anthropological Association
 1983 Award for Highest 22 of Unemployed PhD's Goes to – Anthropol-
 ogy. *Anthropology Newsletter* 24 (6):6–7
American Association for State and Local History
 1990 Reauthorization Critical for NEH. *History News Dispatch* 5 (6):1
Ames, Michael M.
 1977 Visible Storage and Public Documentation. *Curator* 20 (1):65–79
 1979 Applied Anthropology in Our Backyards. *Practicing Anthropology* 2
 (1):7, 23–4
 1981a Preservation and Access: A Report on an Experiment in Visible
 Storage. *Gazette,* Journal of the Canadian Museums Association
 (Summer-Fall):22–33

1981b Museum Anthropologists and the Arts of Acculturation on the Northwest Coast. *BC Studies* 49:3–14

1983a Canaries and Court Jesters: Some Practical Implications of Practicing Anthropology in Museums and Academic Institutions. In Kathryn T. Molohon, ed., panel discussion on the Present State of the Art of Applied Social Science in Canada. *Occasional Papers of the Society of Applied Anthropology in Canada/Société d'anthropologie appliquée du Canada* 1:3–11

1983b De-Schooling the Museum: A Report on Accessible Storage for the International Committee of Architecture and Museum Techniques, thirteenth general conference of the International Council of Museums, London, July-August, 1983

1983c How Should We Think About What We See in a Museum of Anthropology? *Transactions of the Royal Society of Canada* 21 (4):93–101

1984–5 Bill Holm, Willie Seaweed and the Problem of Northwest Coast Indian 'Art': A Review Article. *BC Studies* 64:74–81

1986a *Museums, The Public and Anthropology.* New Delhi: Concept Publishing and Vancouver: University of British Columbia Press

1986b Report from the Field: The Democratization of Anthropology and Museums. *Culture,* Journal of the Canadian Anthropology Society, 6 (1):61–4

1987 'Free Indians from Their Ethnological Fate': The Emergence of the Indian Point of View in Exhibitions of Indians. *Muse,* Journal of the Canadian Museums Association, 5 (2):14–25

1987–8 Is the McDonald's Hamburger a Work of Art? A Discourse on Popular Aesthetics and Unpopular Curators. *Parachute* 49:22–7

1988a Proposals for Improving Relations between Museums and the Indigenous Peoples of Canada. *Museum Anthropology* 12 (3):15–19

1988b Daring to be Different: An Alternative. *Muse,* Journal of the Canadian Museums Association, 6 (1):38–47

1988c Cannibal Tours and Glass Boxes: A Discussion of 'The Objects of Culture' and the Politics of Interpretation. Paper presented to the special symposium, 'The Objects of Culture,' chaired by Peter H. Welsh and Nancy J. Parezo, annual meeting of the American Anthropological Association, Phoenix, 19 November

1988d The Canadianization of an American Fair: The Case of Expo '86. Paper presented to the Conference on American Popular Culture: Mass Communications and Public Performances, London, Ontario: University of Western Ontario, 4–6 May

1989 The Liberation of Anthropology: A Rejoinder to Professor Trigger's 'A Present of Their Past?' *Culture,* Journal of the Canadian Anthropology Society, 8 (1):81–5

1990 Cultural Empowerment and Museums: Opening Up Anthropology Through Collaboration. In Susan Pearce, ed., *New Research In Museum Studies, Vol. 1, Objects of Knowledge.* London: Athlone, 158–73

1991 Are Museums Becoming Irrelevant? *Round Up,* Newsletter of the British Columbia Museums Association, 164:11

Ames, Michael M. and Claudia E.J. Haagen

1988 A New Native Peoples' History for Museums. *Native Studies Review* 4 (1–2):119–27

Ames, Michael M., Julia Harrison, and Trudy Nicks

1988 Proposed Museum Policies for Ethnological Collections and the Peoples They Represent, *Muse,* Journal of the Canadian Museums Association, 6 (3):47–52

Anderson, Robert and Eleanor Wachtel, eds.

1986 *The Expo Story.* Madeira Park, BC: Harbour Publishing

Anonymous

1985a Frontier Outlook Leans to 'Loan Gun.' *Province,* 6 October, 29

1985b Planner has Beef with Floating McDonald's. *Vancouver Sun,* 25 July, A1–2

1985c The Object and the Museum: Indian and Inuit Art Curators Report. *Museogramme,* Newsletter of the Canadian Museums Association, 13 (5):4

Appadurai, Arjun

1988 Introduction: Commodities and the Politics of Value. In Arjun Appadurai, ed., *The Social Life of Things: Commodities in Cultural Perspective.* Cambridge: Cambridge University Press, 3–63

Appell, George

1977 The Plight of Indigenous Peoples: Issues and Dilemmas. *Survival International Review* 2 (3):11–16

1980 The Social Separation Syndrome. *Survival International Review* 5 (1):13–15

Arnell, Ulla, Inger Hammer, and Goran Nylof

1976 *Going to Exhibitions.* Stockholm: Riksutstallningar

Assembly of First Nations

1989 Minutes of 'Preserving Our Heritage' Conference, Ottawa, 3–5 November, 1988. Dated 18 January 1989

Atwood, Margaret

1972 *Survival: A Thematic Guide to Canadian Literature.* Toronto: Anansi

Balfe, Judith H.

1987 Affinities of Art and Politics: Gilt by Association. *Controversies in Art and Culture* 1 (1):1–17

Bandara, H.H.

1972 *Cultural Policy in Sri Lanka.* Paris: UNESCO Studies and Documents on Cultural Policies

Baxi, Smita J.
 1973 Museum Exhibitions and Display Techniques. In S.J. Baxi and V.P.
 Dwivedi, eds., *Modern Museum Organization and Practice in India*.
 New Delhi: Abhinav Publications, 57–84
Bedard, Joanna
 1988 Foreword to Doxtator 1988a, 5
Bell, David
 1982 Walk in Beauty. *Four Winds: The International Forum for Native Amer-
 ican Art, Literature, and History* 2 (4):28–31
Bell, Ken
 1986 False Creek McFeast. *Province*, 8 June, 29
Benedict, Burton
 1983 *The Anthropology of World's Fairs. San Francisco's Panama Pacific Inter-
 national Exposition of 1915*. London and Berkeley: Lowie Museum
 of Anthropology and Scolar
 1986 The Competition of Nations at World's Fairs. Paper presented to
 'Making Exhibitions of Ourselves: The Limits of Objectivity in
 Representations of Other Cultures.' Conference at the British Mu-
 seum, London, 13–14 February, 1986
Bennett, Diane L.
 1986 The Culturally Conditioned World of Expo '86: Gender Splitting at a
 World's Fair. Vancouver: University of British Columbia Museum
 of Anthropology manuscript
Bennett, Julia
 1990 High Flyers: National Gallery's Shirley Thomson Masters the Mod-
 ern Art World. *Privilege* 2 (1):11–12
Berger, Thomas R.
 1985 *Village Journey: The Report of the Alaska Native Review Commission*. New
 York: Hill & Wang
Berkhofer, Robert, Jr.
 1979 *The White Man's Indian: Images of the American Indian From Columbus to
 the Present*. New York: Vintage Books
Bernstein, Richard J.
 1978 *The Restructuring of Social and Political Theory*. Philadelphia: Univer-
 sity of Pennsylvania Press
Bewley, Les
 1983 Cancelling the Penalty for Failure. *Vancouver Sun*, 25 October, 5
Blackwood, Beatrice
 1970 Classification of Artefacts in the Pitt Rivers Museum, Oxford. *Occa-
 sional Papers on Technology 2*. Oxford: Pitt Rivers Museum
Blizzard, Christina
 1990 Exhibit Mirrors History. *Toronto Sun*, 8 May, 29

Blundell, Valda
 1989 Speaking the Art of Canada's Native Peoples. *Australian and Canadian Studies* 7 (1):23–43

Blundell, Valda and Laurence Grant
 1989 Preserving Our Heritage: Getting Beyond Boycotts and Demonstrations. *Inuit Art Quarterly* 4 (1):12–16

Boas, Franz
 1887 Museums of Ethnology and Their Classification. *Science* 9:587–9
 1907 Some Principles of Museum Administration. *Science*, n.s., 25 (650):921–33
 1927 *Primitive Art*. Series B., vol. 8. Oslo: Instittutet for Sammenlignende Kulturforskning. Reprint: Dover, 1955
 1955 *Primitive Art*. New York: Dover

Bocock, Robert
 1986 *Hegemony*. London: Tavistock Publications

Bogaart, N.C.R.
 1978 Reality in Motion: Audio-Visuals as a Means of Transmitting Information in Museums. In Grace Morley, ed., *Visualization of Theoretical Concepts in Anthropology in Museums of Ethnography*. New Delhi: National Museum of Natural History, 43–7

Bonner, Alice
 1981 Smithsonian Counts its Treasures – 78 Million or So. *Vancouver Sun*, 17 October, 3

Boucher, Pierre
 1977 A Museums Policy for Quebec. *Gazette*, Journal of the Canadian Museums Association, 10 (3):54–56

Britan, Gerald M.
 1978a The Place of Anthropology in Programme Evaluation. *Anthropological Quarterly* 51 (2):119–28
 1978b Experimental and Contextual Models of Program Evaluation. *Evaluation and Program Planning* 1:229–34

British Columbia Place
 1984 False Creek: Rescued from Obscurity Almost as an Afterthought. *Update*, Spring issue, 3–4

Brown, Walter S.
 1978 The Museum Visitor: Demography and Behavior. Unpublished paper, University of Washington, Seattle, Washington

Broyles, Julie
 1988 Defining an Anthropology of Museums: Native American Museums as 'Artifacts of Society.' Paper presented to the eighty-seventh annual meeting of the American Anthropological Association, Phoenix, 19 November

Bruce, Jean

　1976　　Reclaiming the History of Canada. *Saturday Night*, June, 29–34

Bruman, Carol

　1982　　A 21st Century Walk Through Time. *Maclean's*, 27 September, 48

Burns, William A.

　1971　　The Curator-as-Canary. *Curator* 14 (3):213–20

Burridge, Kenelm

　1983　　An Ethnology of Canadian Ethnology. In Manning 1983a, 306–20

Butler, Barbara H., and Adrienne L. Horn

　1983　　A Natural Partnership. *Museum News*, August, 42–3

Cameron, Duncan F.

　1971　　The Museum, a Temple or the Forum. *Curator* 14 (1):11–24

　1982　　Museums and Public Access: The Glenbow. *International Journal of Museum Management and Curatorship* 1:177–96

　1983　　Museums and Public Access. In Barry Lord and Gail Dexter Lord, eds., *Planning Our Museums*. Ottawa: National Museums of Canada, 84–102

Canada Pavilion

　1985　　Design Brief–Main Hall. *Canadian Pavilion Expo '86*. 4 February

Canadian Museums Association

　1989　　Preserving Our Heritage: Talks to Continue Between Native Peoples and Museum, *Museogramme*, Newsletter of the Canadian Museums Association, 16 (8):1–2

　1990　　MP's Try to Intervene on Gallery's Purchase. *Museogramme*, Newsletter of the Canadian Museums Association, 18 (3):1–2

Canadian Press

　1987　　Goodwill Ambassador [Photograph]. *Globe and Mail*, 22 January, A5

　1989a　Kinsella 'Ripping Off' Indians. *Globe and Mail*, 8 December, C10

　1989b　Past Being Mined for Future. *Vancouver Sun*, 23 June, A16

　1990a　Gallery Purchase Raises Questions. *Globe and Mail*, 10 March, C6

　1990b　Civilization Museum Seeks Popularity: A Million Visitors Logged in First Year. *Vancouver Sun*, 2 July, B3

　1990c　Moscow Maks 'Beeg' Success Under Arches. *Vancouver Sun*, 1 August, A1

Cannizzo, Jeanne

　1979　　Historical Myths and Mythical Histories: The View From The Small Museum. Paper presented to the annual conference of the Canadian Ethnology Society, Banff, Alberta

　1982　　*Old Images/New Metaphors: The Museum in the Modern World, Parts 1–3* [Transcripts *Ideas* program]. Canadian Broadcasting Corporation, 21–5 February

　1989　　*Into the Heart of Africa*. Toronto: Royal Ontario Museum

Chalmers, Irene and Milton Glaser

　1986　　*Great American Food Almanac*. New York: Harper & Row

Chambers, Iain
 1986 *Popular Culture: The Metropolitan Experience*. London and New York:
 Methuen
Charnley, Kerrie
 1990 Neo-Nativists: Days Without Singing. *Front*, Newsletter of the West-
 ern Front Society, Vancouver (January):15–17
Clavir, Miriam
 1982–3 Notes on Changing Case Lighting. *Round Up*, Newsletter of the
 British Columbia Museums, 88:22–3
Clifford, James
 1989 The Global Issue: A Symposium. *Art in America*. July, 86–7, 152–3
 ✕ 1991 Four Northwest Coast Museums: Travel Reflections. In Karp and
 Lavine 1991:212–54
Codere, Helen
 1966 Introduction, Franz Boas, *Kwakiutl Ethnography*. Chicago: University
 of Chicago Press
Cole, Douglas
 1985 *Captured Heritage: The Scramble for Northwest Coast Artifacts*. Vancou-
 ver and Toronto: Douglas & McIntyre
Collier, Donald and Harry Tschopik, Jr.
 1954 The Role of Museums in American Anthropology. *American Anthro-
 pologist* 56:768–79
Colombo, John Robert
 1990 Fire the Curators. Letter to *Globe and Mail*, 17 March, D7
Cruickshank, John
 1986a Expo's Space Race: Three Superpowers Use Fair to Build Up Their
 Prestige with Showcase Technology. *Globe and Mail*, 29 March, A1
 1986b Vancouver Hits 100: Hard-bitten Timber Town Evolves into
 Sophisticated City. *Globe and Mail*, 5 April, A1–2
Da Breo, Hazel A.
 1989–90 Royal Spoils: The Museum Confronts its Colonial Past. *Fuse*,
 Winter, 28–37
Dafoe, Chris
 1989 Jelinek Angers Arts Groups with Remarks on Grants. *Globe and Mail*,
 21 December, C2
Dahrendorf, Ralf
 1970 The Intellectual and Society: The Social Function of the 'Fool' in the
 Twentieth Century. In Philip Rieff, ed., *On Intellectuals: Case
 Studies*. New York: Anchor Books, 53–6
Danzker, Jo-Anne Birnie
 1984 Reviews of The Box of Daylight: Northwest Coast Indian Art, Seattle
 Art Museum, and Smoky-Top: The Art and Times of Willie
 Seaweed, Seattle Science Centre. *Vanguard* 13 (1):38

Darnell, Regna
 1976 The Sapir Years at the National Museum, Ottawa. In J. Freedman,
 ed., *The History of Canadian Anthropology*. Canadian Ethnology So-
 ciety, 98–121
Day, Lois
 1985 Canadian Northwest Coast Cultural Revival. *Anthropology Today* 1
 (4):16–17
Dharamsi, Nazir
 1986 Pakistan Pavilion Zooms Through Ages. *Rainbow World*, Vancouver,
 2 May, 1
Dickson, David
 1983 France's Monumental Science Museum. *Science* 221:836–8
DiMaggio, Paul J.
 1985 When the 'Profit' is Quality: Cultural Institutions in the Market Place.
 Museum News 63 (5):28–35
Dominguez, Virginia R.
 1988 On Creating a Material Heritage. Paper presented to the symposium
 'The Objects of Culture,' chaired by Peter H. Welsh and Nancy J.
 Pavezo, annual meeting of the American Anthropological Associa-
 tion, Phoenix, AZ, 19 November
Doxtator, Deborah
 1985 The Idea of the Indian and the Development of Iroquoian Museums.
 Museum Quarterly 14 (2):20–6
 1988a *Fluffs and Feathers: An Exhibition on the Symbols of Indianness. A Re-
 source Guide*. Brantford, Ontario: Woodland Indian Cultural Edu-
 cation Centre
 1988b The Home of Indian Culture and Other Stories in the Museum:
 Erasing the Stereotypes. *Muse*, Journal of the Canadian Museums
 Association, 6 (3):26–31
Drainie, Bronwyn
 1989 Minorities Go Toe to Toe with Majority. *Globe and Mail*, 30 Septem-
 ber, C1–2
 1990 Black Groups Protest African Show at 'Racist Ontario Museum.'
 Globe and Mail, 24 March, C1
Duff, Wilson
 1975 *Images: Stone: BC: Thirty Centuries of Northwest Coast Indian Sculpture.*
 Saanichton, BC: Hancock House
Duffek, Karen
 1982 'Authenticity' and the Marketing of Contemporary Northwest Coast
 Indian Art. Paper presented to the ninth annual meeting of the Ca-
 nadian Ethnology Society, Vancouver, BC, 11 May
 1983a *A Guide to Buying Contemporary Northwest Coast Indian Arts.* Vancou-
 ver: University of British Columbia Museum of Anthropology
 Note No. 10

1983b Authenticity and the Contemporary Northwest Coast Indian Art
 Market. BC *Studies* 57:99–111
1983c Contemporary Northwest Coast Indian Art: The Market Context.
 Unpublished MA thesis. Vancouver, University of British Colum-
 bia
1983d The Revival of Northwest Coast Indian Art. In Luke Rombout et al.,
 Vancouver: Art and Artists 1931–1983. Vancouver: Vancouver Art
 Gallery, 312–17
1989 Exhibitions of Contemporary Native Art. *Muse*, Journal of the Cana-
 dian Museums Association, 7(3):26–8
1991 The End of Indian Art. *Step*, Jan/Feb, 18–22
Duncan, Carol
1983 Who Rules the Art World? *Socialist Review* 13 (4):99–119
1985 Public Displays in a Privatizing World. Paper presented to 'Making
 Exhibitions of Ourselves: The Limits of Objectivity in Representa-
 tions of Other Cultures.' Conference at the British Museum, Lon-
 don, 13–14 February, 1986
Duncan, Carol and Alan Wallach
1978 Museum of Modern Art as Late Capitalist Ritual: An Iconographic
 Analysis. *Marxist Perspectives* (Winter):28–51
1980 The Universal Survey Museum. *Art History* 3 (4):448–73
Dyck, Noel
1985 Aboriginal Peoples and Nation-States: An Introduction to the
 Analytical Issues. In Noel Dyck, ed., *Indigenous Peoples and the
 Nation State: Fourth World Politics in Canada, Australia and Norway*.
 Social and Economic Papers No. 14. St. John's, Newfoundland: In-
 stitute of Social and Economic Research, Memorial University of
 Newfoundland
Dykk, Lloyd
1986 Goose Laid Egg, But Still on Loose. *Vancouver Sun*, 31 May, E1
Edwards, John
1989 Novel Approaches. Letter to *Globe and Mail*, 21 October, D7
Enright, Robert
1990 Notes on 'The Arts Tonight.' Canadian Broadcasting Corporation FM
 program, 2 and 5 April
Errington, Shelly E.
1988 Objects of Power. Paper presented to the special symposium, 'The
 Objects of Culture,' chaired by Peter H. Welsh and Nancy J.
 Parezo, annual meeting of the American Anthropological Associa-
 tion, Phoenix, AZ, 19 November
Farber, Carole and Joan Ryan
1983 *Report: National Native Indian Artists Symposium*. 25–30 August,
 Hazelton, BC

Farrow, Moira

1985 Umbrellas to Spacecraft Will Adorn World Pavilions. *Vancouver Sun*,
 27 June, F6

Fay, Brian

1975 *Social Theory and Political Practice.* London: George Allen and Unwin

1987 *Critical Social Science: Liberation and its Limits.* Ithaca, NY: Cornell University Press

Fenton, William N.

1960 The Museum and Anthropological Research. *Curator* 3 (4):327–35

Findley, Timothy

1990 The Man Who Kissed Books and Bread Out of Respect. *Globe and Mail*, 16 June, C1

Fisher, Lizanne and Elizabeth L. Johnson

1988 Bridging the Gaps: A Museum-Based Heritage Awareness Programme. *Museum Anthropology* 12 (4):1–8

Fisher, Philip

1985 *Hard Facts: Setting and Form in the American Novel.* New York: Oxford University Press

Fishwick, Marshall, ed.

1983 *Ronald Revisited: The World of Ronald McDonald.* Bowling Green, KY: Bowling Green University Popular Press

Fleming, Marnie

1982 Patrimony and Patronage: The Legacy Reviewed. *Vanguard* 11 (5–6):18–21

Frankenstein, Susan, and M.J. Rowlands

1978 The Internal Structure and Regional Context Of Early Iron Age Society in South-Western Germany. *Bulletin of the Institute of Archaeology* 15:73–112

Freedman, Adele

1980 The Fellini of Fibreglass Thinks Big. *Globe and Mail*, 28 June, Entertainment Section, 3

1989 A Revealing Journey through Time and Space. *Globe and Mail*, 17 November, C11

Freedman, Maurice

1979 *Main Trends in Social and Cultural Anthropology.* New York: Holmes & Meier

Frese, H.H.

1960 *Anthropology and the Public: The Role of Museums.* Leiden, Netherlands: E.J. Brill

Fried, Nicky

1990 Fashion by Dorothy Grant. *Design Vancouver*, 9–10

Fulford, Robert

1984 Notebook: The Spirit of '86. *Saturday Night* 99(11):5–7

Gablik, Suzi

1985 *Has Modernism Failed?* New York: Thames & Hudson

Gardner, Helen

1959 *Art through the Ages.* 4th ed. New York: Harcourt Brace

Geertz, Clifford

1988 *Works and Lifes: The Anthropologist as Author.* Stanford: Stanford University Press

Gibbons, Paul 'Garbanzo'

1983 Summation ... A Fool's Ransom – A Play in One Act. In Manning 1983a:321–31

Gill, Ian

1986 Pattison: The Other Side to Gentleman Jim. *Vancouver Sun,* 3 May, C10

Globerman, Steven

1983 *Cultural Regulation in Canada.* Montreal: Institute of Public Policy

Goddard, Peter

1990 The Best and the Worst of 1990: The Arts. *Toronto Star,* 29 December, H1

Godfrey, Stephen

1985 'Bazooka' Approach used in Expo '86 Ad Campaign. *Globe and Mail,* 26 October, C4

1986 How Expo Rates as a Work of Art. *Globe and Mail,* 9 August, C5

1990 Foe of Elitism Has Had His Say on Arts. *Globe and Mail,* 9 April, A17

Gordon, Allan M.

1981 Confluences: An Essay. *Confluences of Tradition and Change: 24 American Indian Artists.* (Exhibition Catalogue) University of California, Davis: Regents of the University of California

Gould, Richard A. and Michael B. Schiffer, eds.

1981 *Modern Material Culture: The Archaeology of Us.* New York: Academic Press

Gouldner, Alvin A.

1970 *The Coming Crisis of Western Sociology.* New York: Avon Books

Graburn, Nelson H.H.

1968 Art and Acculturative Process. *International Social Science Journal* 21 (3):457–68

1976 *Ethnic and Tourist Arts: Cultural Expressions from the Fourth World.* Berkeley and Los Angeles: University of California Press

1977 The Museum and the Visitor Experience. In Linda Draper, ed., *The Visitor and the Museum.* Prepared for the American Association of Museums annual conference. Seattle, 29 May–2 June 1977 by the 1977 Program Planning Committee, Museum Educators of the American Association of Museums, and Lowie Museum of Anthropology 5–26

1981 1,2,3,4 . . . Anthropology and the Fourth World. *Culture* 1 (1):66–70
Gray, Charlotte
1988 Museum Pieces. *Saturday Night* 103 (9):11–17
Green, Bryan R.
1977 On the Evaluation of Sociological Theory. *Philosophy of Social Sciences*
 7:33–50
Greer, Sandy
1989 Ojibway Storyteller Speaks Out Against Film. *Kainai News*, 9 Novem-
 ber, 14–15
Gruneau, Richard
1988 Introduction: Notes on Popular Culture and Political Practice. In
 Richard Gruneau, ed., *Popular Cultures and Political Practices.*
 Toronto: Garamond, 11–32
Guba, Egon G. and Y.S. Lincoln
1983 *Effective Evaluation,* San Francisco: Jossey-Bass
Guédon, Marie-Francoise
1983 A Case of Mistaken Identity (the Education of a Naïve Museum Eth-
 nologist). In Manning 1983a, 253–61
Haacke, Hans
1986 Museums, Managers of Consciousness. In Brian Wallis, ed., *Hans
 Haacke: Unfinished Business.* Cambridge, MA: MIT Press and New
 York: The New Museum of Contemporary Art, 60–73
Haagan, Claudia E.J.
1989 Strategies for Cultural Maintenance: Aboriginal Cultural Education
 Programs and Centres in Canada. MA thesis, Vancouver: Univer-
 sity of British Columbia
Hall, Stuart
1981 Notes on Deconstructing 'the Popular.' In R. Samuel, ed., *People's
 History and Socialist Theory.* London: Routledge & Kegan Paul,
 227–39
Hallowell, Christopher
1983 The Proper Study of Mankind. *Nova: Anthropology on Trial,* 1 Novem-
 ber. *The Dial* [publication of KCTS 9]. Seattle, WA, 4 (11):46–7
Halpin, Marjorie M.
1978 Review of 'The 12,000 Year Gap: Archaeology in British Columbia,'
 and 'First Peoples: Indian Cultures in British Columbia' at the Brit-
 ish Columbia Provincial Museum. *Gazette* 11 (1):40–8
1979 *Cycles: The Graphic Art of Robert Davidson, Haida.* Vancouver: Univer-
 sity of British Columbia Museum of Anthropology Note No. 7
1983 Anthropology as Artefact. In Manning 1983a, 262–75
1988 Museum Review: 'The Spirit Sings: Artistic Traditions of Canada's
 First Peoples.' *Culture* 8 (1):89–93

Hamilton, Gordon

1985a Expo Prepares 'Tidal Wave' Ad Campaign. *Vancouver Sun*, 12 February, c11

1985b The Life and Time of Mr. Expo. *Vancouver Sun*, 23 March, c5

1985c Canada Place Begs More Money. *Vancouver Sun*, 26 October, a3

1985d Pavilion Seeking Sponsors. *Vancouver Sun*, 15 November, a18

1985e Souvenir Firm Finds a Crack in Trade Outside Expo Gates. *Vancouver Sun*, 18 December, b6

1986a Woodall: Compass of Expo. *Vancouver Sun*, 15 May, b1

1986b Fair Seen as the Site of Huge 'Garage Sale.' *Vancouver Sun*, 30 June, b1

1986c Smaller Expo to Remain. *Vancouver Sun*, 8 August, a1–2

Handler, Richard

1988 Review of *Museums, the Public and Anthropology: A Study in the Anthropology of Anthropology*. *American Anthropologist* 90 (4):1,035–6

Hanson, James A.

1980 The Reappearing Vanishing American. *Museum News* 59 (2):44–51

Hargreaves, Jennifer

1985 Theorising Sport: An Introduction. In Jennifer Hargreaves, ed., *Sport, Culture and Ideology*. London: Routledge & Kegan Paul, 1–29

Harjo, Suzan Shown

1991 I Won't be Celebrating Columbus Day: When Worlds Collide. *Newsweek*, Columbus Special Issue, Fall/Winter, 32

Harris, Neil

1978 Museums, Merchandising, and Popular Taste: The Struggle for Influence. In M. Quimby, ed., *Material Culture and the Study of American Life*. New York: Norton, 140–74

1981a *Humbug, The Art of P.T. Barnum*. Chicago: University of Chicago Press

1981b Cultural Institutions and American Modernization. *Journal of Library History* 16 (1):28–47

1990 *Cultural Excursions: Marketing Appetites and Cultural Tastes in Modern America*. Chicago and London: University of Chicago Press

Harris, Marvin

1979 *Cultural Materialism: The Struggle for a Science of Culture*. New York: Random House

Harrison, Julia D.

1988 'The Spirit Sings' and the Future of Anthropology. *Anthropology Today* 4 (6):6–9

Harrison, Julia D., et al.

1987 *The Spirit Sings: Artistic Traditions of Canada's First Peoples*. Toronto: McClelland & Stewart and Glenbow Museum

Harrison, Julia D., Bruce Trigger, and Michael M. Ames

1988 Point/Counterpoint: 'The Spirit Sings' and the Lubicon Boycott. *Muse*, Journal of the Canadian Museums Association, 6 (3):12–25

Hartline, David

1986 Expo: You Rate It . . . Tops! *Province Magazine*, 15 June, 4–5

Hawthorn, Audrey

1956 *People of the Potlatch: Native Arts and Culture of the Pacific Northwest Coast*. Vancouver: Evergreen

Helphand, Kenneth I.

1983 The Landscape of McDonald's. In Fishwick 1983:39–44

Henry iii, William A.

1990 Cover Stories: Beyond the Melting Pot. *Time* 135 (15):38–41

Hill, Tom

1984 Indian Art in Canada: An Historical Perspective. In Elizabeth McLuhan and Tom Hill, *Norval Morrisseau and the Emergence of the Image Makers*. Toronto: Art Gallery of Ontario and Methuen, 11–27

Hoebel, E. Adamson, Richard Currier, and Susan Kaiser, eds.

1982 *Crisis in Anthropology: View from Spring Hill, 1980*. New York: Garland

Holecek, Barbara G.

1983 *Papua New Guinea: Anthropology on Trial* [Transcripts]. Boston: wgbh

Holm, Bill

1965 *Northwest Coast Indian Art: An Analysis of Form*. Seattle and London: University of Washington Press

1983 *Smoky-Top: The Art and Times of Willie Seaweed*. Seattle: University of Washington Press and Vancouver: Douglas & McIntyre

Holm, Margaret

1986 Molding the Image of the American Indian: A History of Ethnology Exhibits at World's Fairs. Paper presented to 'Making Exhibitions of Ourselves: the Limits of Objectivity in Representations of Other Cultures.' Conference at the British Museum, London, 13–14 February, 1986

Horne, Donald

1986 *The Public Culture: The Triumph of Industrialism*. London: Pluto

Houle, Robert

1982 The Emergence of a New Aesthetic Tradition. In *New Work by a New Generation*. Exhibition catalogue, Mackenzie Art Gallery. Regina, Saskatchewan: University of Regina, 2–5

Hume, R.M.

1958 *One Hundred Years of bc Art: An Exhibition Held at the Vancouver Art Gallery to Commemorate the British Columbia Centennial Year*. Vancouver: Keystone

Hunter, Don

1990 The $1.8-Million Stripe. *Province*, 18 March, 37

Hymes, Dell
1969 The Use of Anthropology: Critical, Political, Personal. In Dell
 Hymes, ed., *Reinventing Anthropology*. New York: Pantheon Books,
 3–82
Illich, Ivan
1971 The De-Schooling of Society. In Bruce Rusk, ed., *Alternatives on
 Education*. Toronto: General Publishing, 103–26
Inglis, Stephen
1979 Cultural Readjustment: A Canadian Case Study. *Gazette*, Journal
 of the Canadian Museums Association, 12 (3):26–31
1982 'Good Lord Man, This Stuff is Crude': Beneath the Patina of Cana-
 dian Folk Art. Paper presented to the ninth annual conference of
 the Canadian Ethnology Society, Vancouver, BC, 9 May. See Inglis
 1989
1990 'Good Lord Man, This Stuff is Crude': Beneath the Patina of Cana-
 dian Folk Art. In Boyd White and Lynn M. Hart, eds., *Living Tradi-
 tions in Art: First International Symposium*. Montreal: McGill Uni-
 versity Press, 92–100
Jameson, Fredric
1990 *Signatures of the Visible*. New York and London: Routledge
1991 *Postmodernism or, The Cultural Logic of Late Capitalism*. Durham, NC:
 Duke University Press
Japan Association for International Exposition, Tsukuba
1985 *Tsukuba Expo '85 Official Guide Book*. Kodansha International
Jennings, Sarah
1990 Museum's Costs Questioned. *Globe and Mail*, 16 May, A14
Jensen, Doreen and Polly Sargent
1986 *Robes of Power: Totem Poles on Cloth*. Vancouver: University of Brit-
 ish Columbia Press
Johnson, Eve
1983 A Celebration of Art and Elegance. *Vancouver Sun*, 13 October, D1
Karp, Ivan and Steven D. Lavine, eds.
1991 *Exhibiting Cultures: The Poetics and Politics of Museum Display*. Wash-
 ington and London: Smithsonian Institution
Kelly, Robert F.
1982 Museums as Status Symbols: A Cynic's View of Museum-Public
 Interface. Paper presented to the ninth annual conference of the
 Canadian Ethnology Society, Vancouver, BC, 10 May. See Kelly
 1987
1983 The Socio-Symbolic Role of Museums. Paper presented to the
 eleventh International Congress of Anthropological and Eth-
 nological Sciences, Vancouver, BC, 20–24 August

1987 Museums as Status Symbols II: Attaining a State of Having Been. *Advances in Nonprofit Marketing* 2:1–38

Kelly, Russell
1986 *Pattison: Portrait of a Capitalist Superstar.* Vancouver: New Star Books

Kettner, Bonni Raines
1985 Supers Battle. *Province,* 12 July, 3
1986a It's the Jimmy Pattison Show! *Province Magazine,* 30 March, 2
1986b Ontario 'the Best.' *Province,* 6 April, 19

Key, Archie F.
1973 *Beyond Four Walls: The Origin and Development of Canadian Museums.* Toronto: McClelland & Stewart

Koepp, Stephen
1987 Big Mac Strikes Back. *Time* 129 (15):58–61

Kopper, Philip
1982 *The National Museum of Natural History.* New York: Harry N. Abrams

Kramer, Hilton
1989 Is Art Above the Laws of Decency? *New York Times,* 2 July, Section 2, 1, 7

Lacey, Liam
1989 Colleague's Attack Only Serves to Motivate Iconoclastic Author. *Globe and Mail,* 21 December, A14

Lacey, Liam and Isabel Vincent
1990 Saskatoon Gallery under Fire for 'Offensive' Exhibition. *Globe and Mail,* 23 March, A13

Lambert, Anne M.
1983 *Storage of Textiles and Costumes: Guidelines for Decision Making.* Vancouver: University of British Columbia Museum of Anthropology

Lawless, Benjamin and Marilyn S. Cohen
1977 The Smithsonian Style. In *The Smithsonian Institutions, the Smithsonian Experience. Science – History – The Arts . . . The Treasures of the Nation.* New York: W.W. Norton, 52–9

Leiss, William, Stephen Kline, and Sut Jhally
1986 *Social Communication in Advertising: Persons, Products, and Images of Well-Being.* Toronto: Methuen

Levine, Louis D. and Henry Sears
1982 The ROM: No Disneyland. Letter to the Editor, *Maclean's,* 8 November, 10

Lévi-Strauss, C.
1943 The Art of the Northwest Coast at the American Museum of Natural History. *Gazette des Beaux Arts* 24:175–82

Lewis, Brian N.
1980 The Museum as an Educational Facility. *Museum Journal* 80 (3):151–5

Lohof, Bruce A.

1982 *American Commonplace: Essays on the Popular Culture of the United States.* Bowling Green, KY: Bowling Green University Popular Press

Longfish, George C. and Joan Randall

1983 Contradictions in Indian Territory. *Contemporary Native American Art.* Exhibition Catalogue, Gardiner Art Gallery, Oklahoma State University, Stillwater, Oklahoma City, OK: Metro

Loubser, Jan J.

1983 Consciousness, Inquiry, Imagination and Action. In Manning 1983a, 2–21

Love, John F.

1986 *McDonald's: Behind the Arches.* Toronto: Bantam Books

1987 McDonald's goes Global. *Report on Business* 3 (7):54–9

Lowenthal, David

1985 *The Past is a Foreign Country.* Cambridge: Cambridge University Press

Lurie, Nancy Oestreich

1966 The Enduring Indian. *Natural History* 75:10–22

1971 The Contemporary American Indian Scene. In Eleanor B. Leacock and Nancy O. Lurie, eds., *North American Indians in Historical Perspective.* New York: Random House, 418–80

1981 Museum Land Revisited. *Human Organization* 40 (2):180–7

MacCannell, Dean

1976 *The Tourist: A New Theory of the Leisure Class.* New York: Schocken Books

MacDonald, George F.

1987 The Future of Museums in the Global Village. *Museum* 39 (3):209–16

1988 Epcot Centre in Museological Perspective. *Muse,* Journal of the Canadian Museums Association, 6 (1):27–37

MacDonald, George F. and Stephen Alsford

1989 *A Museum for the Global Village: The Canadian Museum of Civilization.* Hull, Quebec: Canadian Museum of Civilization

MacDonald, George F., et al.

1977 *Northwest Coast Indian Artists Guild: 1977 Graphics Collection.* Ottawa: Canadian Indian Marketing Services

Macfarlane, Nathalie

1978 *Joe David.* Vancouver: University of British Columbia Museum of Anthropology Note No. 2

Macfarlane, Nathalie and Stephen Inglis

1977 *Norman Tait, Nishga Carver.* Vancouver: University of British Columbia Museum of Anthropology Note No. 1

MacGregor, Arthur
 1983a Collectors and Collections of Rarities in the Sixteenth and Seven-
 teenth Centuries. In MacGregor 1983b, 70–97
MacGregor, Arthur, ed.
 1983b *Tradescant's Rarities. Essays on the Foundations of the Ashmolean Mu-
 seum, 1683, with a Catalogue of the Surviving Early Collections.* Ox-
 ford: Clarendon
MacNair, Peter L., Alan L. Hoover, and Kevin Neary
 1980 *The Legacy: Continuing Traditions of Canadian Northwest Coast Indian
 Art.* Victoria, BC: British Columbia Provincial Museum
McCracken, Grant
 1986 Culture and Consumption: A Theoretical Account of the Structure
 and Movement of the Cultural Meaning of Consumer Goods. *Jour-
 nal of Consumer Research* 13 (1):71–84
 1988 *Culture and Consumption: New Approaches to the Symbolic Character
 of Consumer Goods and Activities.* Bloomington and Indianapolis, IN:
 Indiana University Press
McFeat, Tom F.S.
 1962 Museum Ethnology and the Algonkian Project. *Anthropology
 Papers.* National Museums of Canada No. 2
 1967 The Object of Research in Museums, *Contributions to Ethnology 5.*
 Bulletin 204, Ottawa, National Museums of Canada, 91 9
McManus, Greg
 1988 The Question of Significance and the Interpretation of Maori Cul-
 ture in New Zealand Museums, AGMANZ *Journal,* Art Galleries and
 Museums Association of New Zealand, 19 (4):8–12
McMartin, Pete
 1983 A Gallery You Must See for Yourself. *Vancouver Sun,* 12 October, 5
 1986 Rare Treats or Not, McDonald's You Have with You Always. *Van-
 couver Sun,* 5 May, B5
Malinowski, Bronislaw
 1929 Practical Anthropology. *Africa* 2:22–38
Manning, Frank
 1983a *Consciousness and Inquiry: Ethnology and Canadian Realities.* Ottawa.
 National Museums of Canada
 1983b Confusion and Creative Engagement: A Comment on Canadian
 Ethnology. In Manning 1983a, 2–11
Marchak, Patricia M.
 1988 *Ideological Perspectives on Canada.* 3rd ed. Toronto: McGraw-Hill
 Ryerson
Mathews, Tom
 1990 Fine Art or Foul? *Newsweek* 116 (1):46–52

Mays, John Bentley
 1990a National Gallery Should Tune Out Static over Painting. *Globe and Mail*, 14 March, A11
 1990b Carving or Sculpture? *Globe and Mail*, 16 June, C4
Mead, Margaret and R.L. Bunzel, eds.
 1960 *The Golden Age of American Anthropology*. New York: George Braziller
Merton, Robert K.
 1972 Insiders and Outsiders: A Chapter in the Sociology of Knowledge. *American Journal of Sociology* 78 (1):9–47
Meyer, Karl E.
 1979 *The Art Museum: Power, Money, Ethics*. New York: Morrow
Millard, Peter
 1990 Art of the Inuit. Letter to *Globe and Mail*, 26 June, A18
Milrod, Linda
 1990 Message from the Director. *Folio*, Newsletter of the Mendel Art Gallery, February/March, 4
Mitchell, John
 1983 News Release: Briefing Notes on a Western Vancouver Island Cultural Enterprise. City of Port Alberni, BC, 5 March
Moore, Mavor
 1986 Expo '86: A World's Fair for People Who Hate World's Fairs. *Connoisseur*, June, 98–103
 1987 Canada's Cultural Road Takes a Disturbing Turn. *Globe and Mail*, 27 June, C2
Morris, Brian
 1983 The Special Demands Placed upon Museums by Their Users. Paper presented to the thirteenth general conference of the International Council of Museums, London, 23 July
Muratorio, Blanca
 1984 Dominant and Subordinate Ideologies in South America: Old Traditions and New Faiths. *Culture* 4 (1):3–18
Nader, Laura
 1969 Up the Anthropologist – Perspectives Gained from Studying Up. In Dell Hymes, ed., *Reinventing Anthropology*. New York: Pantheon, 284–311
 1980a *No Access to Law*. New York: Academic Press
 1980b The Vertical Slice: Hierarchies and Children. In Gerald M. Britan and Ronald Cohen, eds., *Hierarchy and Society: Anthropological Perspectives on Bureaucracy*. Philadelphia: Institute for the Study of Human Issues, 31–44
 1983 Who Reviews the Reviewers? *American Anthropologist* 85:660–2

Nason, James D.
 1981 A Question of Patrimony: Ethical Issues in the Collecting of Cultural
 Objects. *Round Up,* Newsletter of the British Columbia Museums
 Association, 83:13–20
 1987 The Determination of Significance: Cultural Research and Private
 Collections. In B. Reynolds and M. Stott, eds., *Material Anthropol-
 ogy: Contemporary Approaches to Material Culture.* New York and
 London: University Press of America, 31–68
National Museums of Canada
 1982 Exhibitions Assistance Programmes and Museums of Human and
 Natural History, Science and Technology. Unpublished Note, 2
 pp.
Nehru, Jawaharlal
 1946 *The Discovery of India.* New York: John Day
Newton, Douglas
 1981 The Art of Africa, the Pacific Islands, and the Americas: A New
 Perspective. *The Metropolitan Museum of Art Bulletin,* Fall, 9–10
Nicks, Trudy and Tom Hill
 1991 *Turning the Page: Forging New Partnerships between Museums and
 First Peoples.* Ottawa: Canadian Museums Association
Nietzsche, Friedrich
 1975 *Beyond Good and Evil.* Harmondsworth, England: Penguin
O'Rourke, Dennis (director)
 1987 *Cannibal Tours* [film]. Los Angeles: Direct Cinema
Ozick, Cynthia
 1989 A Critic at Large (T.S. Eliot). *New Yorker* 65 (4):119–54
Paine, Robert
 1985 Ethnodrama and the 'Fourth World': The Saami Action Group in
 Norway, 1979–1981. In Noel Dyck, ed., *Indigenous Peoples and the
 Nation-State: 'Fourth World' Politics in Canada, Australia and Norway.*
 Social and Economic Papers No. 14. St. John's, Newfoundland: In-
 stitute of Social and Economic Research, Memorial University of
 Newfoundland
Parachini, Allan
 1989 The National Endowment for the Arts: Arts Agency – Living Up to
 its Billing? *Western Museums Conference Newsletter,* Fall, 1, 3–5
Parezo, Nancy J.
 1986 Now is the Time to Collect. *Anthropology of the Americas Masterkey*
 59 (4):11–18
 1988 A Glass Box for Everyone: Displaying Other Cultures. Paper pre-
 sented to the special symposium, 'The Objects of Culture,' chaired
 by Peter H. Welsh and Nancy J. Parezo, annual meeting of the
 American Anthropological Association, Phoenix, 19 November

Parsons, T., and Gerald M. Platt
 1973 *The American University.* Cambridge, MA: Harvard University Press
Patterson, Pam
 1988 Doreen Jensen and Joane Cardinal-Schubert: Two Native Women
 Artists Tackle Issues Through Their Art. *Gallerie: Women's Art* 1
 (2):4–8
Philip, Marlene Nourbese
 1990 The 6% Solution. *Fuse,* Fall, 28–9
Phillips, Carol A.
 1982 New Work by a New Generation: Foreword. In *New Work By A
 New Generation.* Exhibition Catalogue, Mackenzie Art Gallery.
 Regina, Saskatchewan, University of Regina, 1
Phillips, Ruth
 1988 Indian Art: Where Do You Put It? *Muse,* Journal of the Canadian
 Museums Association, 6 (3):64–71
Preston, Richard J.
 1983 The Social Structure of an Unorganized Society: Beyond Intentions
 and Peripheral Boasians. In Manning 1983a, 286–305
Price, John A.
 1984 Native American Studies: The Development of a New Discipline.
 Unpublished paper, York University, North York, Ontario
Price, Sally
 1989 *Primitive Art in Civilized Places.* Chicago and London: University of
 Chicago Press
Rees, A.L. and F. Borzello, eds.
 1986 *The New Art History.* London: Camden
Rees, Ann
 1986a Layoffs Hit Expo. *Province,* 22 June, 13
 1986b This Mac's the Biggest. *Province,* 17 August, 70
Reid, Bill
 1982 The Legacy Review Reviewed. *Vanguard* 11 (8–9):34
Richardson, Michael
 1990 Enough Said: Reflections on Orientalism. *Anthropology Today* 6
 (4):16–19
Ridington, Robin
 1979 Mirrors and Masks. *Parabola* 4 (4):84–90
 1986 Texts That Harm: Racist Journalism in British Columbia. *Currents:
 Readings in Race Relations* 3 (4):6–11
Risatti, Howard
 1991 Guest Editor's Comments. *New Art Examiner* 18 (6):9
Rivard, René
 1984 *Opening up the Museum – Toward a New Museology: Ecomuseums and
 'Open' Museums.* Quebec City: published by the author

Robertson, Art
 1990 Art Gets Much-Needed Publicity. *Saskatoon Sun*, 31 March
Rogers, Bob, et al.
 1986 *'Spirit Lodge': The Story Behind the Haunting Show Presented by General Motors at the 1986 World's Fair*. Vancouver: Mitchell
Rowan, Madeline B.
 1978 The Museum – School and Theatre. *Round Up*, Newsletter of the British Columbia Museums Association, 72:32–3
Rowe, John Howland
 1965 The Renaissance Foundations of Anthropology. *American Anthropologist* 67 (1):1–20
Rydell, Robert W.
 1984 *All the World's a Fair*. Chicago: Chicago University Press
Ryan, Alan
 1991 *The Cowboy/Indian Show: Recent Works by Gerald McMaster*. Kleinburg, Ontario: McMichael Canadian Art Collection
Rushdie, Salman
 1990 *In Good Faith*. London: Granta
Salisbury, Richard F.
 1983 Applied Anthropology in Canada – Problems and Prospects. In Manning 1983a, 192–200
Scholte, Bob
 1969 Toward a Reflexive and Critical Anthropology. In Dell Hymes, ed., *Reinventing Anthropology*. New York: Pantheon, 430–58
Schroeder, Fred E.H.
 1977 *Outlaw Aesthetics: Arts and the Public Mind*. Bowling Green KY: Bowling Green University Popular Press
Scott, Andrew
 1978 BC's Great Art Bonanza. *Vancouver Sun*, 21 July
Shadbolt, Doris
 1974 *Bill Reid: A Retrospective Exhibition*. Vancouver: Vancouver Art Gallery
Shadbolt, Doris, et al.
 1967 *Arts of the Raven: Master Works by the Northwest Coast Indians*. Vancouver: Vancouver Art Gallery
Shadbolt, Jack
 1954 Has BC Betrayed Its Heritage of Art? *Province*, 6 November, 10–11
Shelly, Henry C.
 1911 *The British Museum: Its History and Treasures*. Boston: L.C. Page
Shils, Edward
 1972 *The Constitution of Society*. Chicago: Chicago University Press
 1981 *Tradition*. Chicago: University of Chicago Press

Shuh, John Hennigar
 1982 Teaching Yourself to Teach with Objects. *Nova Scotia Journal of Education* 7 (4):8–15
Siminovitch, Louis
 1979 *University Research in Jeopardy: The Threat of Declining Enrollment.* Hull, Quebec: Canadian Government Publishing Centre
Singer, Milton
 1959 Preface. *Traditional India: Structure and Change,* ix–xxii
 1972 *When a Great Tradition Modernizes: An Anthropological Approach to Indian Civilization.* New York: Praeger
 1977 On the Symbolic and Historic Structure of an American Identity. *Ethos* 5 (4):431–54
 1984 *Man's Glassy Essence: Exploration in Semiotic Anthropology.* Bloomington, IN: Indiana University Press
 1988 A Changing American Image of India: The Palimpsest of a Civilization. Foreword to Carla M. Borden, ed., *Contemporary Indian Tradition: Voices on Culture, Nature and the Challenge of Change.* Washington: Smithsonian Institution, 1–17
Sinha, Surajit
 1981 Tribes and Indian Civilization: Transformation Processes in Modern India. *Man in India* 61 (2):105–42
Smithsonian Institution
 1977 *The Smithsonian Experience: Science–History–The Arts . . . The Treasures of the Nation.* New York: Norton
Special Committee on Antiquities
 1959 *Final Report of the Special Committee of Antiquities.* Colombo, Ceylon: Government of Ceylon Sessional Papers 7
Squires, Donald P.
 1969 Schizophrenia: The Plight of the Natural History Curator. *Museum News* 48 (2):18–21
Srivastava, Anila and Michael M. Ames
 1990 South Asian Women's Experience of Gender, Race and Class. In Milton Israel, ed., *Ethnicity, Identity, Migration: The South Asian Experience.* Toronto: Centre for South Asian Studies, University of Toronto (in press)
Stevenson, Sheila
 1987 Balancing the Scales: Old Views and New Muse. *Muse,* Journal of the Canadian Museums Association, 5 (2):30–3
Stocking, George W., Jr.
 1971 *Race, Culture, and Evolution: Essays in the History of Anthropology.* New York: Free Press and Macmillan

Stocking, George W., Jr., ed.
1985 *Objects and Others: Essays on Museums and Material Culture. History of Anthropology Volume 3*. Madison, WI: University of Wisconsin Press
Sturtevant, William C.
1969 Does Anthropology Need Museums? *Proceedings of the Biological Society of Washington* 182:619–50
Taylor, William E., Jr., et al.
1978 *Northwest Coast Indian Artists Guild 1978 Graphics Collection*. Ottawa: Canadian Indian Marketing Services
1982 *Sharing the Challenge: An Invitation to Comment on New Public Facilities for the National Museum of Man*. Ottawa: National Museum of Man
Terrell, John
1991 Disneyland and the Future of Museum Anthropology. *American Anthropology* 93:149–53
Thorsell, William
1989 A Spectacular Disregard for Cultural Integrity. *Globe and Mail*, 21 October, D6
Todorov, Tzvetan
1982 *La conquête de l'Amérique: La question de l'autre*. Paris: Seuil
Tompkins, Jane
1990 At the Buffalo Bill Museum – June 1988. *South Atlantic Quarterly* 89 (3):525–45
Townsend-Gault, Charlotte and Elizabeth J. Thunder
1989 Two Reports from the Fall 1988 Conference 'Preserving Our Heritage.' *Native Art Studies Association of Canada* 3 (1):4–5
Tremblay, Marc-Adélard
1983 Anthropology in Question: What Knowledge and Knowledge for What? In Manning 1983a, 332–47
Trigger, Bruce
1989 A Present of Their Past? Anthropologists, Native People, and Their Heritage. *Culture*, Journal of the Canadian Anthropology Society, 8 (1):71–9
Twigg, Alan
1986 At Large: World's Fair Is a Wrong Turn. *Georgia Straight*, 20 (962), 30 May-6 June
Updike, John
1989 Modern Art: Always Offensive to Orthodoxy. *Western Museums Conference Newsletter*, Fall, 12–13
Vallance, Julie
1981 The Internal Dynamics of the Community Museum. Unpublished MA thesis, Vancouver: University of British Columbia

Vance, Carol
 1989 The War on Culture. *Art in America*, September, 39–43
 1990 Misunderstanding Obscenity. *Art in America*, May, 49–55
Vastokas, Joan M.
 1975 Bill Reid and the Native Renaissance. *Artscanada*, June, 198/199:
 12–21
Vincent, Isabel
 1990 Minority Artists Assail the Mainstream: Delegates to Conference
 Accuse Arts Councils of Racism. *Globe and Mail*, 25 June, A9
Wachtel, Eleanor
 1986 Expo '86 and the World's Fairs. In Robert Anderson and Eleanor
 Wachtel, eds., *The Expo Story*. Madeira Park, BC: Harbour Publish-
 ing, 19–44
Wade, Edwin L. and Rennard Strickland
 1982 Magic Images. *Four Winds: The International Forum for Native Amer-
 ican Art, Literature, and History* 2 (4):22–7
Wallace, Irving
 1959 *The Fabulous Showman. The Life and Times of P.T. Barnum*. New
 York: Signet Books from New American Library and Alfred A.
 Knopf
Wallace, Mike
 1985 Mickey Mouse History: Portraying the Past at Disney World. *Radi-
 cal History Review* 32:33–57
Wallis, Brian
 1986 The Art of Big Business. *Art in America*, June, 28–33
 1990 Vice Cops Bust Mapplethorpe Show for Obscenity. *Art in America*,
 May, 41–2
Washburn, Wilcomb E.
 1961 Scholarship and the Museum. *Museum News*, October, 16–19
 1968 Are Museums Necessary? *Museum News* 47(2):9–10
Watts, Dolly
 1988 Cultural Empowerment Within Museums and Anthropology. Un-
 published paper, Vancouver, University of British Columbia Mu-
 seum of Anthropology
Weaver, Sally M.
 1981 *Making Canadian Indian Policy. The Hidden Agenda 1968–1979*.
 Toronto: University of Toronto Press
Weil, Stephen E.
 1990 *Rethinking The Museum*. Washington and London: Smith-
 sonian Institution
Welch, Martin
 1983 The Ashmolean as Described by Its Earliest Visitors. In MacGregor
 1983b, 59-69

Welsh, Peter H.

1988 Exotic Illusions: Museum Exhibits and Cultural Interpretation. Paper presented to the special symposium 'Objects of Culture,' chaired by Peter H. Welsh and Nancy J. Parezo, annual meeting of the American Anthropological Association, Phoenix, AZ, 19 November

1989 Whose Afterlife Is It Anyway? Paper presented to the panel 'Native American Collections: Legal and Ethical Concerns,' chaired by Carey Caldwell, the 1989 annual meeting of the American Association for State and Local History, Seattle, WA, 9 September

Wentinck, Charles

1978 *Modern and Primitive Art*. Oxford: Phaidon

White, Leslie A.

1947 The Expansion of the Scope of Science. *Journal of the Washington Academy of Sciences* 37:181–210. Reprinted in L.A. White, *The Science of Culture*. New York: Grove, 1949, Chapter 5

Williams, B.

1989 A Class Act: Enthropology and the Race to Nation across Ethnic Terrain. In Bernard J. Siegel, ed., *Annual Review of Anthropology* 18:401–44

Williamson, Judith

1978 *Decoding Advertisements: Ideology and Meaning in Advertising*. London: Marion Boyars.

Wilson, David J.

1985 A Real Expo Never Ends. *Province Magazine*, 3 February, 4, 11

Wilson, Thomas

1891 Anthropology at the Paris Exposition in 1889. *Annual Report of the Smithsonian Institution for 1890*. Washington, 654–80

Winner, Langdon

1980 Do Artifacts Have Politics? *Daedalus* 109:121–36

Wolf, Eric

1982 *Europe and the People Without History*. Berkeley, Los Angeles, and London: University of California Press

Wolf, Robert L.

1980 A Naturalistic View of Evaluation. *Museum News*, July/August, 39–45

Wyman, Max

1986 Wooing the Yuppies. *Vancouver Sun*, 27 July, B1

Young, David R.

1980 *Northwest Renaissance*. Burnaby, BC: Burnaby Art Gallery

Younger, Erin
 1983 Contemporary Native American Art – Historical Background.
 Contemporary Native American Art. Exhibition Catalogue, Gardiner
 Art Gallery, Oklahoma State University, Stillwater, Oklahoma
 City, OK: Metro

Index

Printed on acid-free paper ∞

Set in Palatino by The Typeworks,
 Vancouver, BC
Printed and bound in Canada by Friesen
 Printers, Altona, Manitoba

Copy-editor: Emma-Elizabeth Peelstreet
Proofreader: Joanne Richardson
Indexer: Laura Houle
Jacket design: George Vaitkunas